SOCKEYE SALMON
A PICTORIAL TRIBUTE

Photographs by

HIROMI NAITO

Introduction by Stefani Paine

The Mountaineers
Seattle

Copyright © 1995 by Hiromi Naito
Text copyright © 1995 by Stefani Paine

95 96 97 98 99 5 4 3 2 1

All rights reserved. No part of this book may be reproduced, stored in a retrieval system or transmitted in any form or by any means, without the prior written permission of the publisher.

Published in the United States by
The Mountaineers
1011 SW Klickitat Way, Seattle WA 98134

Published simultaneously in Canada by
Greystone Books, a division of Douglas & McIntyre Ltd.
1615 Venables St., Vancouver BC v5l 2h1

LIBRARY OF CONGRESS CATALOG CARD NUMBER 95-76657

ISBN 0-89886-458-5

Edited by Nancy Flight
Cover photography by Hiromi Naito
Design by Barbara Hodgson
Printed and bound in Hong Kong

PHOTOGRAPHER'S MESSAGE

This book is a realization of a dream that began in 1977, when I was a university student in Japan studying the chum salmon. In Japan, most Pacific salmon no longer make the upstream journey to a natural spawning bed. Instead, they are collected at the river mouths and transferred to hatcheries, where they are spawned artificially.

I had heard of the sockeye salmon runs in Canada, where fish returned to rivers and streams in such numbers that the waters turned red. It was my wish to one day see this life cycle unfold in nature, to see salmon swim upstream and spawn in their birth rivers, where their progeny would develop and hatch before setting out on their own journey to the sea. Some five years later, I came to North America and for the first time saw salmon spawning in a river. I remember watching with excitement as my wish was fulfilled. This experience made a deep and lasting impression on me, and I returned to Canada in 1986 with the idea of creating this book.

In photographing the salmon, I had three goals. First, I wanted the camera's "eye" to show a fish's perspective of the spawning migration. This meant getting underwater shots from the midst of a travelling school of fish. Second, I wanted not only to document the species but also to create aesthetic and emotive images of the fish in their habitat. Third, I wanted to describe the passage of time and space over the salmon's life cycle, to depict the different environments the salmon travelled through and their interrelationships with other animals. These ideas guided my shooting style and determined how the photographic story unfolded.

To capture the story of the sockeye salmon in this way set me on my own journey, which took many years and led me to hundreds of sites all over British Columbia and into Alaska. So many factors were involved in getting the right shots that most of my time was spent travelling to various locations and scouting the sites rather than shooting. The only way to know where the fish were, what stage they were in, and what the water conditions were at different times and in different places was to go and see for myself.

Throughout this project, I met many people who shared their extensive knowledge of individual rivers and runs. Department of Fisheries and Ocean scientists, field technicians and hatchery workers provided valuable information as well as suggestions for the book. Although the people who have helped are too numerous to mention here by name, I would like to take this opportunity to thank everyone who so generously gave of their time and expertise to help make this book a reality.

Finally, my concluding thoughts are for those who will see this book. I hope that through these images people will take away a feeling for the importance of maintaining suitable habitats for salmon. We are fortunate to have such rich and healthy natural rivers where salmon can return home from their ocean travels and set the stage for the continuation of their species. I hope that this cycle will continue forever.

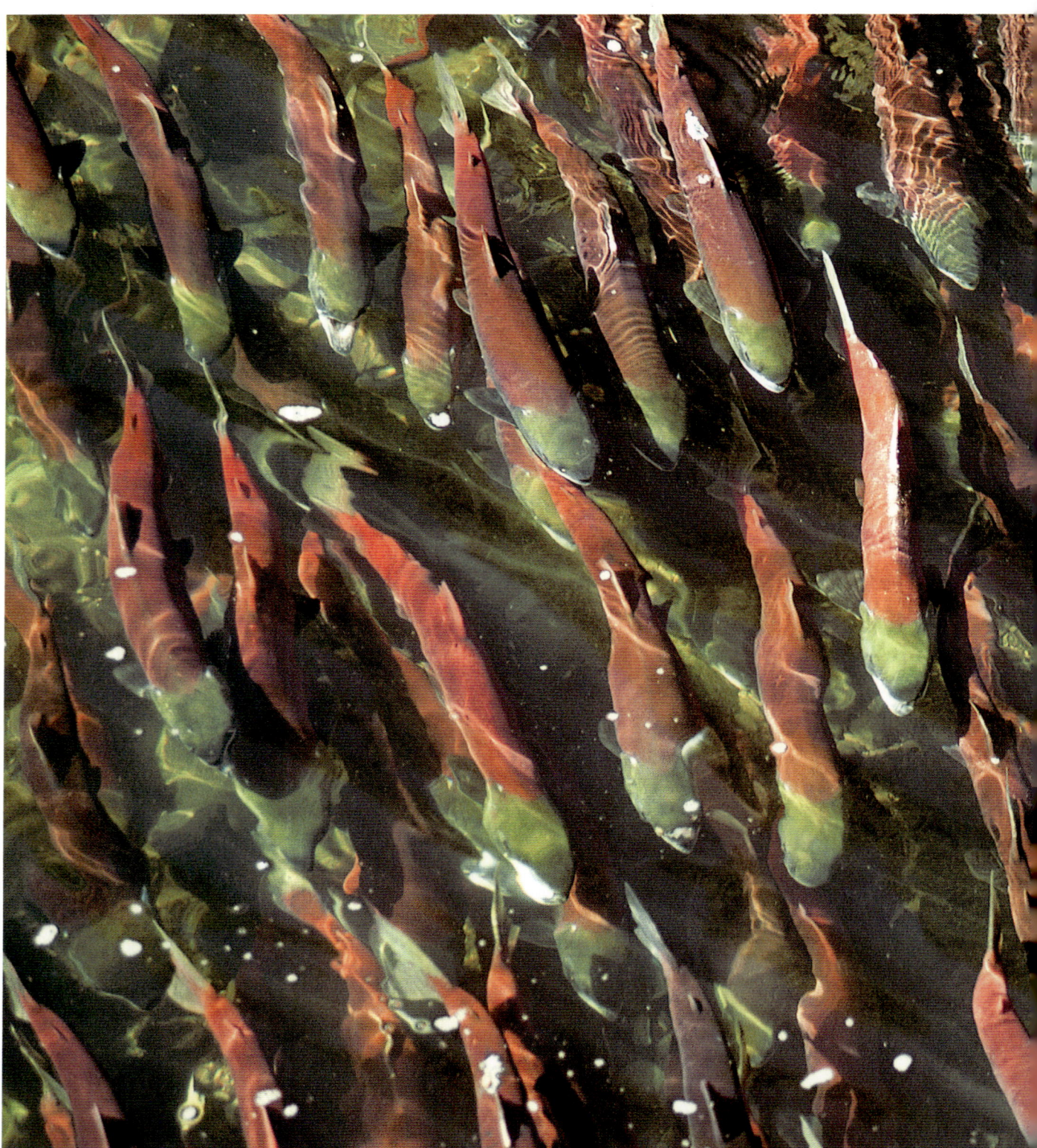

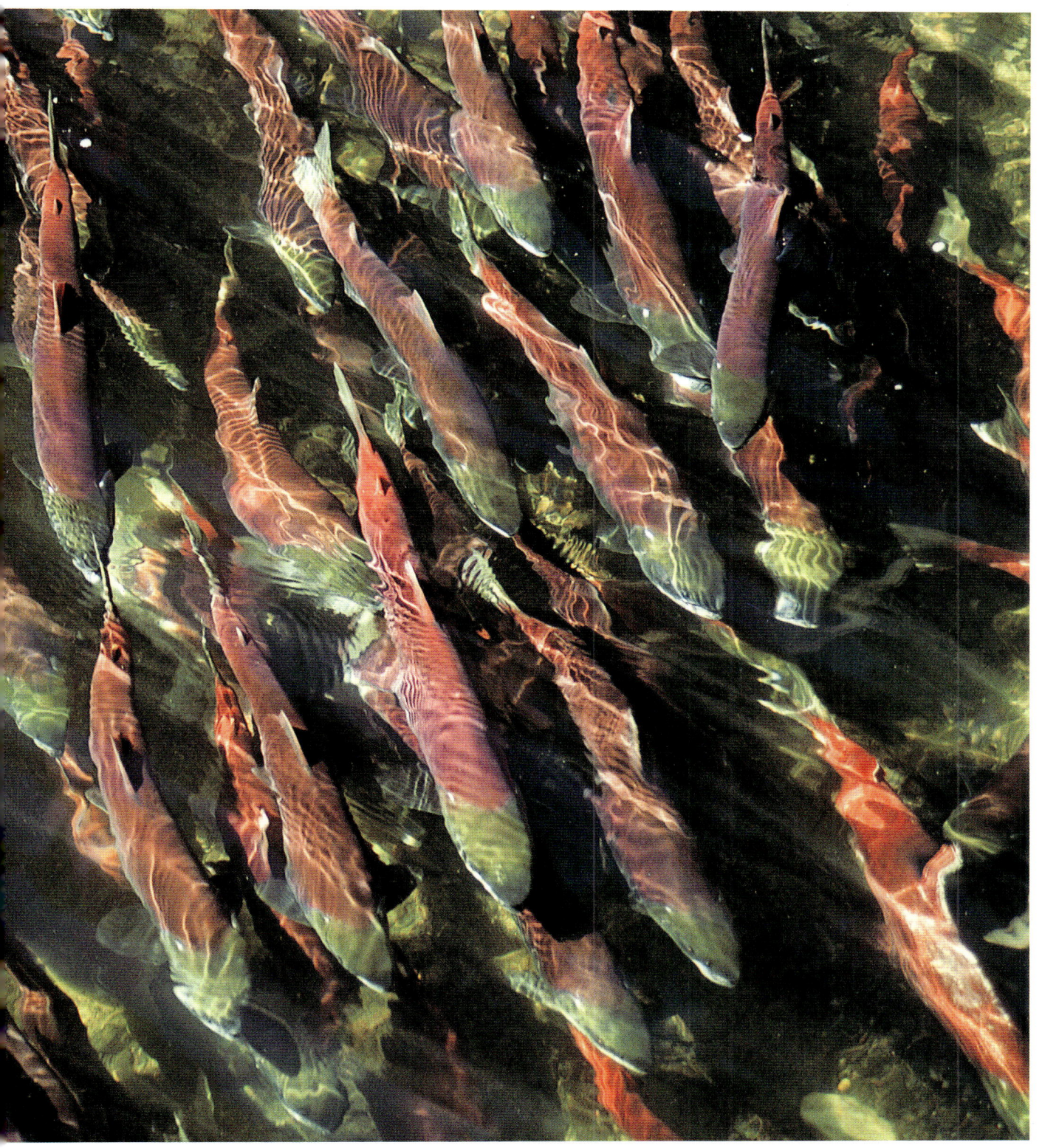

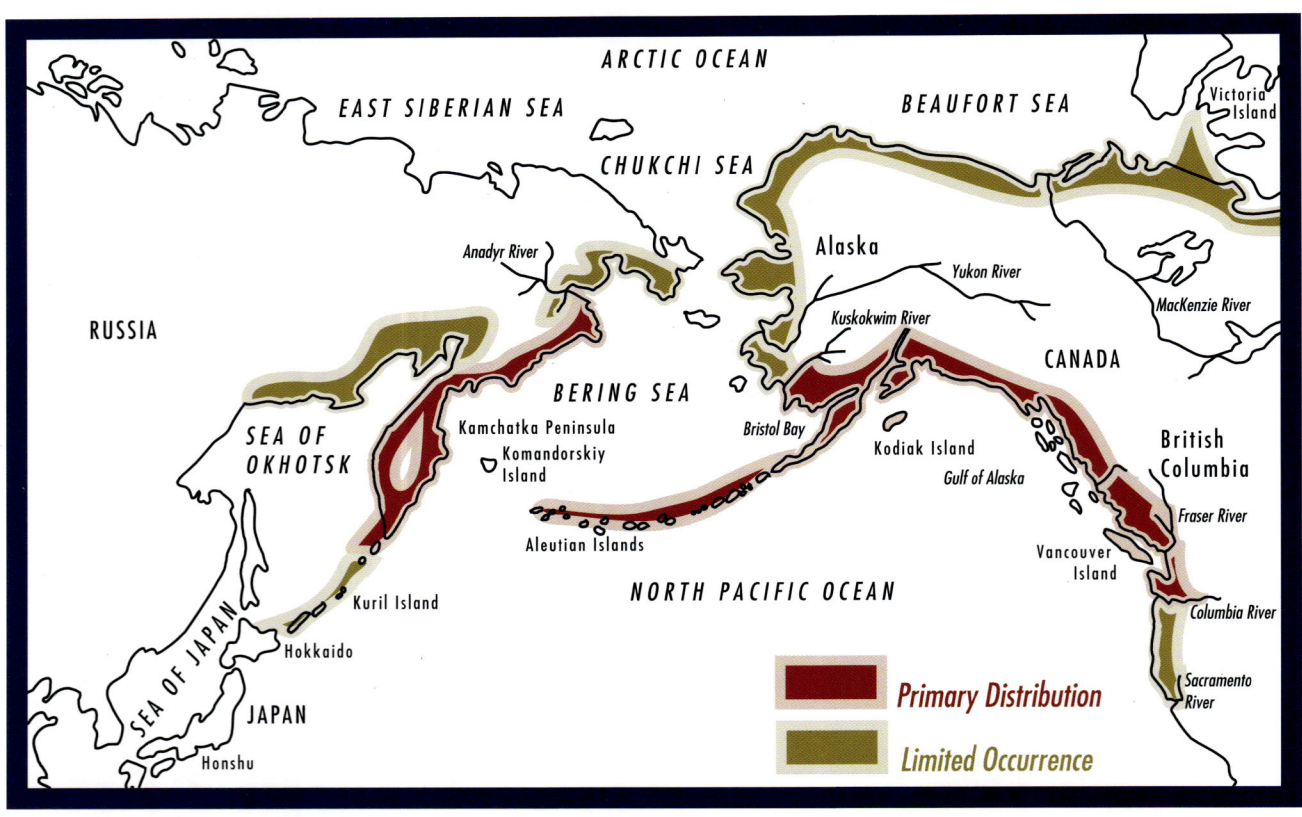

Coastal and spawning distributions of sockeye salmon. Data from Robert L. Burgner, "Life History of Sockeye," in Pacific Salmon Life Histories, *edited by C. Groot and L. Margolis (Vancouver: University of British Columbia Press, 1991), p. 4*

Pages 2–3: Brilliant red and green nuptial colours are unique to the mature sockeye salmon.

INTRODUCTION: A NATURAL HISTORY

Life Cycle of the Sockeye Salmon

It is dark and cool in the loose gravel of the stream bed. Clear fresh water tumbles and rumbles overhead, swirling through the gravel, around and between the multicoloured stones. As the crystal water reaches deep into the gravel, it gurgles by the few hundred red-orange sockeye salmon eggs lodged here and there in open spaces between the rocks, bathing the tiny eggs with life-giving oxygen. No parent will tend or protect these new lives, but stones overhead will hide the developing embryos from predators and protect them from freezing during the coldest months of the approaching winter. When temperatures drop and moisture is frozen into ice and snow, the stream that was a torrent will become little more than a trickle. If the gravel pocket is deep enough, what little water there is will still cover the eggs.

The seven species of Pacific salmon all begin their remarkable life cycle in a freshwater stream like this one. Although the fish are individually fragile and vulnerable, each species is exquisitely adapted to survive natural hazards. Yet today all salmon are severely challenged or even threatened by ever-increasing human encroachment. Five species, including the sockeye salmon, spawn in both Asia and North America, and two spawn in Asia only. The term "sockeye salmon" (*Oncorhynchus nerka*) is a corruption of the word *sukkai*, the name for the fish used by native people of southern British Columbia. The same fish is also known as redfish in Alaska, blueback in the Columbia River region, *nerka* and *krasnaya ryba* in the former Soviet Union, and *benizake* and *benimasu* in Japan.

Wherever the sockeye salmon occurs and whatever it is called, its spectacular biological journey begins with the single amber egg. Somewhere in the oil-filled capsule, two microscopic reproductive cells, one each from its mother and father, fuse into an invisible dot containing the most astounding amount of information. Like a microscopic computer, the dot contains an intricate blueprint for growth that will direct the organism's development through half a dozen physical changes and more. It contains instructions that will enable the adult fish to remember

and recognize years later the unique odours of this, its birth stream. Even at the embryonic stage, the cells contain maps of such scope and detail that the fish will be able to use star patterns, the positions of the sun and moon, and the earth's magnetic fields to navigate during its lifetime travels of 10 000 km (6000 miles) or more. The embryo holds special instructions for dramatic physiological alterations that will allow the fish to live in freshwater rivers, lakes or streams as a juvenile and in a saltwater habitat as an oceangoing adult. And it contains a precisely tuned inner clock that will control the fish's swimming speed so that no matter where it is in the vast North Pacific, it will return to this exact stream at precisely the right time four years hence.

The newly fertilized egg also contains instructions for behaviour—when to hunt, swim or rest, when to do things alone or join a school, and finally, when to assume the appropriate role of either nest-building female or aggressive, courting male. But that is years away. Now the tiny egg grows and rests in the bottom of the stream.

The embryo does not eat. Its lives on energy stored in the egg's drop of orange oil. On this finite food supply, it will survive months of winter and develop into a miniature fish with mouth, fins, gills, eyes—everything it will need to begin independent living in the spring. Over the winter months, a small fish takes shape atop of the amber drop of oil until only a vestige of its winter food supply remains as a transparent yolk sack on its belly.

One night in April, May or even June if it is a northerly stream, the tiny fish, no larger than a matchstick, threads its way in the dark up through the gravel into the flowing stream above. It doesn't stop to rest but vigorously flutters its tiny tail, pushing itself to the surface against gravity, because it is heavier than water. At the surface, the little fish, now called a fry, gulps air, filling its swim bladder and gaining buoyancy. It gulps and gulps again. After gulping enough air so that it is neither lighter nor heavier than water, the fry begins its first open-water journey out of the stream, into the river and down to the lake that will be its home for the next ten to eleven months. Other salmon species typically move directly to sea after emerging in the spring. Because of its extra time in fresh water, the sockeye has the most variable and complicated life history of all the Pacific salmon.

Subtle changes in the earth's magnetic field and the position of the sun will guide the little fish to its spot in the nursery lake. There it will school with other fry, most likely from the same stream. If the lake is a large one, populations from other streams in the same river system may be massing in different locations.

Once in the lake, young fish migrate to where their food—aquatic insects, smaller fish and insect larvae or other zooplankton—is concentrated. The millions of sockeye fry need an abundance of food if they are to grow quickly through the spring, summer and fall. They move up or

down in the water daily to feed when there is light enough to see their prey.

Sockeye fry are not the only hungry fish in the lake. Sticklebacks, pond smelt, pygmy whitefish and lake whitefish compete for the same food, while voracious char, pike and trout attack and eat the youngsters. Even though sockeye fry mass in schools for protection and avoid lake zones where their enemies live, predation is heavy. In some years and in some systems, up to 84 per cent of the salmon fry become food for larger fish, gulls and other aquatic birds. Still other silent enemies lurk in the placid lake water—parasites. Like the victims of any disease, the infected fry is compromised, smaller, with less stamina, vigour and ability to adapt to ocean life later. In systems such as the Babine in British Columbia, close to 30 per cent of the fry are infected.

Every sockeye salmon river, tributary and lake throughout the North Pacific from the Kamchatka Peninsula in Asia, across the Aleutian Islands to Alaska and down the Pacific coast to Oregon has its own unique characteristics. Some lakes are deep and cold; others are shallow and warm. Some are a short distance from the ocean; others are hundreds of kilometres inland. Most freeze over in winter; a few do not. Food organisms and predators vary from lake to lake.

Just as each stream, lake and river has a character of its own, so each sockeye population living there is different from the next. Each population differs in its development, behaviour, feeding strategy, spawning time and so on according to the character of the waters that make up its home environment. This is why on a large river system like the Fraser in British Columbia, there will be dozens, perhaps hundreds, of sockeye stocks. The variations are endless and confusing, with the result that for virtually every statement one can make about the sockeye there is an exception. Most spend ten to eleven months in a their rearing lake, but some stay two years or more. Some never leave. Those that never go to sea are known as kokanee, little redfish, silver trout and *himemasu*. Most spend two or three years at sea, but some return after one year and others after four. The ensuing description of the sockeye salmon's life cycle is based on the most typical case.

With a combination of warm lake water heated by the summer sun and abundant food, young salmon grow rapidly over the summer. Trees on the hills surrounding the lake have come into full leaf and bears have ambled along the shore, stopped to drink and moved on in search of berries and shoots. Finally, summer moves into fall in as leisurely a fashion as the plump racoon parts reeds on the marshy shore of the lake. As fall fades into winter, the days draw in, temperatures drop, and the lake loses its heat, chills and finally freezes over. In water under the ice, lake fish, including young sockeye, wait out the cold dark of winter.

Although the lake remains covered with ice, longer days in early spring trigger a remarkable transformation in juvenile sockeye salmon as they undergo dramatic physical and internal changes in preparation for their seaward migration. These young travellers will need new swimming skills,

navigational ability and tremendous stamina. Their short bodies, marked with dark, vertical, elliptical stripes known as parr marks, become longer and sleeker, with silvery-black backs. Like the marshalling of a massive army, the young fish, now called smolts, move into tight schools. Their movements are decisive, as they come from all over the lake to mass at its outlet in anticipation of spring breakup.

At last the ice decays, breaks and melts. The smolts begin to move in dense schools, emptying an entire lake of its smolt population in a matter of days. The evacuation can be truly astounding. Lake Iliamna in Alaska, nursery to the world's largest sockeye salmon run, may have 270 million salmon smolts leaving the lake at a rate of 60 million a day, packed into a four-hour period between 10:00 P.M. and 2:00 A.M.

There is no time to waste. Within each small fish a biological clock ticks away the hours and days allotted for the hazardous journey from lake to ocean. Its body has begun the irreversible process of changing from a freshwater to a saltwater animal, and its energy reserves have been committed to the transformation and the journey. Once the journey has begun, anything that slows the traveller's passage is a challenge to its survival. As smolts funnel out of their nursery lakes, they run a gauntlet of waiting predators. With fish attacking from below and birds from above, the salmon's best opportunity for safe passage is after dark, when the gulls stop eating, and during the darkest two to three hours of night, when even the char slow down.

For some, the route to the sea will be short and direct; others will navigate complicated routes along shorelines and through other lakes and connecting rivers. Some will enjoy easy passage once they enter the main stream and ride its current to the ocean. Others will be swept along at 40 km (25 miles) a day through violent rapids and waterfalls, turning tail-first into the turbulence. Some will survive fish and bird predators during their seaward migration only to be sucked up by cruising beluga whales in Alaskan river estuaries.

If you were to open an atlas and trace any one of a number of northern rivers in Asia and North America from origin to mouth, you would easily see that some are longer and more convoluted than others and all end as a black line at the ocean. The map tells only one story—the length and direction of the river relative to the land over which it flows. What is not revealed is that every river is distinctive, as is its mouth and estuary. A river empties itself into an exposed and angry sea or into a sweeping protected delta, a place of strong currents or of little movement. Salinity, temperature, tides, available food and predators vary dramatically from one river mouth to the next, and each young sockeye must be adapted to the conditions it will meet at the mouth of its own river and not to those of another. As a result, some young seafarers will move offshore immediately, whereas others will feed in the estuary for the summer and move offshore in the fall.

Fraser sockeye spend the early summer in the Strait of Georgia's protected waters, leaving the strait via its corridor to the north in June or July. In the Gulf of Alaska, juveniles mass 40 km (25 miles) offshore in an 1800-km (1100-mile) band stretching from Cape Flattery to Yakutat.

By fall, the young sockeye is ready to strike out into the open water of the North Pacific. The oceangoing sockeye salmon is a magnificent creature, sleek and silver bodied, blue-black on the top of its head, shading to steel blue along its back. Its slender jaws and gill covers are silvery white. Its belly is snow white, and the delicately fanned tail is without spots. This silver swimmer roams the temperate subarctic Pacific for one to four years, making an annual journey of 3700 km (2300 miles) or more. It ranges northward in the spring and then southward at the approach of winter, as it searches for food—euphausiids, amphipods, squid and small fish such as juvenile cod, capelin, sand lance, herring and pollack. Most hunt and swim near the surface in water less than 8 m (26 feet) deep. In the great North Pacific, sockeye salmon of various ages intermingle with hundreds of other sockeye stocks from countless rivers. Even sockeye from Asian rivers thousands of kilometres from those originating in North American streams will overlap in the central Pacific between 175° west latitude and 160° east latitude. Yet among the tens of millions of sockeye salmon growing and maturing at any given time, each individual fish has its own timetable, its own map and its own life plan.

In the spring of their returning year, those destined to return separate from those remaining at sea and begin their homeward journey. This is not a simple retracing of steps. Sockeye from the same stream can be spread over a massive area of ocean, yet each one knows where it is relative to its destination. Using celestial cues and magnetic fields, the fish swim day and night at a steady 46 to 56 km per day (29 to 35 miles per day) for as many days as it takes to return to the river mouth in an orderly and predictable fashion. Each mature sockeye adjusts its swimming speed and direction so that it will arrive near shore on time to make the upstream journey to its natal stream when water flow and temperature are optimum; each fish is exquisitely adapted to the specific conditions of its birth river and lake system and none other. So precise is the salmon's ability to coordinate time, speed and direction that 80 per cent of millions of Bristol Bay sockeye spread over an ocean area the size of Australia will pass through the Bristol Bay estuary within fourteen days.

For the sockeye salmon, which has grown into a lithe and powerful fish weighing between 2 and 3 kg (between 4.5 and 6.5 pounds), the return home marks the final chapter of its life history and the most physically taxing challenge it has yet experienced. When it reaches its river estuary on the way to its final destination, it stops feeding, never to eat again. From now on, the great physical demands that lie ahead must be met by energy reserves alone.

Upstream movement begins any time from summer to early fall, depending on the stream. Schools of fish moving upstream conserve precious energy, taking advantage of slower currents near banks, back eddies and stream bottoms. Some battle rapids, log jams, and human and animal predators during up to 1000 km (600 miles) of upstream travel. Many swim against the current, gaining 50 km (30 miles) a day until remembered odours tell them that they are home at last.

By late summer to mid-fall, spawners choke tributary or trunk streams between lakes, creeks, side channels or even tidewater sloughs according to the long traditions of the stocks from which they arose. Startling physical alterations transform the silver athletes so that now male and female are distinctly identifiable as separate sexes. The male develops a hugely elongated upper jaw that hooks ghoulishly over his lower jaw. Canine-like teeth protrude from his receding gums. His body flattens side to side, and a fleshy hump develops on his shoulders. The beautiful metallic silver of his oceangoing colours are replaced by a green head, brilliant red back and black-red sides. His iridescent sheen disappears as his skin thickens and scales are resorbed. Females change colour too, with slightly less intensity. No hump develops, but the female's abdomen swells with developing eggs and she too takes on a hag-toothed look. Male and female are now in courtship dress.

It is the female that initiates the spawning act. She swims over the stream bed searching for a suitable site. She looks for coarse sand, flushed from below, or piles of angular rubble that, once settled, are unlikely to move in a fast-flowing stream. At last satisfied with a location, she begins the arduous task of preparing the redd, an oblong-shaped excavation about a metre (3 feet) long, parallel to the stream's current. Turning her side to the stream bottom, she flexes violently, and suction lifts gravel and sand as silt and debris are flushed away. She rests, momentarily spent after her exertion, and then repeats the procedure, testing the depth and texture of the excavation with her anal and pectoral fins after each bout of digging. Nest-building activity attracts males, and even other females, which she aggressively drives away along with undesirable males.

Although males engage in ritualistic or actual fighting on the spawning grounds, the choice of mate is the female's prerogative. She allows a male of her choosing to court her by gently touching her side with his snout and quivering vigorously for a second or two as they stay side by side. The chosen male drives off other males, though an aspirant often takes up a satellite position behind or to the side of the courting pair. When the female is ready to expel a pocketful of eggs, the spawning fish position themselves side by side, vents close together at the bottom of the nest, jaws agape and backs arched as their dorsal fins undulate and their tails vibrate rapidly for ten to twelve seconds. Eggs and sperm are expelled simultaneously as five hundred to eleven hundred eggs sink to the bottom of the nest. Immediately the female moves upstream to loosen gravel and cover the nest pocket. After a rest of several hours, the female will repeat the spawning act either

with the same male or with another if the first one has departed. By the time she is fully spent, she will have spawned and covered four or five separate nest pockets within the one redd. Now she fills in the entire depression with a cover of 15 to 23 cm (6 to 9 inches) of gravel. She has lost a third of her body weight since she entered the river. Ninety per cent of her fat is gone, along with 30 to 60 per cent of her muscle mass. Exhausted and emaciated, she devotes what little energy she has left to the offspring she will never see. She spends her last days and hours defending her nest. Finally death releases her.

Everywhere that sockeye salmon spawn the drama is repeated. But for each individual fish, it is a life story of no repeats. Each major event happens only once. As the carcasses of spawned-out salmon heap in corpse-grey mounds on shore and in back eddies, they provide a feast for bears and birds. Carcasses taken downstream into lakes eventually sink, decompose and fertilize the lake, putting nutrients back into the system to be recycled as nourishment for another generation of thread-sized sockeye salmon fry that will emerge from the gravel beds when springtime and new life flourish once again.

Challenges to Survival

Today sockeye salmon are fished by the former Soviet Union, North and South Korea, Japan, the United States and Canada. Overall, more fish of North American origin than of Asian origin are caught. This is because North American stocks are much larger than Asian stocks, as a result of the greater abundance of freshwater rearing habitats available to the fish in North America. All manner of nets, set lines, traps and troll gear are used, with the total all-nation catch estimated to be in the neighbourhood of 800 000 tonnes (880 000 tons) annually. Sockeye salmon is the third most abundant commercial salmon species after pink and chum, comprising 17 per cent by weight of the total all-species salmon catch. The United States, Canada and Japan fish the major production areas of Bristol Bay, southern British Columbia and Washington State and the high-seas gillnet fisheries. Japan fishes salmon of Kamchatkan and Bristol Bay origin on the high seas under international treaty agreements between Canada, Japan and the United States. Besides the commercial harvest, sockeye salmon are caught in sports fisheries and in native subsistence fisheries.

In the last fifty years, there has been a massive increase in our knowledge about the sockeye salmon as declines in stocks and international treaties have stimulated research. Computers and new technology such as that used for counting and identifying stocks provide managers and

researchers with powerful new tools to investigate the lives and behaviour of this fascinating animal. The deeper the scientists probe, the more they come to know not only about the fish but also about its environment and the extraordinary relationship between the two.

Water temperature, currents, the seasons, predators and food supply have a tremendous impact on the sockeye but are beyond its control. The sockeye cannot alter its environment. That is why every detail of the fish's life from how it looks to how it behaves is shaped to fit its environment as perfectly as possible and to enhance its chances of survival. The environment sets the rules and calls the tune. Like trying to keep step with a fickle dancing partner, the sockeye moves and sways, keeping step, following as best it can a partner that is indifferent to its presence, surviving extremes and embracing opportunities.

More threatening by far than overharvesting and perhaps impossible to manage are the competing needs of fish and people for clean, fresh, fast-flowing water. The fish in its environment has replaced overfishing as the concern of the future, because it is alterations to the fish's home, its habitat, that pose the greatest threat to its survival. Virtually every freshwater river, stream or lake is subject to human interference, including simple domestic use and the dumping of untreated industrial waste into the water as a result of mining and pulp mill operations, sewage, agricultural runoff and storm sewer effluent. All of these sources of pollution alter the water chemistry, the amount of oxygen the water can hold and potentially the ability of both the salmon and its prey to survive. All of these factors are critical to the developing salmon.

When water is diverted for domestic use, hydro development, irrigation channels, diking and industrial needs, flow rates are altered. Less water in a given stream or river means a lowered water level, with the result that developing eggs will freeze in winter or simply dry out and die. If eggs survive, problems remain because young salmon are adapted to move at particular speeds during critical times in their early development. Artificially slow water from damming or diversion forces them to swim harder, using more of their precious energy reserves and resulting in weakened rather than vigorous juveniles entering the sea. Other smolts are crushed in turbines when they are caught in hydroelectric dams downstream.

Streams and rivers are also disturbed by highway, pipeline and railway construction. Clearcut logging and foreshore development strip foliage that holds soils, and so when the rains come soil is washed into rivers and streams, becoming drifting sediments that smother developing eggs and young fish. Dredging waterways for marinas and shipping lanes has the same effect. Warm industrial waste water might be clean and chemical free, but altering the natural stream temperature is just as damaging as other alterations because water temperatures are critical not only for developing salmon but for the growth and survival of food species as well. Some nursery lakes, which are

so important to young sockeye, are seriously affected by the spread of nuisance plants such as Asian milfoil. And finally there is the insidious and ever-increasing effluent loading of stream, river, estuary and ocean that comes from the expanding human population and urbanization. This problem affects the sockeye at every stage of its life cycle.

These hazards are not the imagined problems of some unknown fish in some hypothetical stream or river. They are real. In the Columbia River, for example, runs of over one million fish in the early 1900s have dwindled to insignificance as a result of the combined pressures of overfishing and dams that block access to spawning grounds. By 1970, of eight lakes on the Columbia system that historically reared sockeye salmon, only three were still producing.

Throughout the sockeye's range, urbanization and stream diversion to make way for agriculture and housing destroy fish stocks. For example, in the land area now covered by Greater Vancouver in British Columbia, 24 stocks have been lost. Scientists estimate that 100 more have disappeared from the Columbia in the Kootenays. In Washington, Oregon and Idaho, an estimated 101 of 214 stocks are at high risk. There may be a total of 10,000 stocks, some strong and many at risk, in British Columbia alone. Many of these stocks are small, and some would argue that they aren't worth keeping when strong stocks can be enhanced to make up the total numbers. But the small stocks represent genetic diversity, which is another name for variety. Put simply, Mother Nature does not put all her eggs in one basket, and neither should we.

To preserve the wild salmon is to preserve its wild habitat and thereby hold in trust and health not only the salmon but a vast network of freshwater lakes, rivers and streams shared by an infinite variety of other life forms that populate the salmon's world—aquatic plants and insects, salamanders, snails, worms and a host of invertebrate creatures that have not yet been identified.

The sockeye salmon's short life is a huge circular journey, marked by dramatic changes and challenges but made only once. May the cycle never end.

The sockeye salmon's four-year life cycle begins with an egg in a freshwater stream and ends with death in the same stream. Thus, the salmon's biological story is properly told beginning with the egg and moving through the fish's years and stages of development until it returns to the river and dies.

Over the centuries, people have watched the salmon as they triumphantly return to the stream of their birth. This is where our photographic story begins, when the adults return from the ocean and move inland, back to the rivers where we can see them and marvel at so wonderful a beast. The final drama unfolds as the spawners, dressed in their brilliant red and green nuptial colours, choke the rivers, prepare to fight their way upstream, do battle with others of their own kind and secure for themselves the best mate and the most advantageous site for offspring that they will never see.

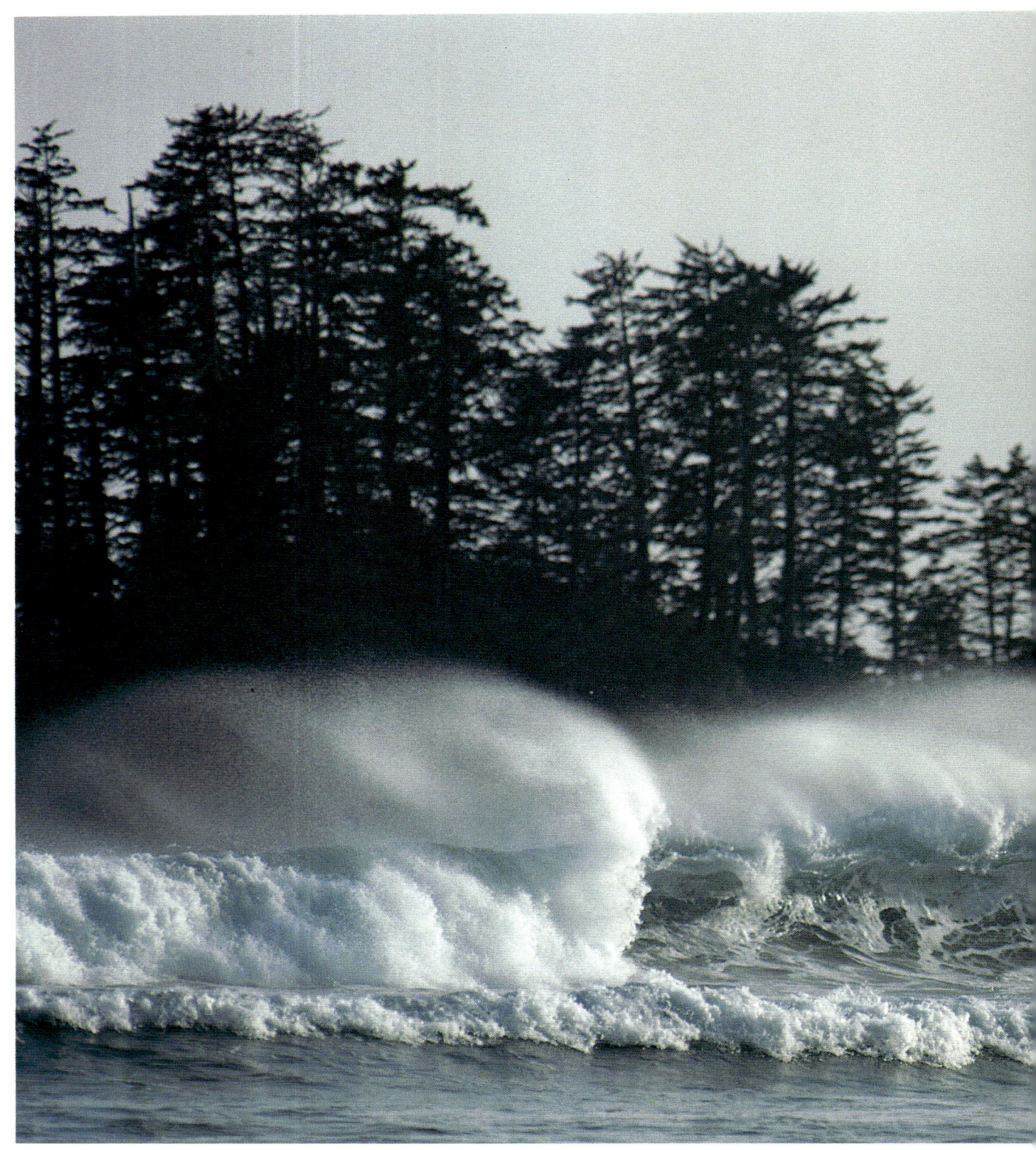

After years of feeding in the open waters of the powerful North Pacific, the sockeye salmon returns to coastal waters.

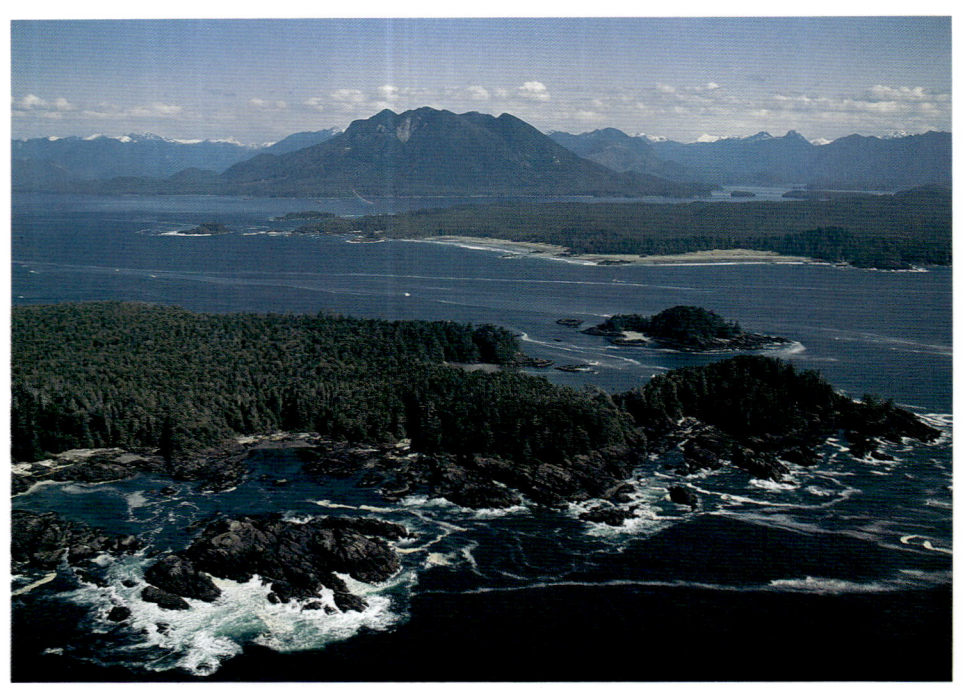

Above: Although sockeye may range over thousands of kilometres in the North Pacific during their ocean-going phase, each will eventually make landfall and travel to its natal river.

Right: Huge schools form where sea-run sockeye gather at river mouths, waiting for the perfect time to begin their upstream migration.

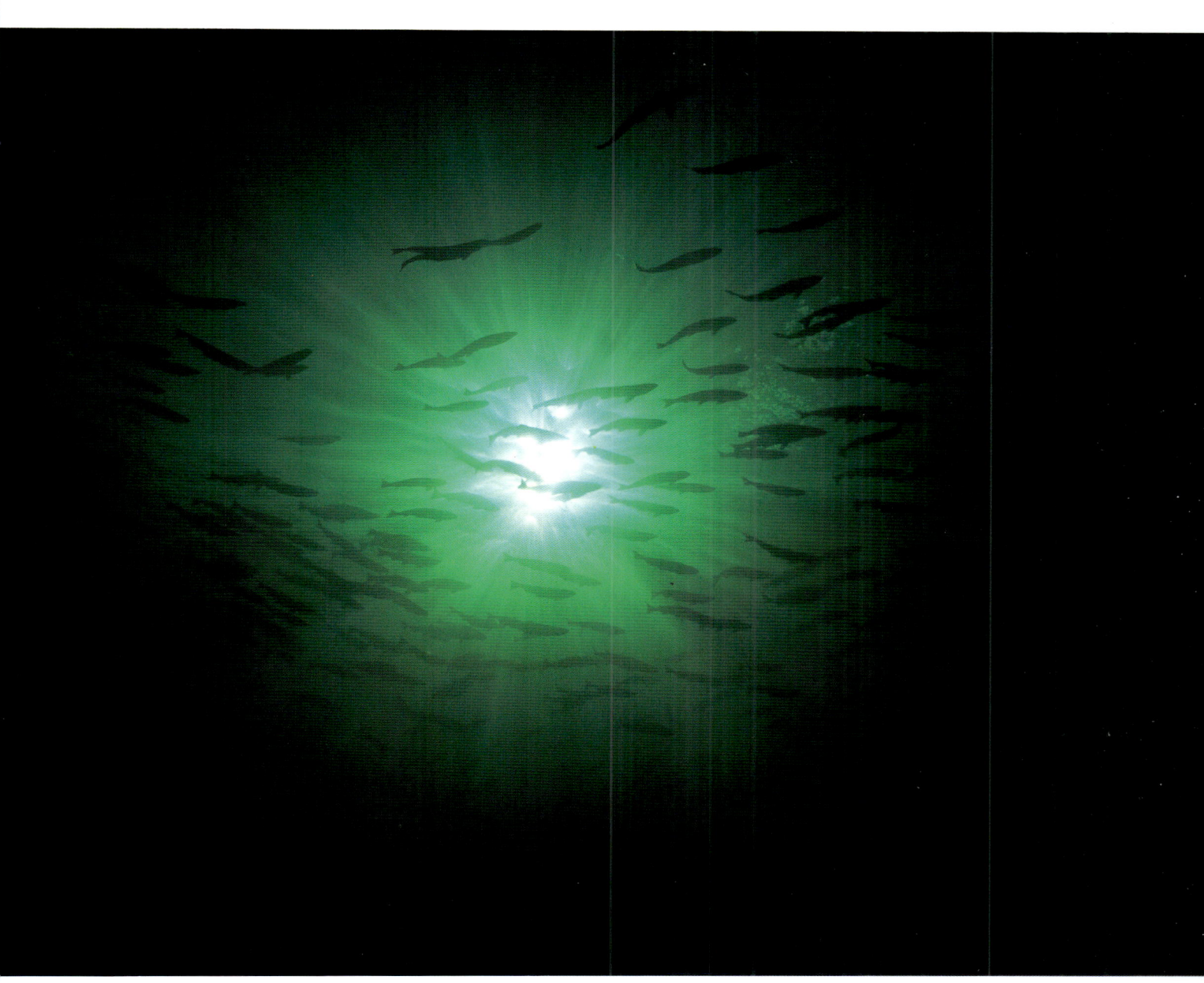

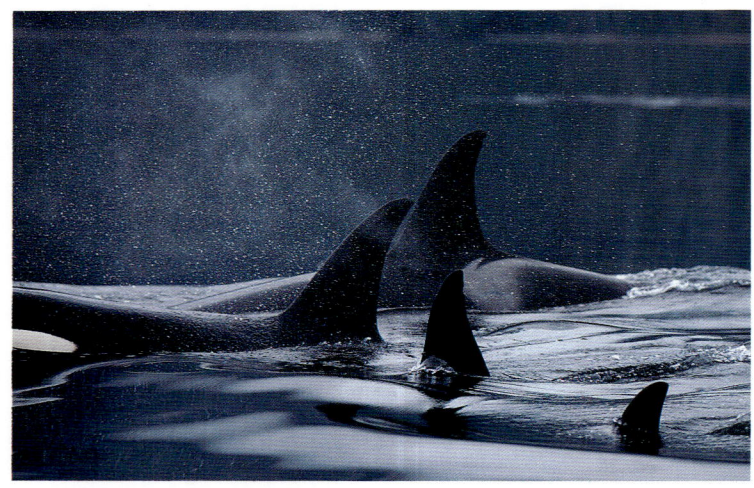

As the sockeye move into coastal waters, they provide a summer feast for pods of majestic killer whales.

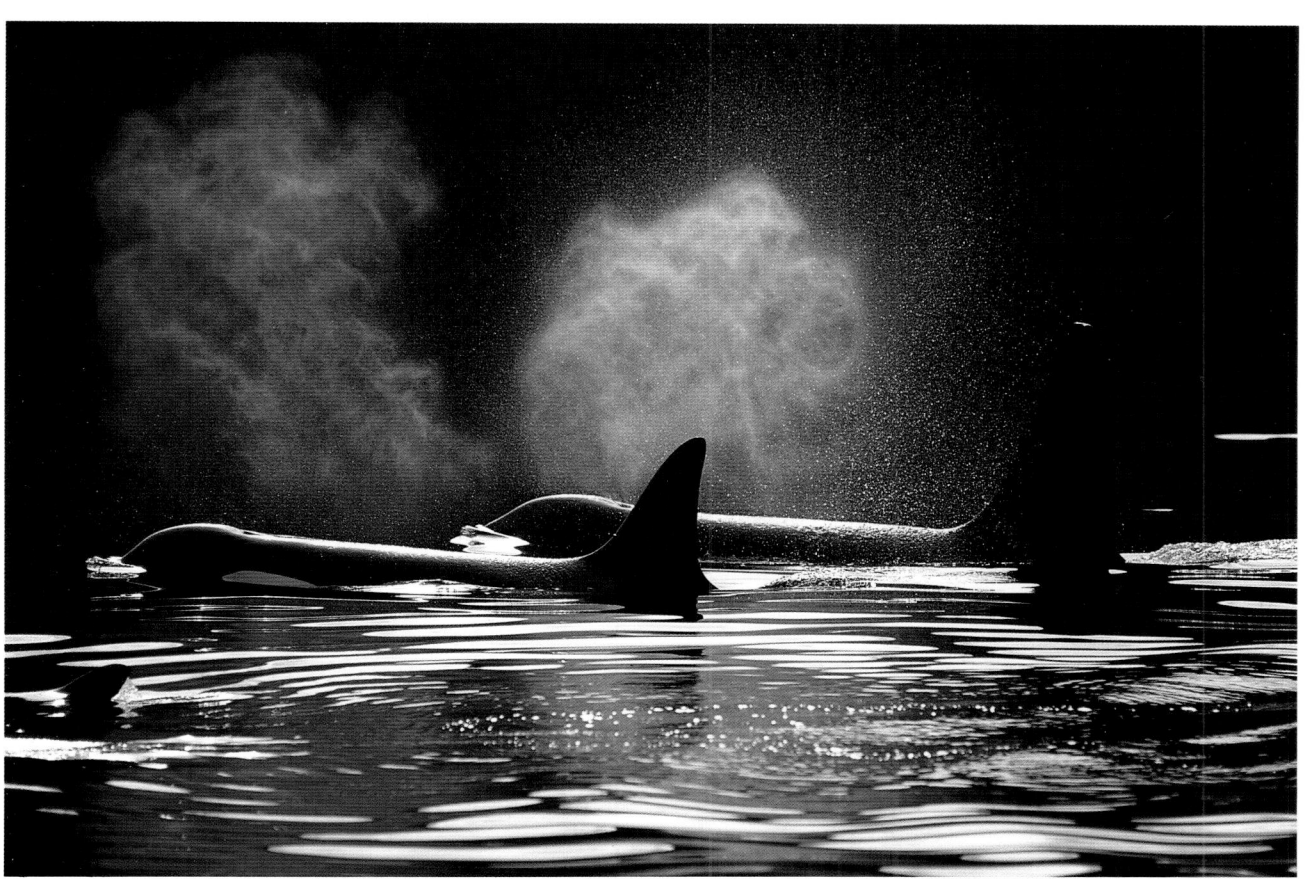

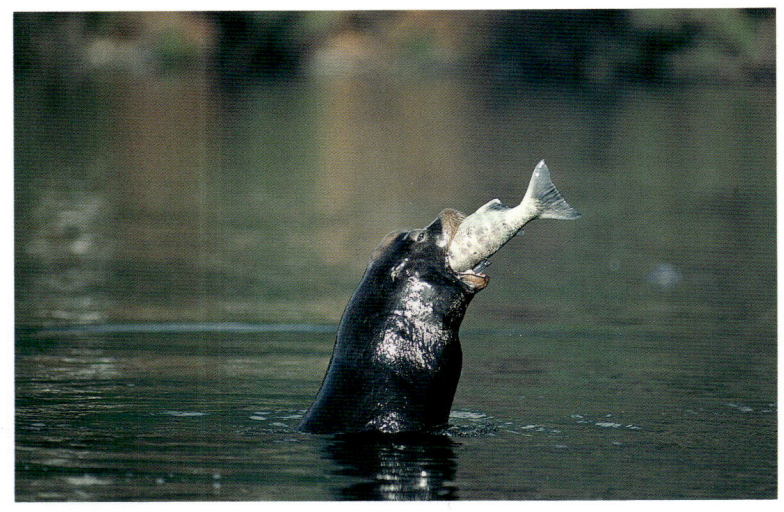

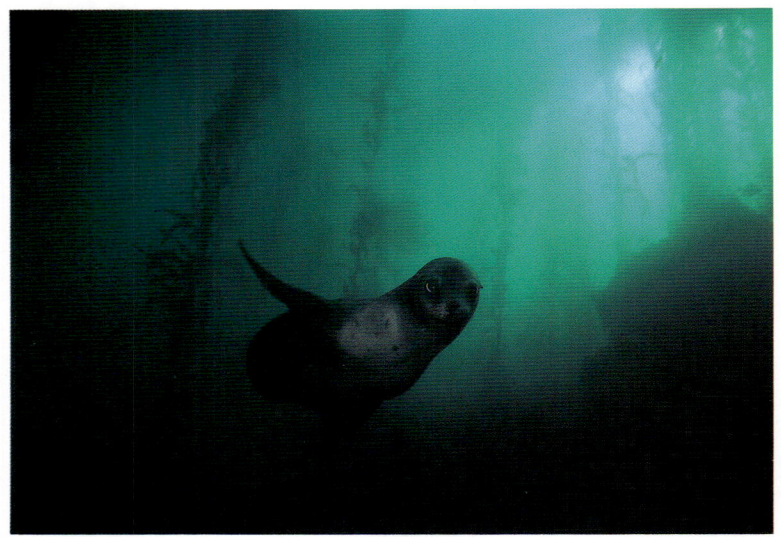

California sea lions hunt returning salmon along the coast and in river estuaries.

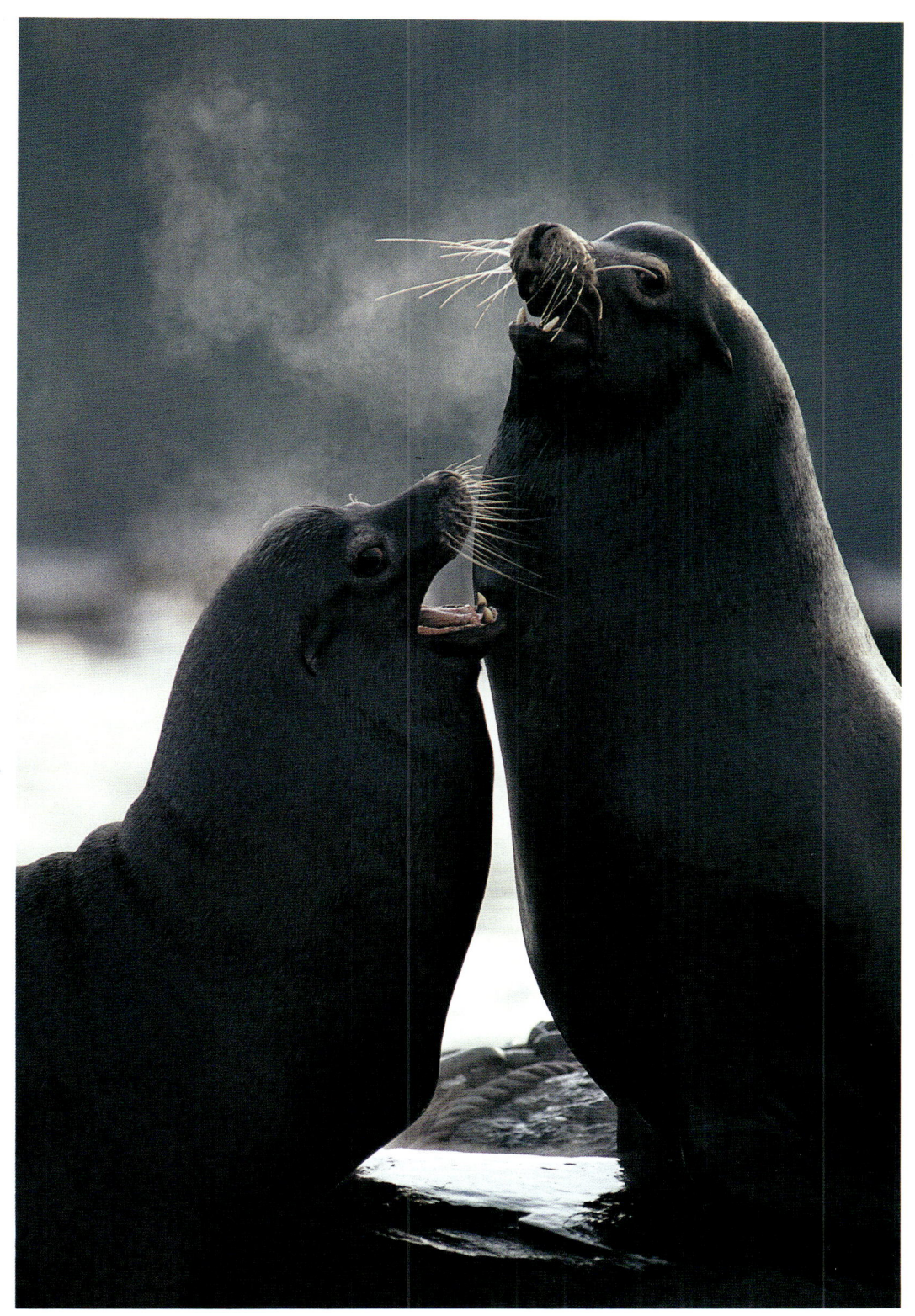

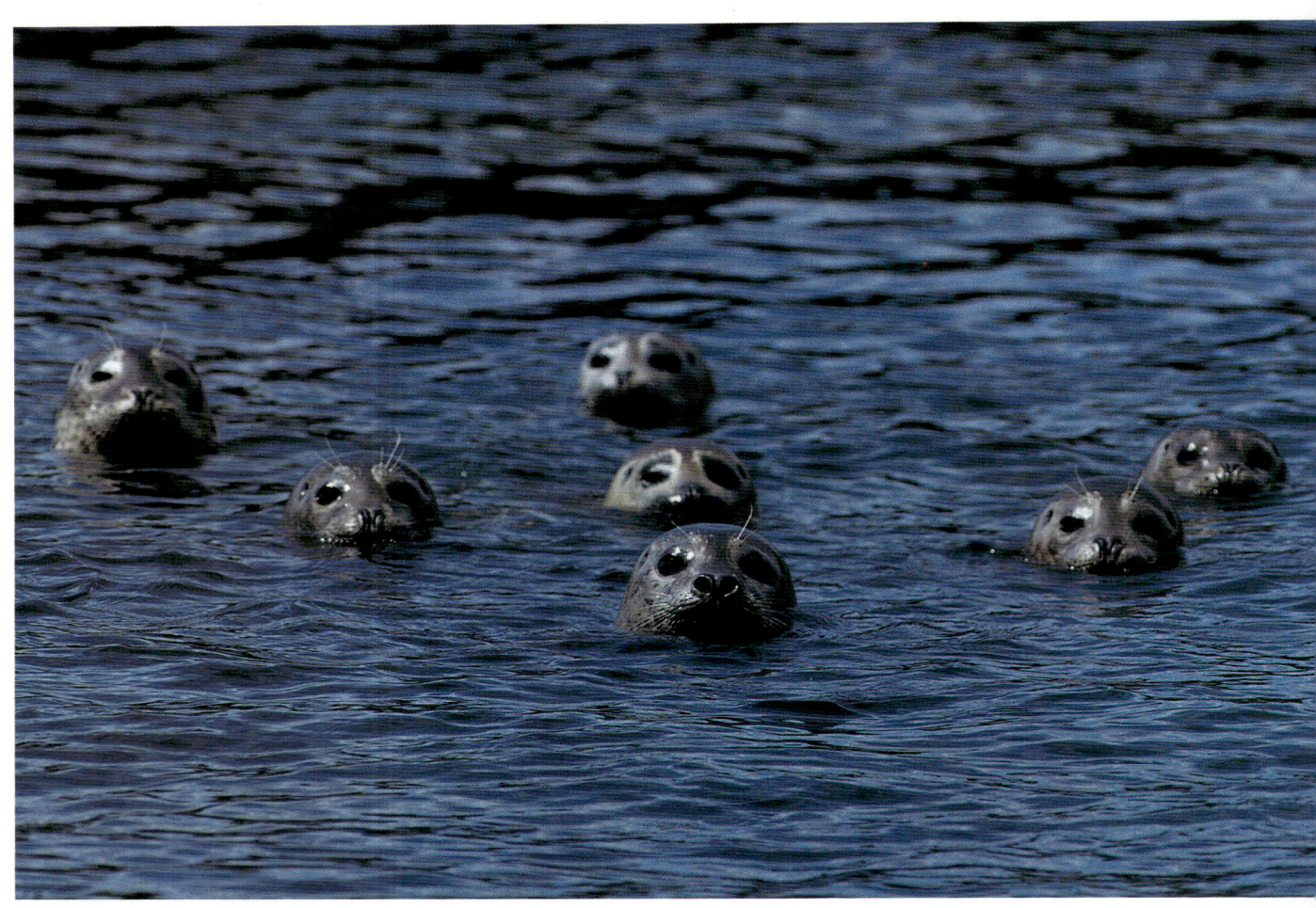

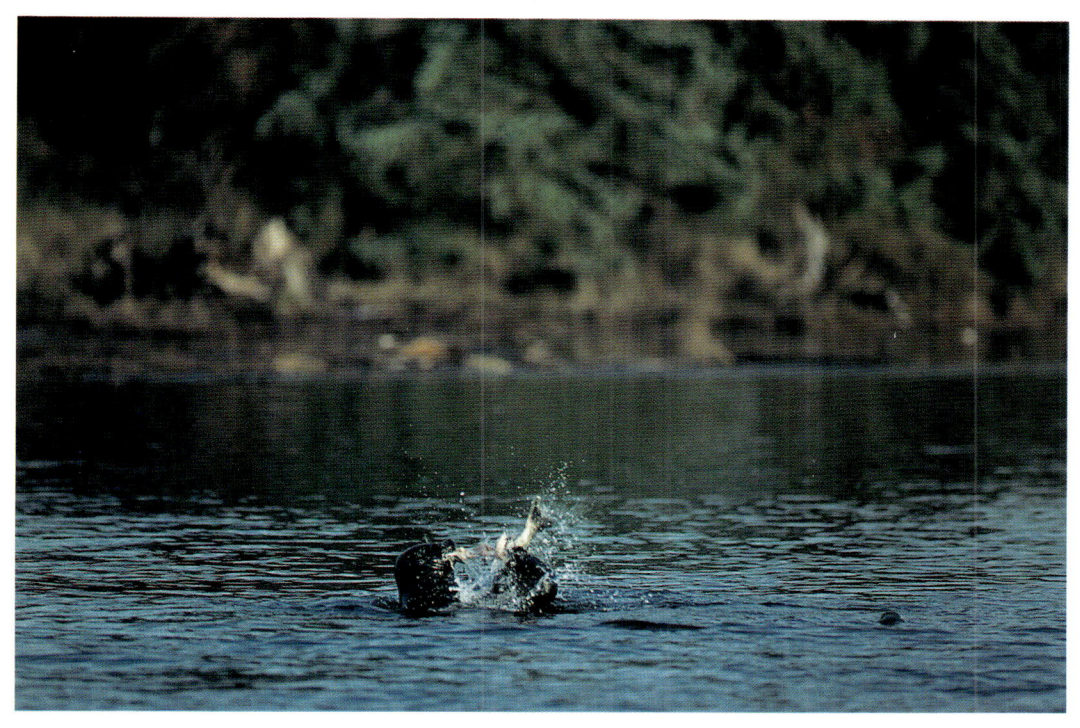

Above and left: Harbour seals too await the seasonal abundance of food provided by returning salmon.

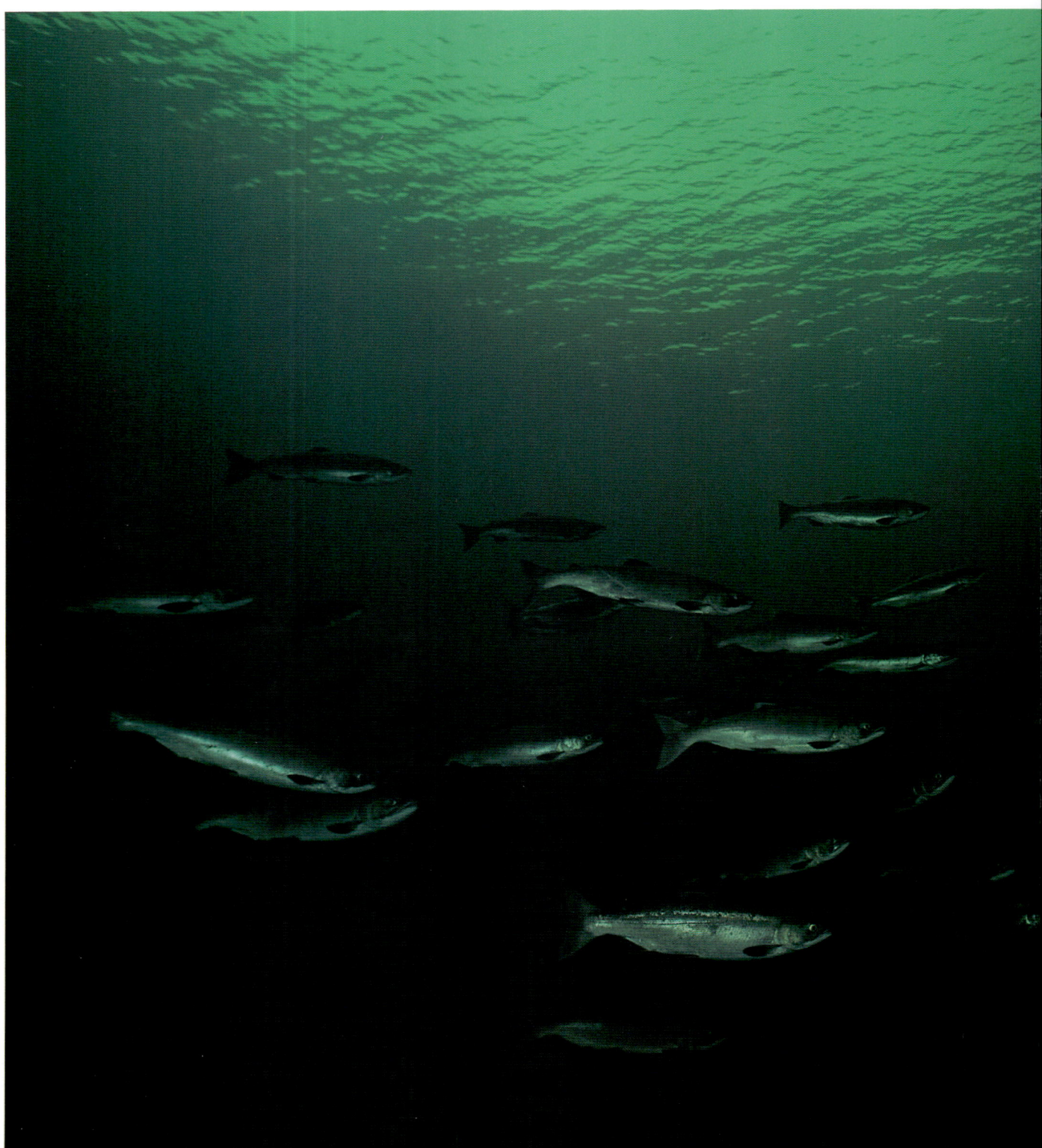

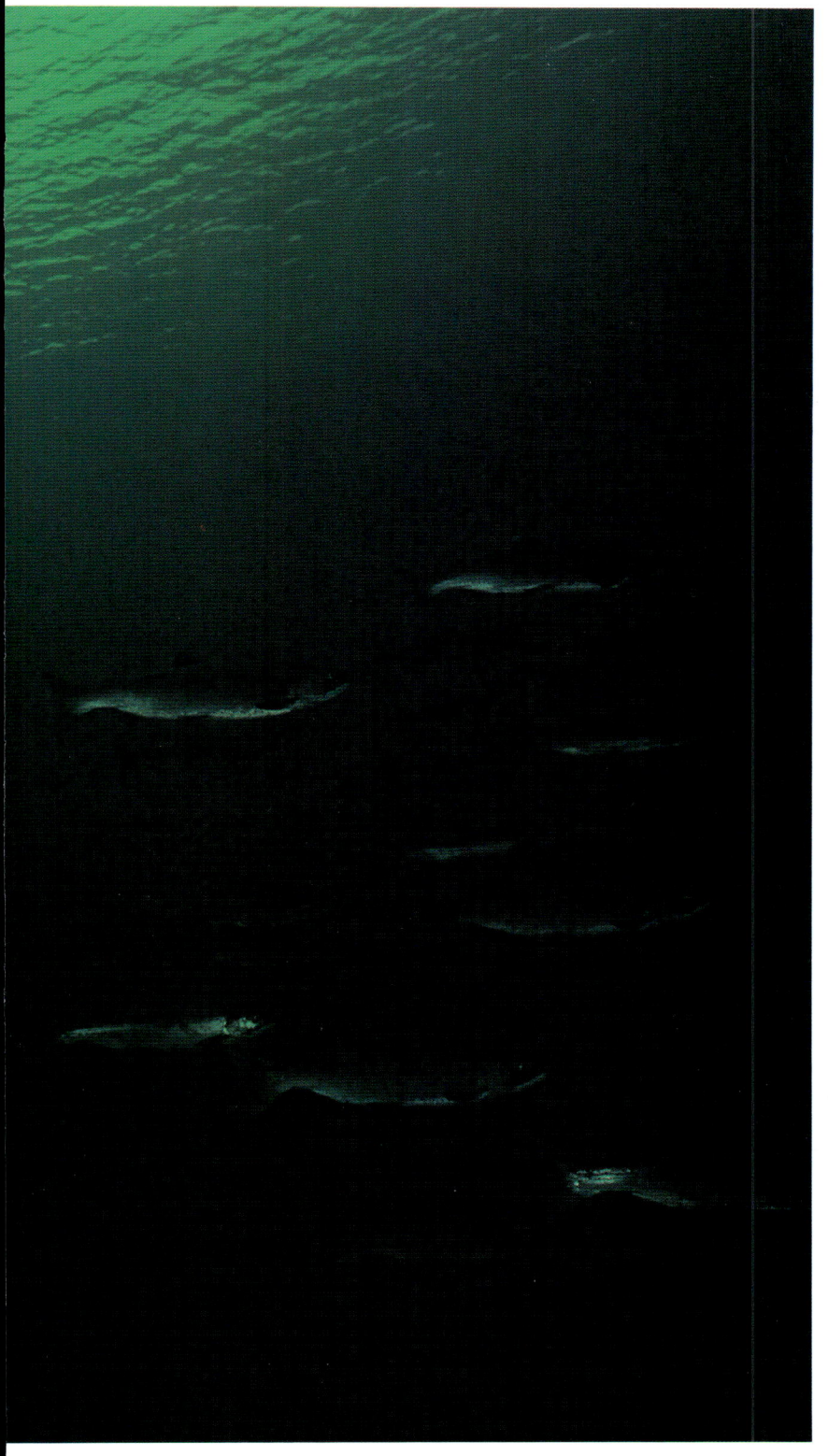

Sleek sea-run sockeye are flashes of bright silver. No spots or bars mark their backs or tails.

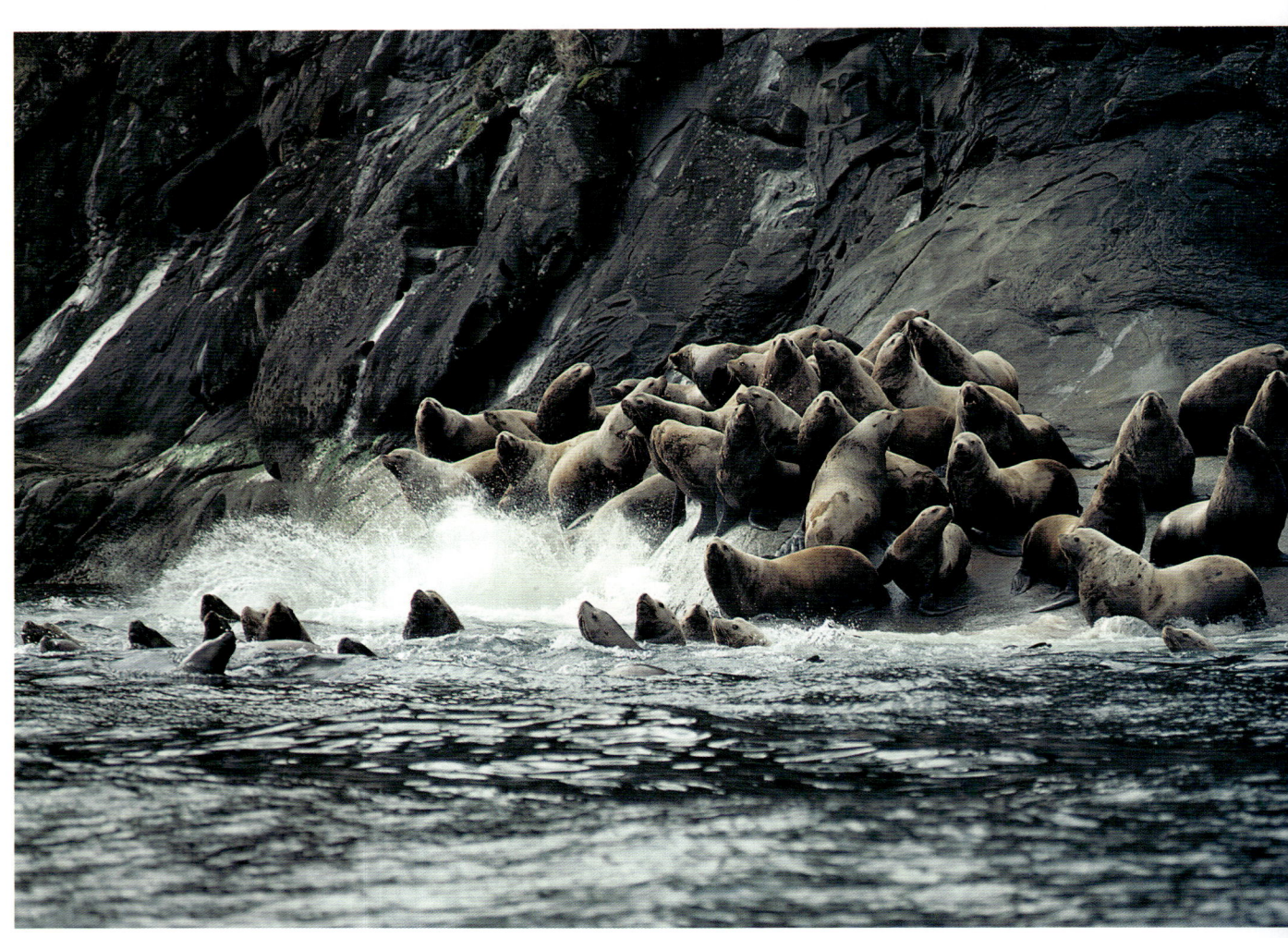

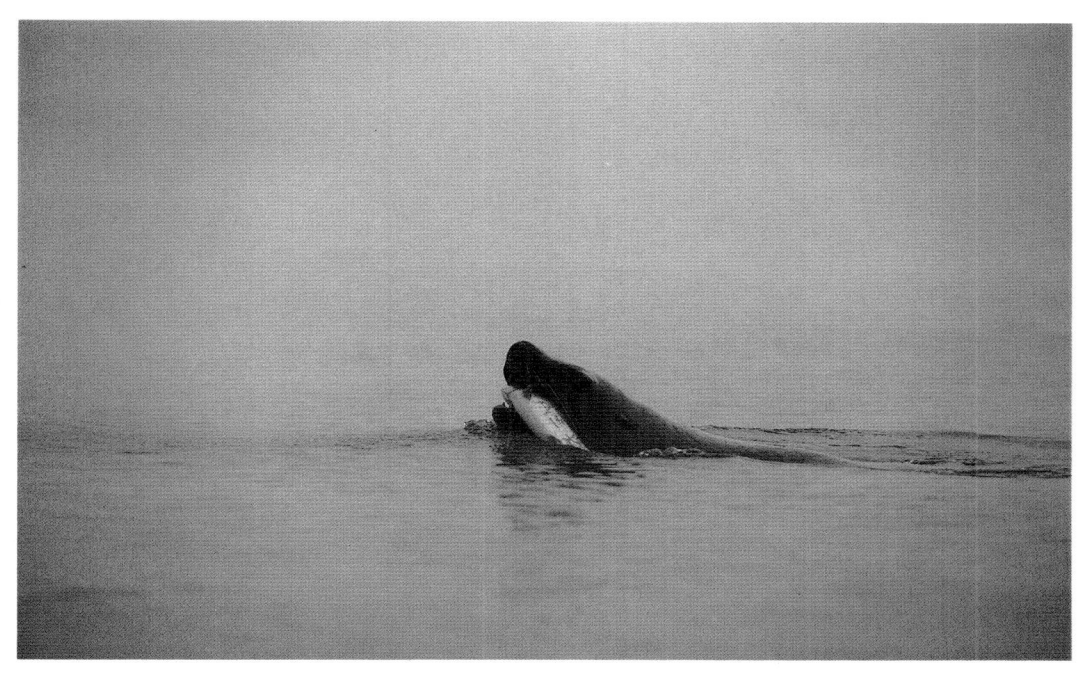

Above: With strong jaws and a mouth full of doglike teeth, the Steller's sea lion has no difficulty holding a large salmon.

Left: Huge Steller's sea lions are predators too.

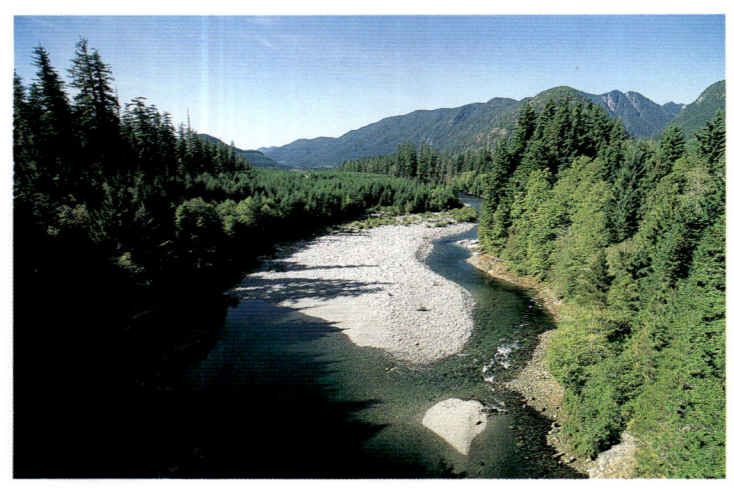

Above: The millions of returning salmon are from various stocks, and the members of each stock are destined for the specific stream where their lives began.

Right: Finally the sockeye enter the river.

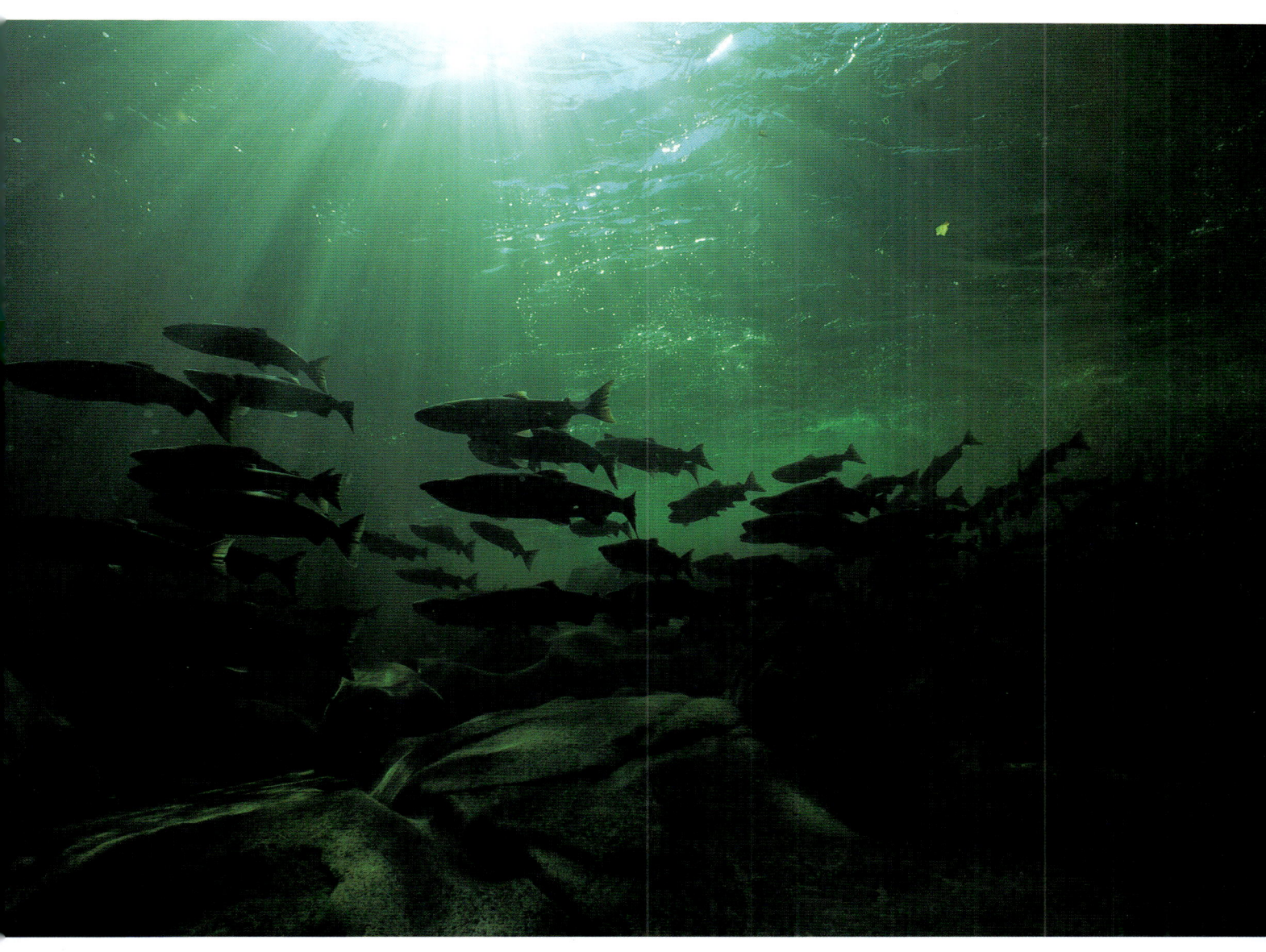

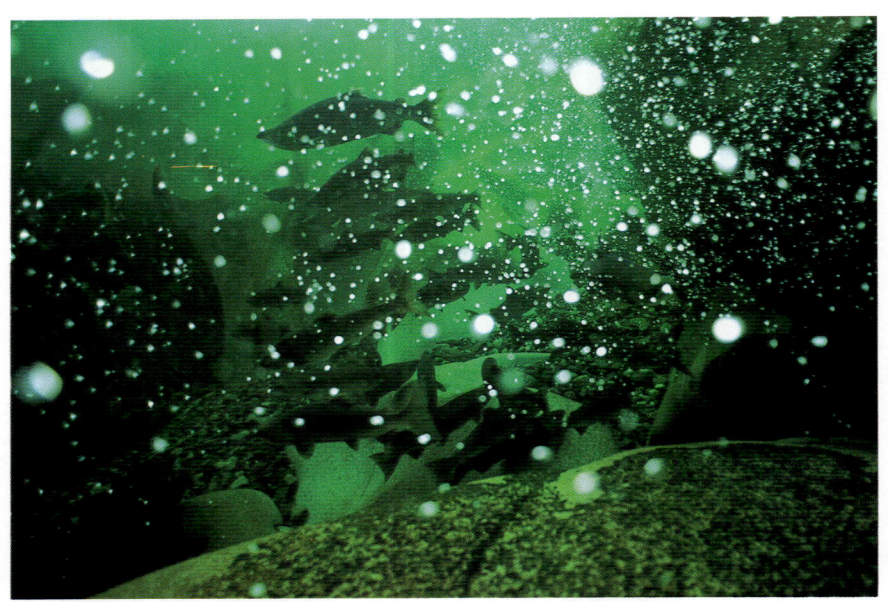

Above: Surrounded by swirling bubbles from nearby rapids, a school of sockeye prepares for its long upstream journey.

Right: Whereas in the ocean the sockeye was sleek and silver, in fresh water its brightness quickly fades and its snout elongates.

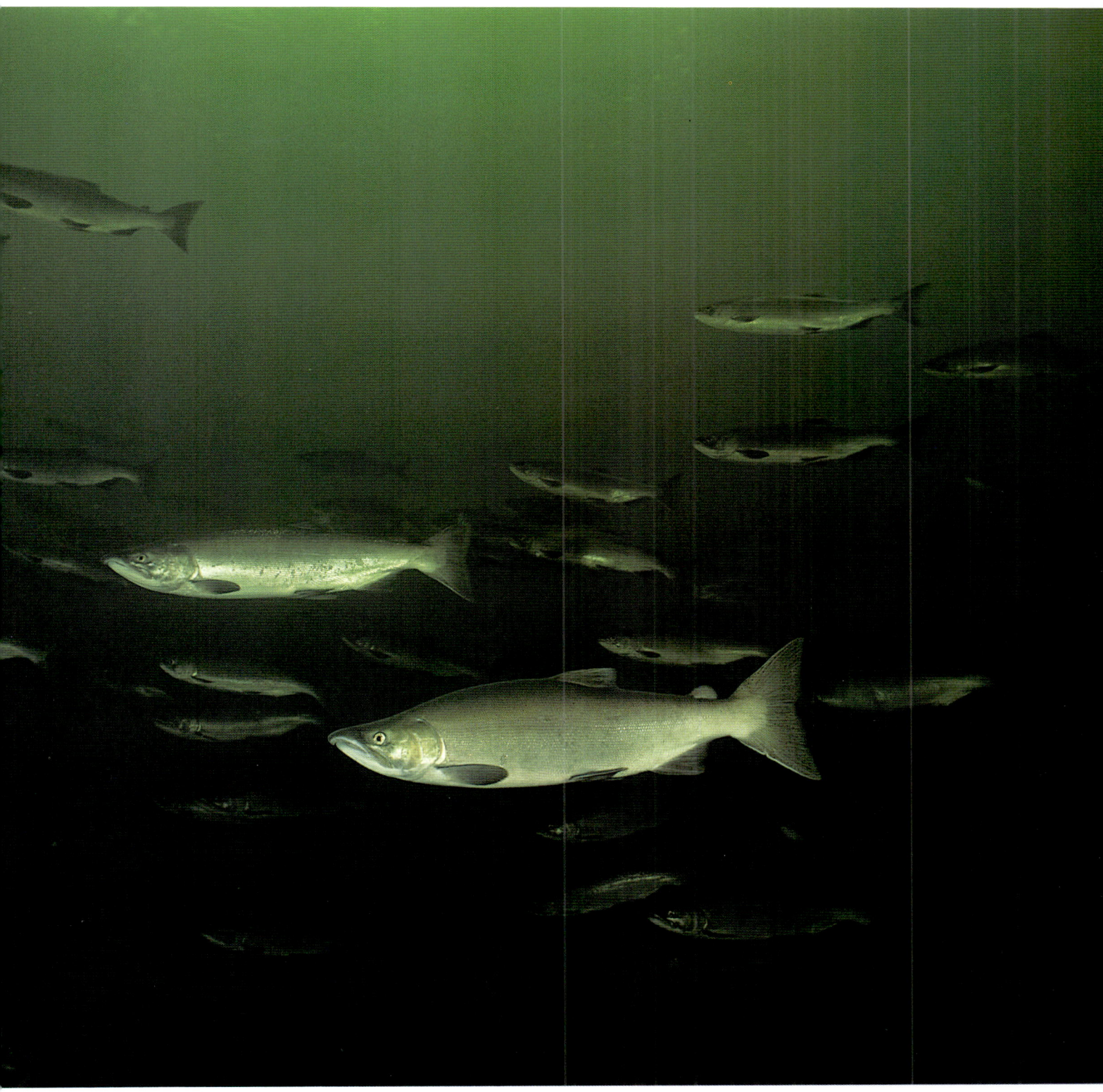

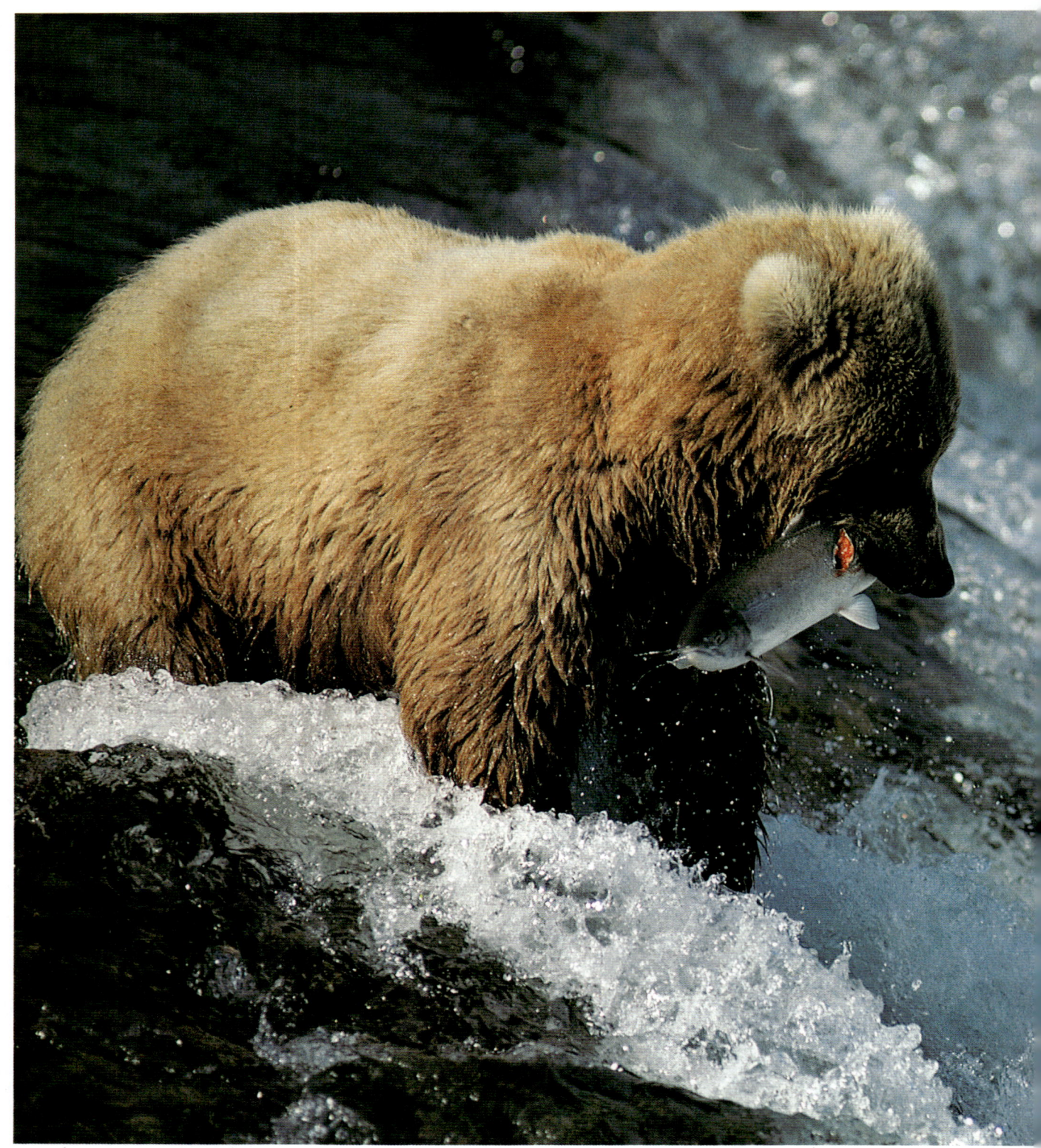

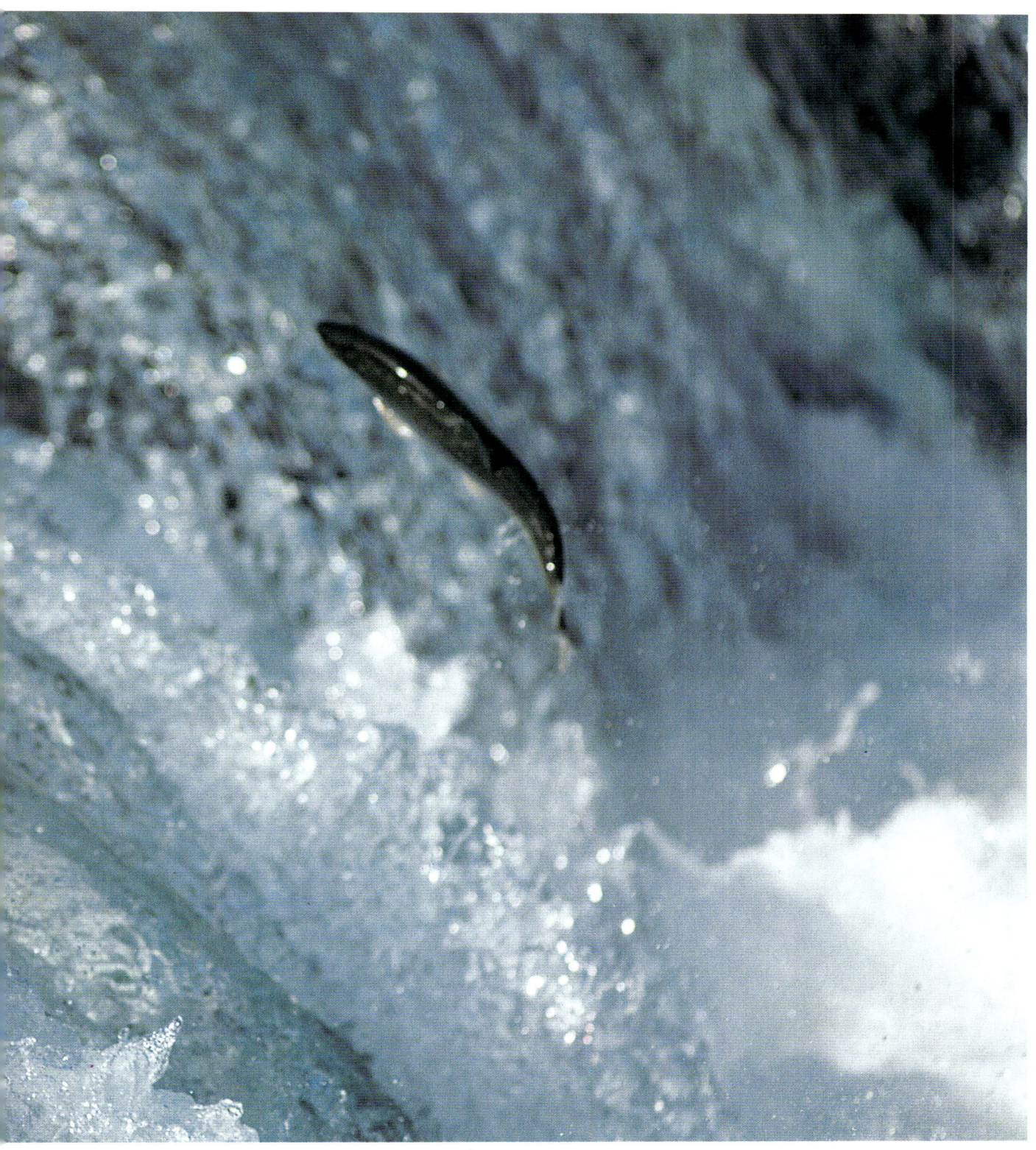

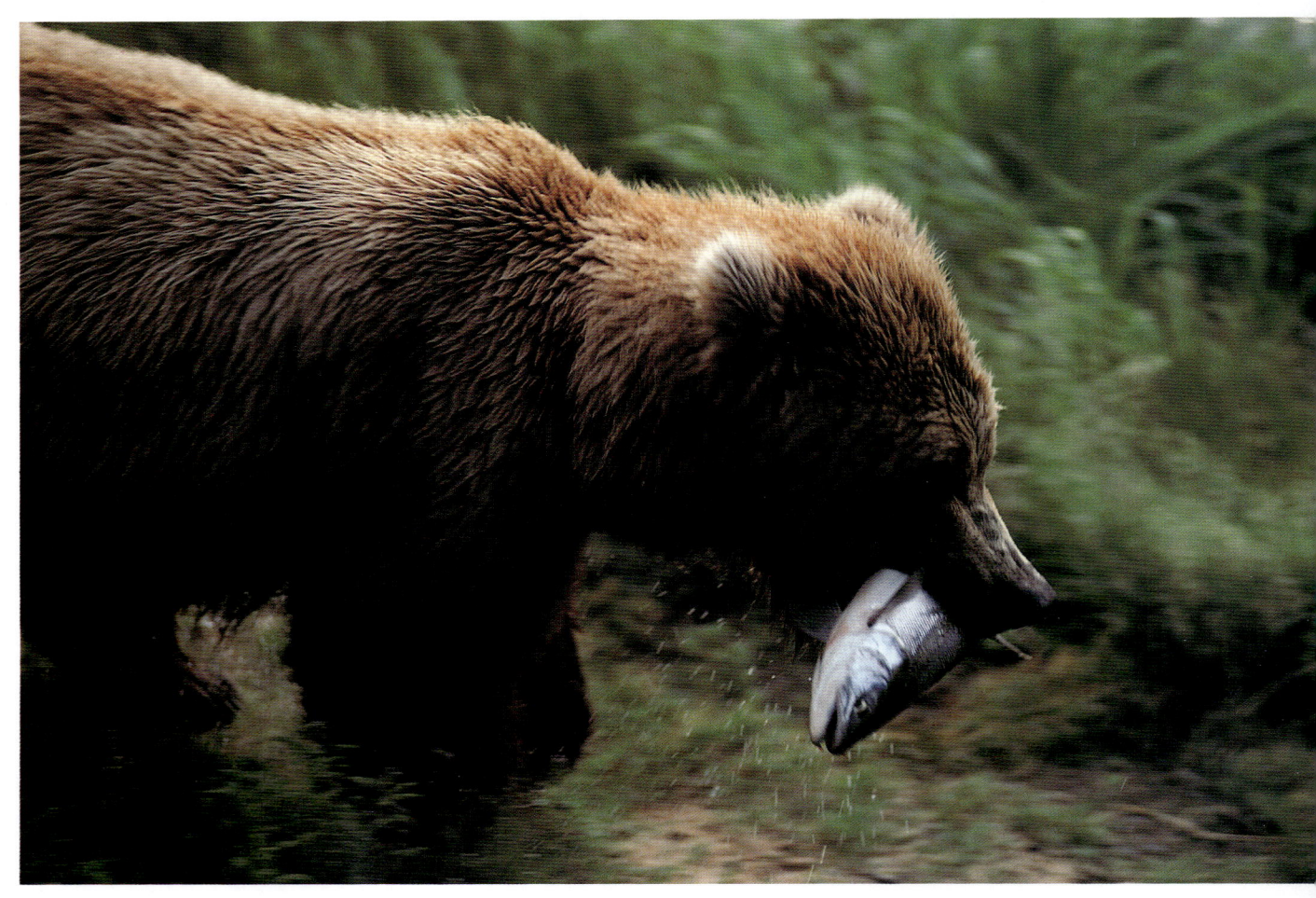

Above: Migrating salmon are an important fall food for grizzly bears.

Right: This timeless image of the migrating salmon leaping to clear a waterfall resonates with strength and perseverance.

Pages 32–33: Bears learn to hunt migrating salmon where the fish are challenged by physical obstacles.

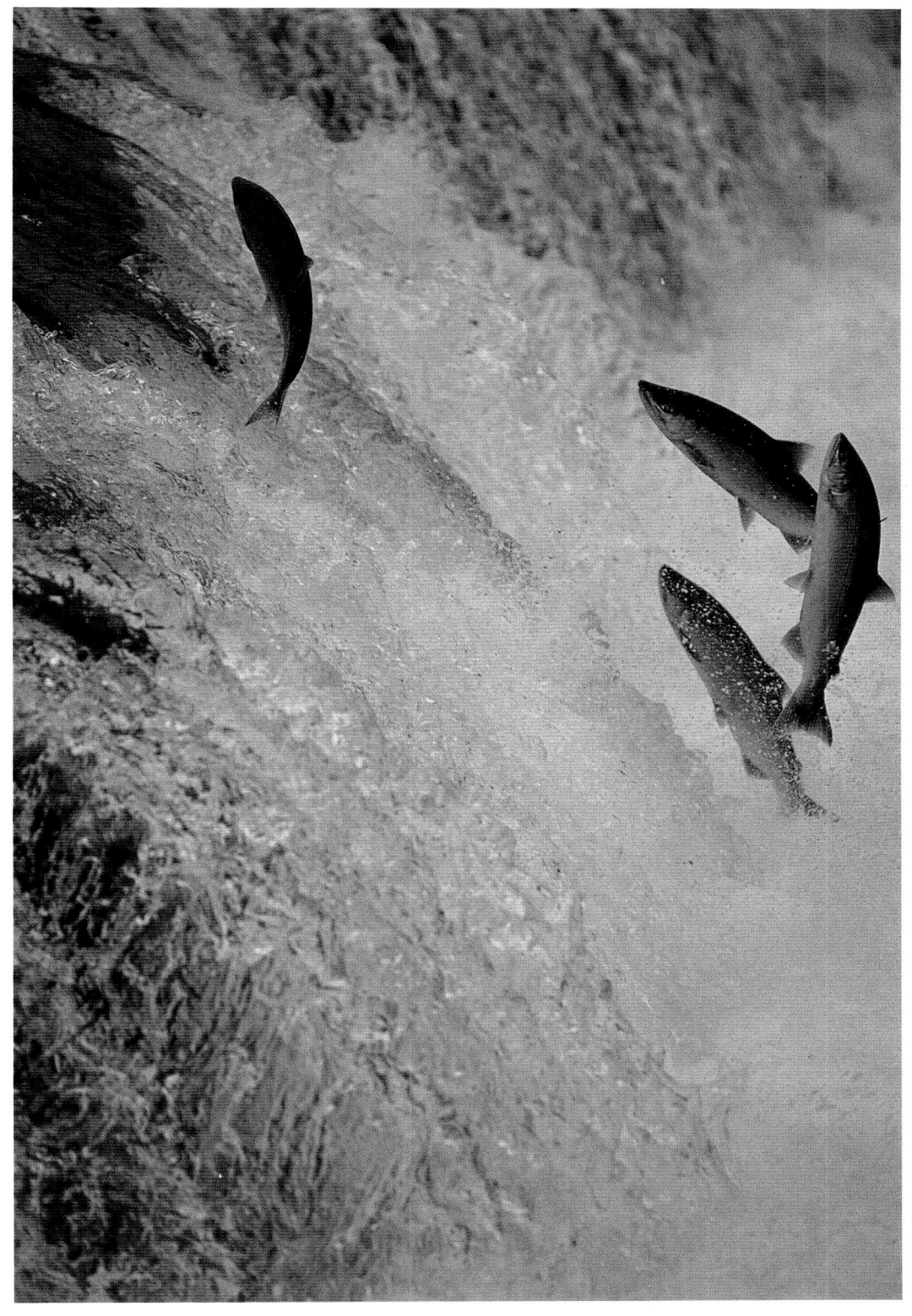

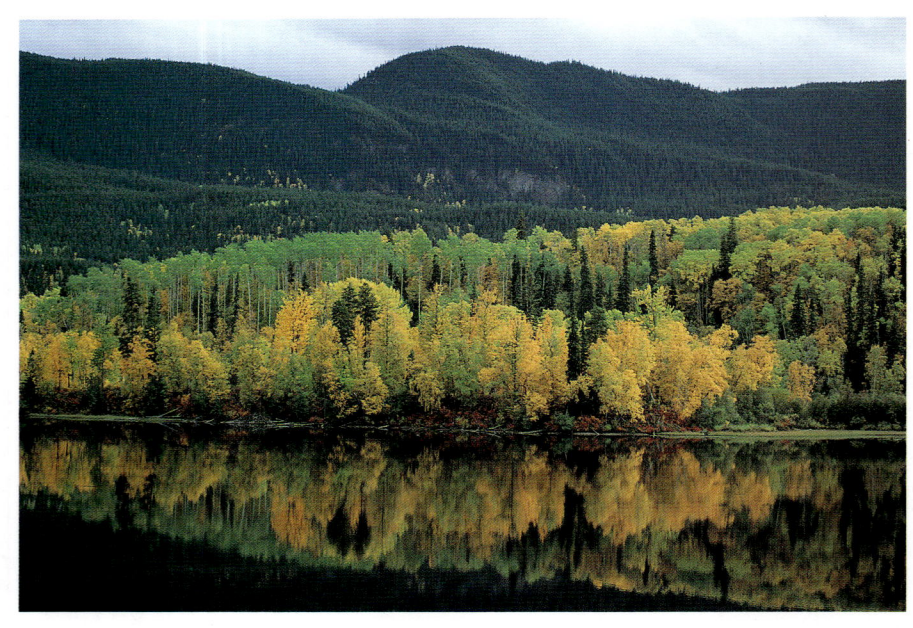

Above: While shoreline trees turn gold, the sockeye change to green and red as they reach the inland lakes.

Right: In various stages of colour change, sockeye salmon cluster in what was their nursery lake years before.

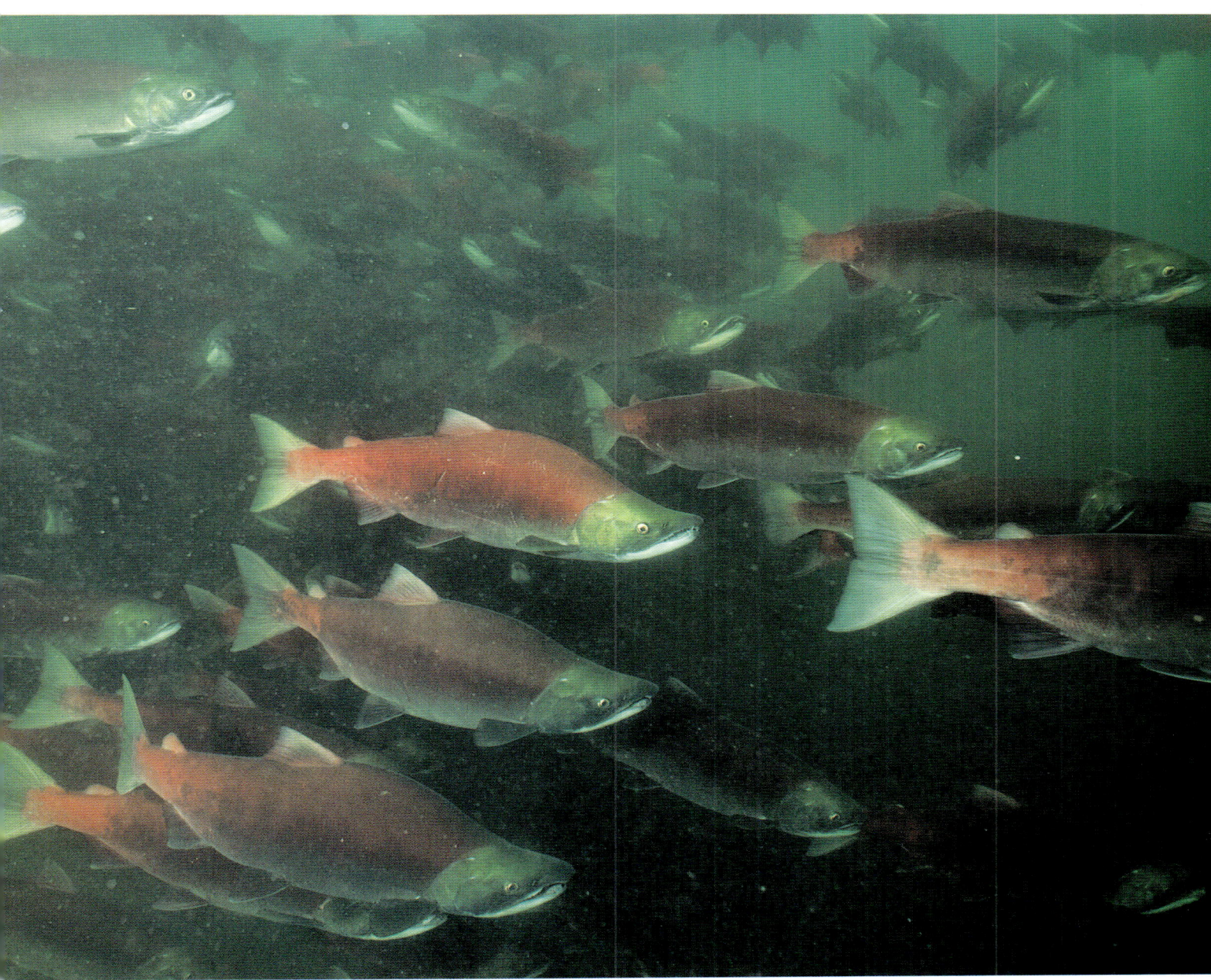

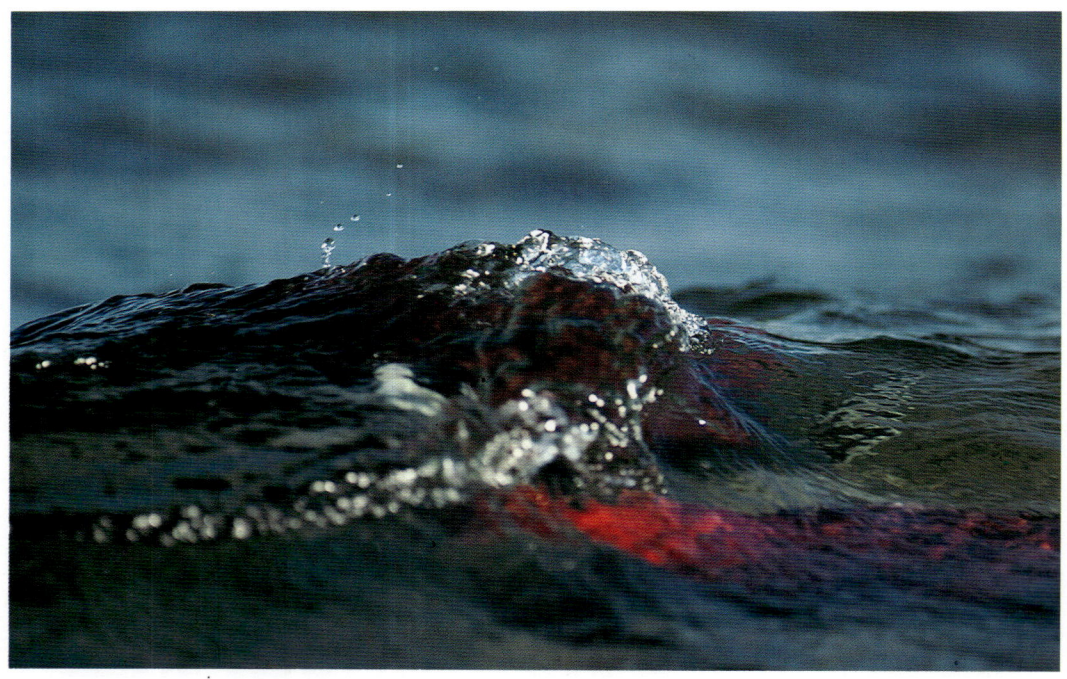

Above: A brilliant red salmon rides a wind wave out of the lake.

Right: Now in full nuptial colours, spawners make the final upstream journey from lake to spawning streams above the lake.

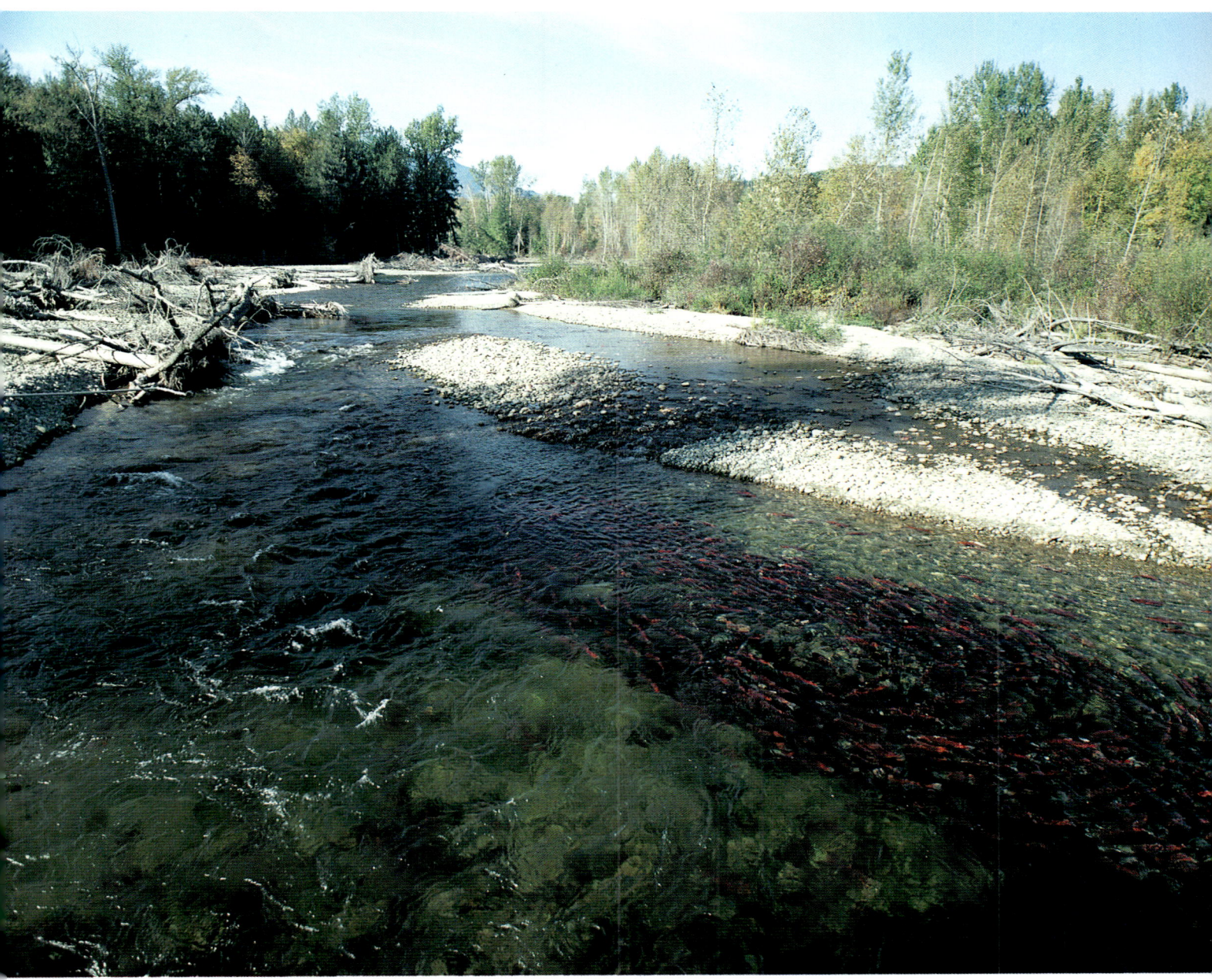

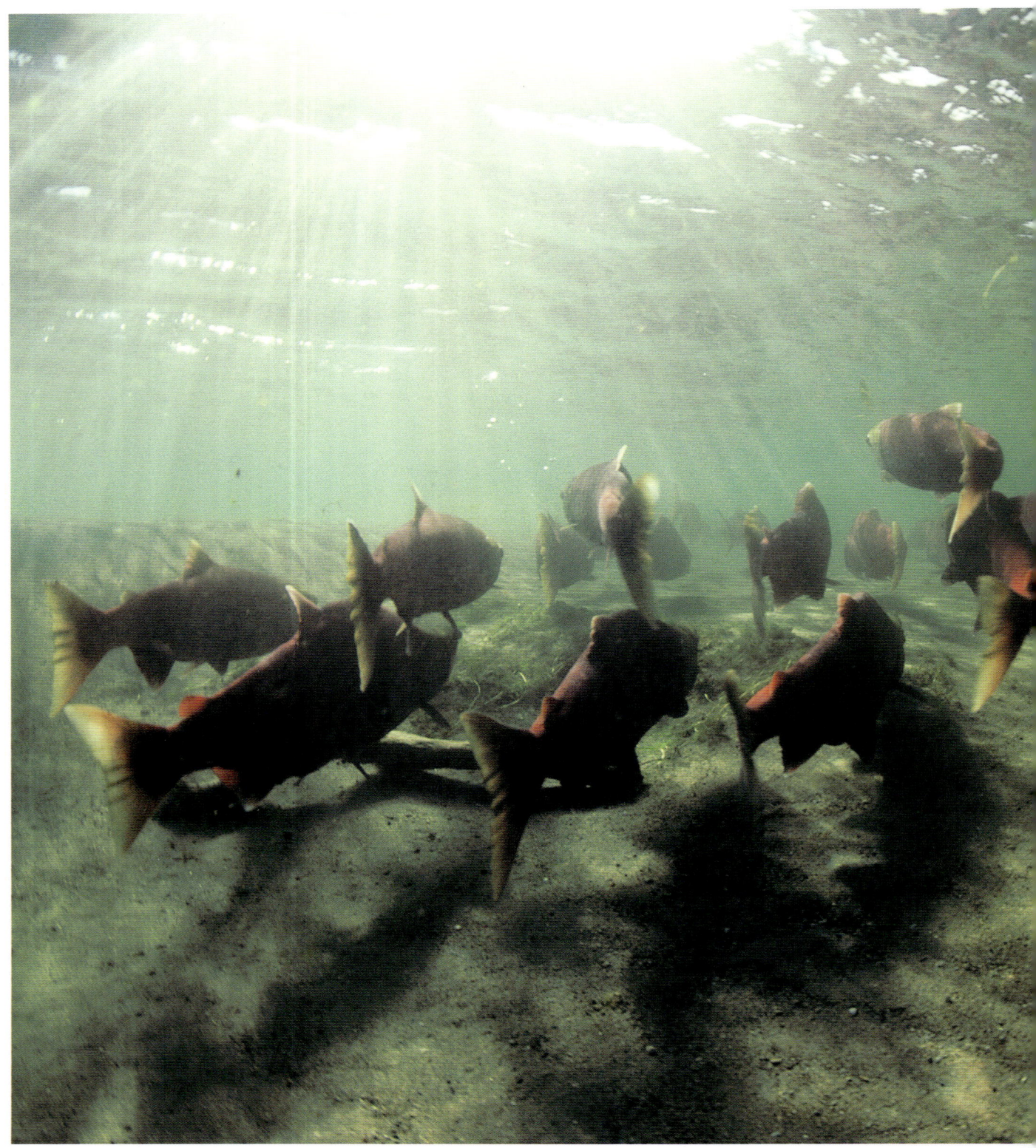

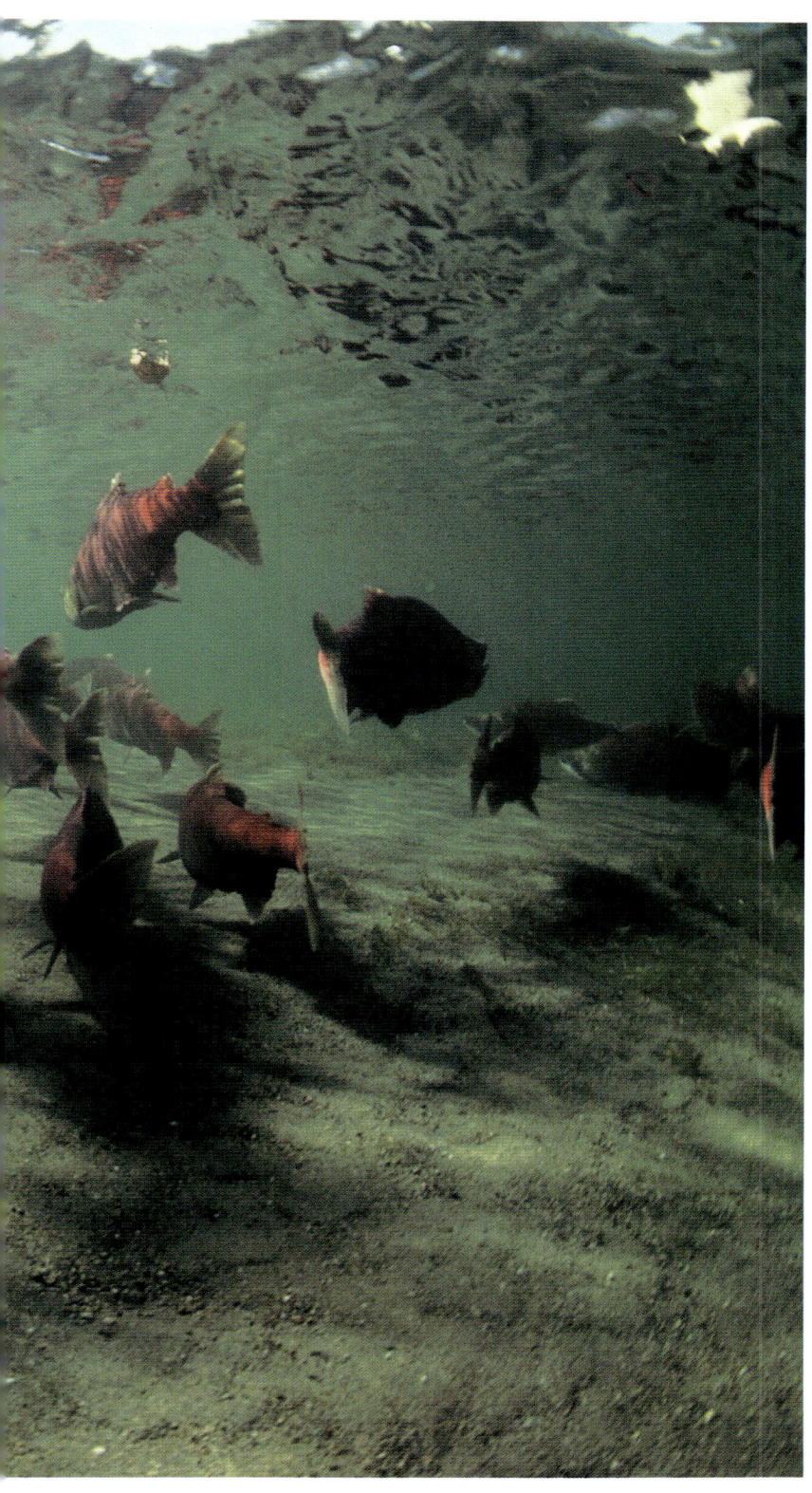

Left: Undulating red bodies rest in the back eddy of a spawning stream.

Pages 42–43: The return each year of tens of thousands of spawners to various river systems in overlapping four-year cycles is essential for the long-term productivity and survival of the sockeye.

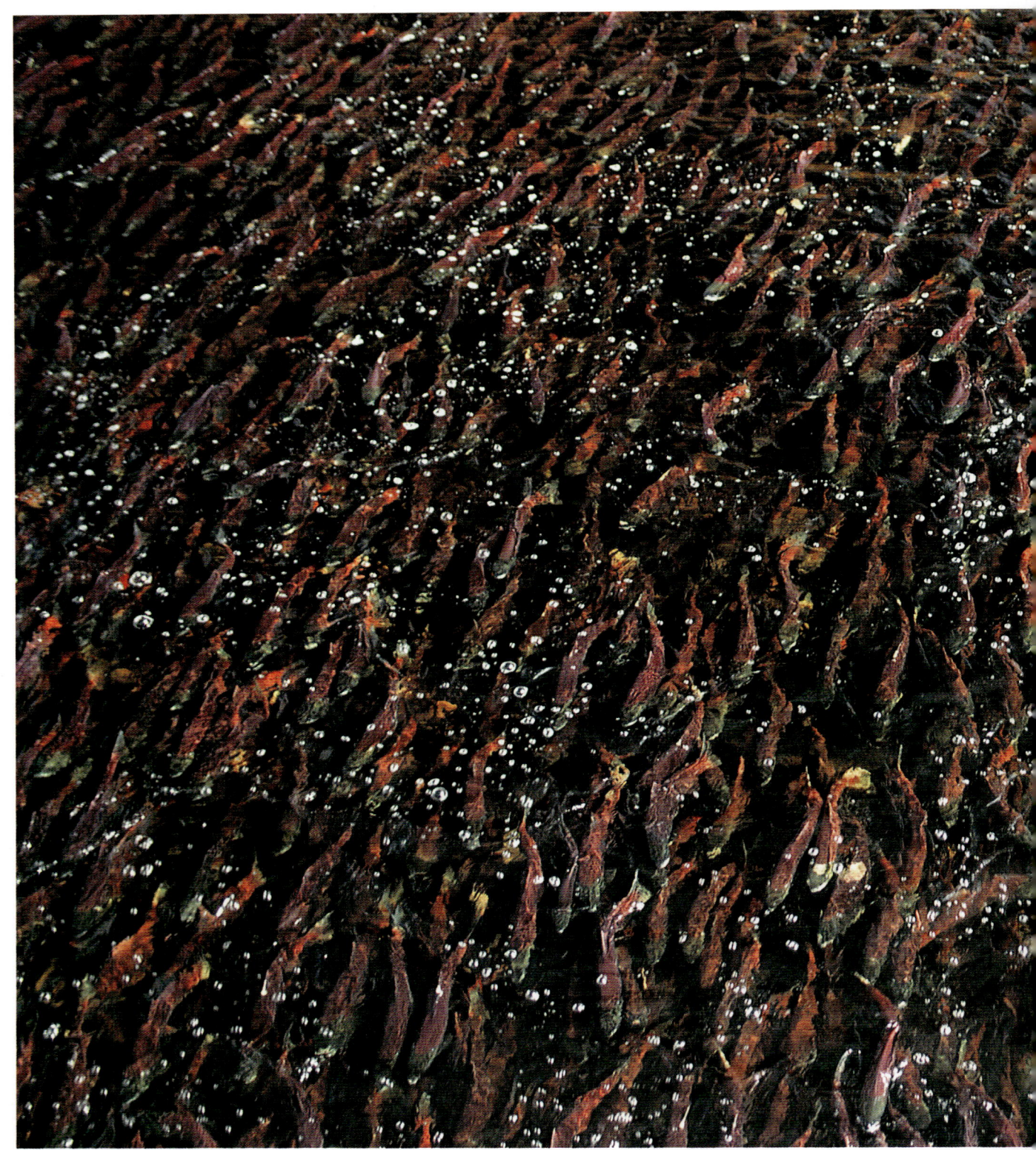

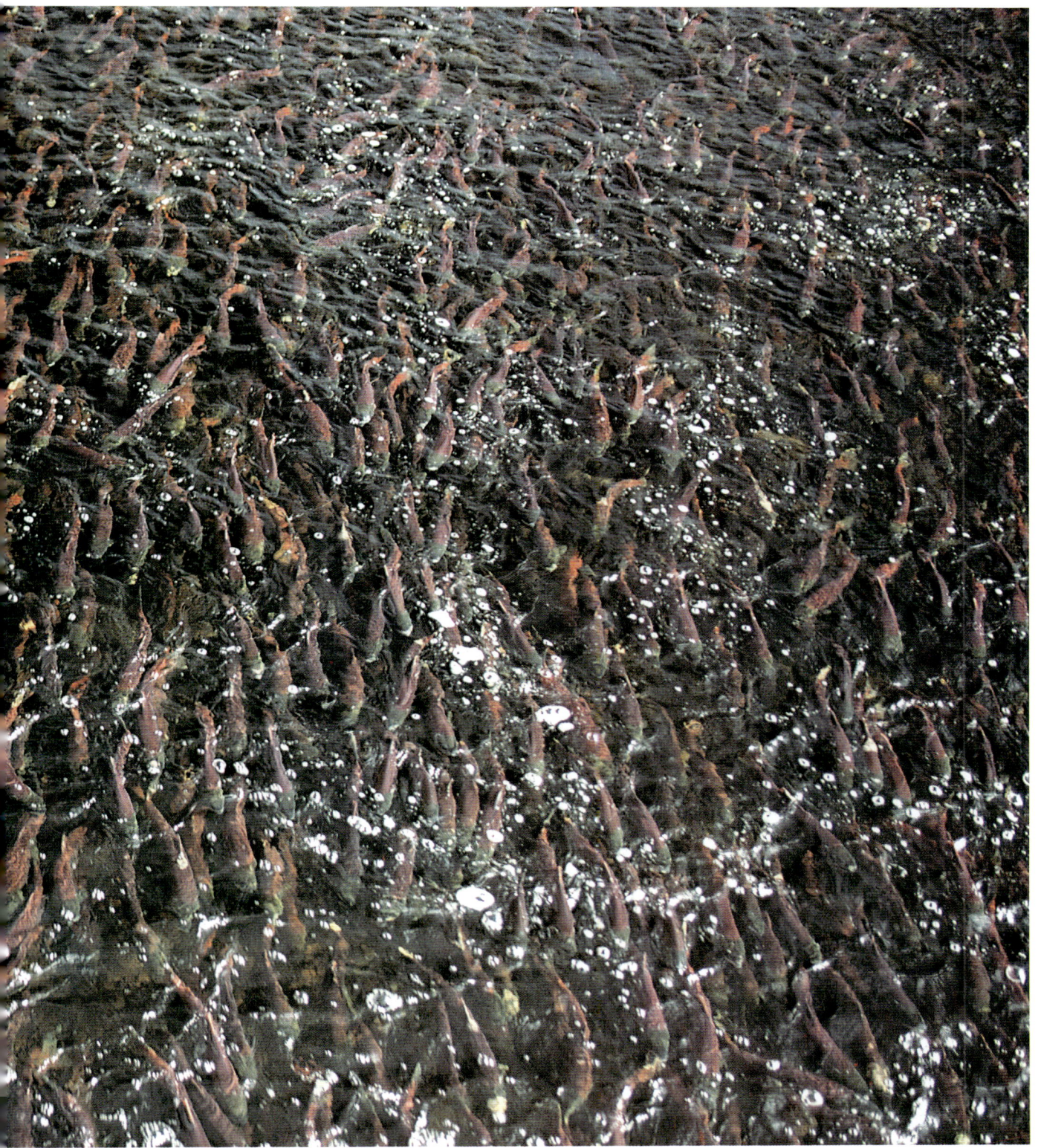

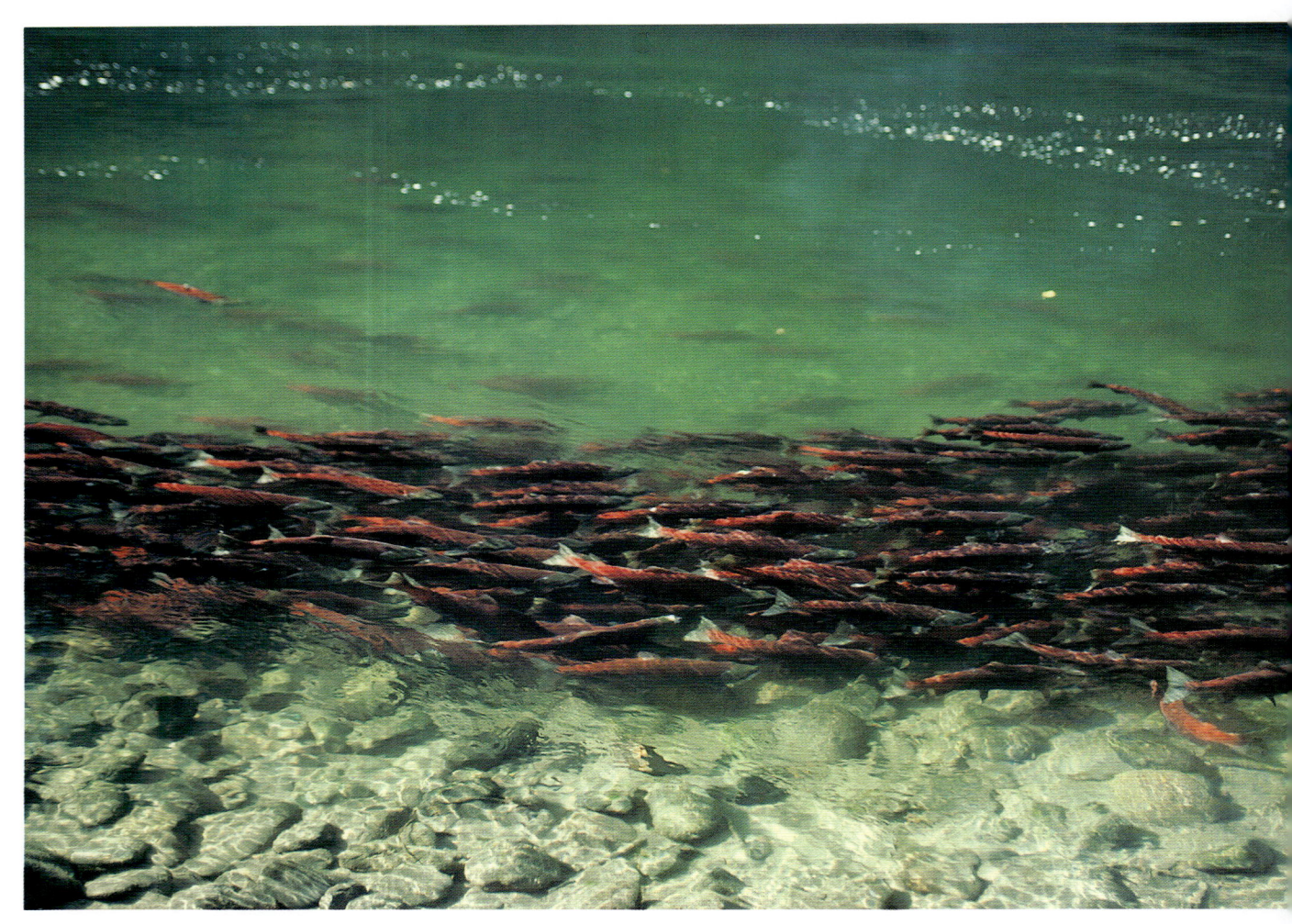

A ribbon of mature red sockeye moves steadily upstream, taking advantage of the weaker downstream current near shore.

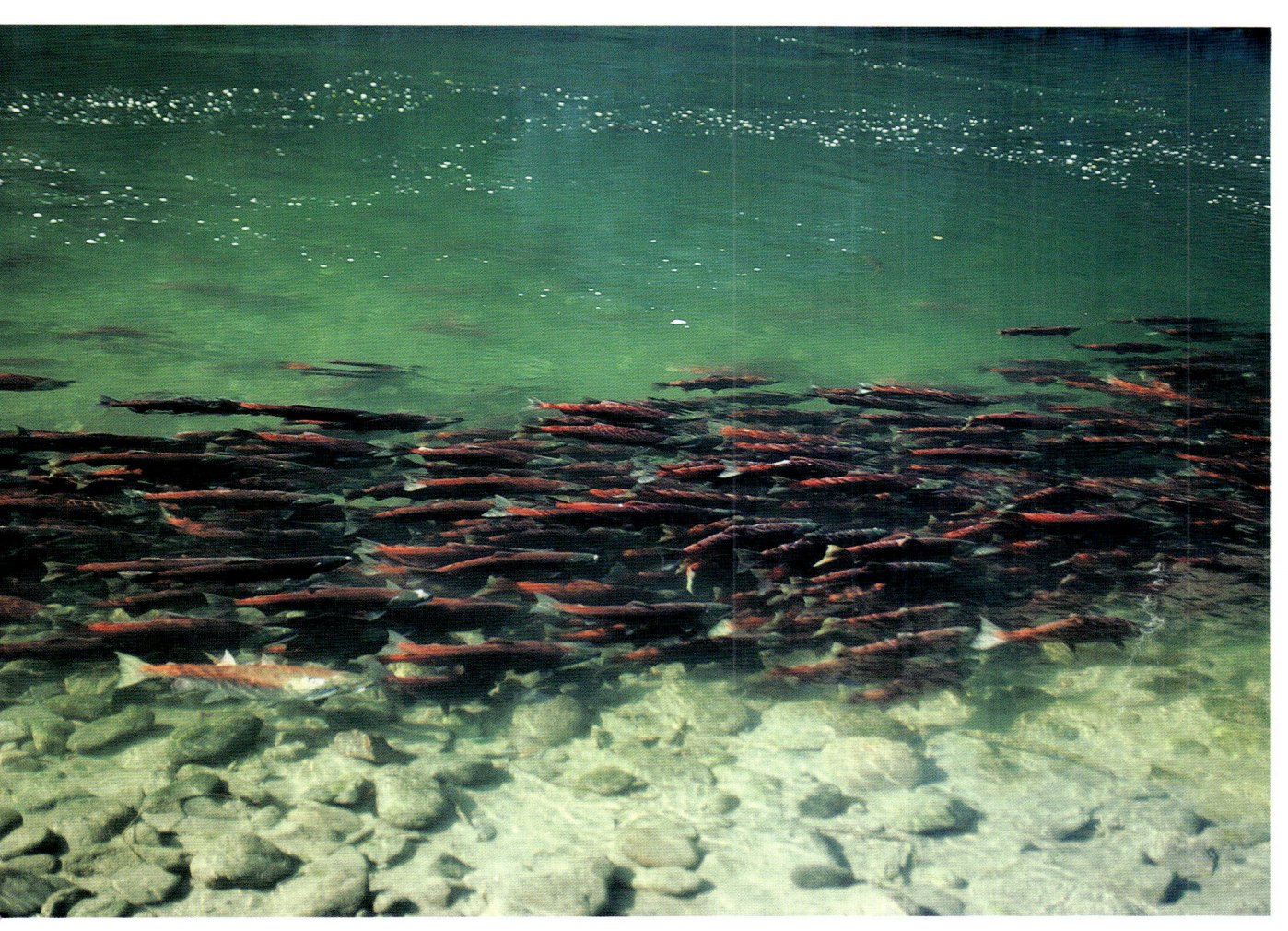

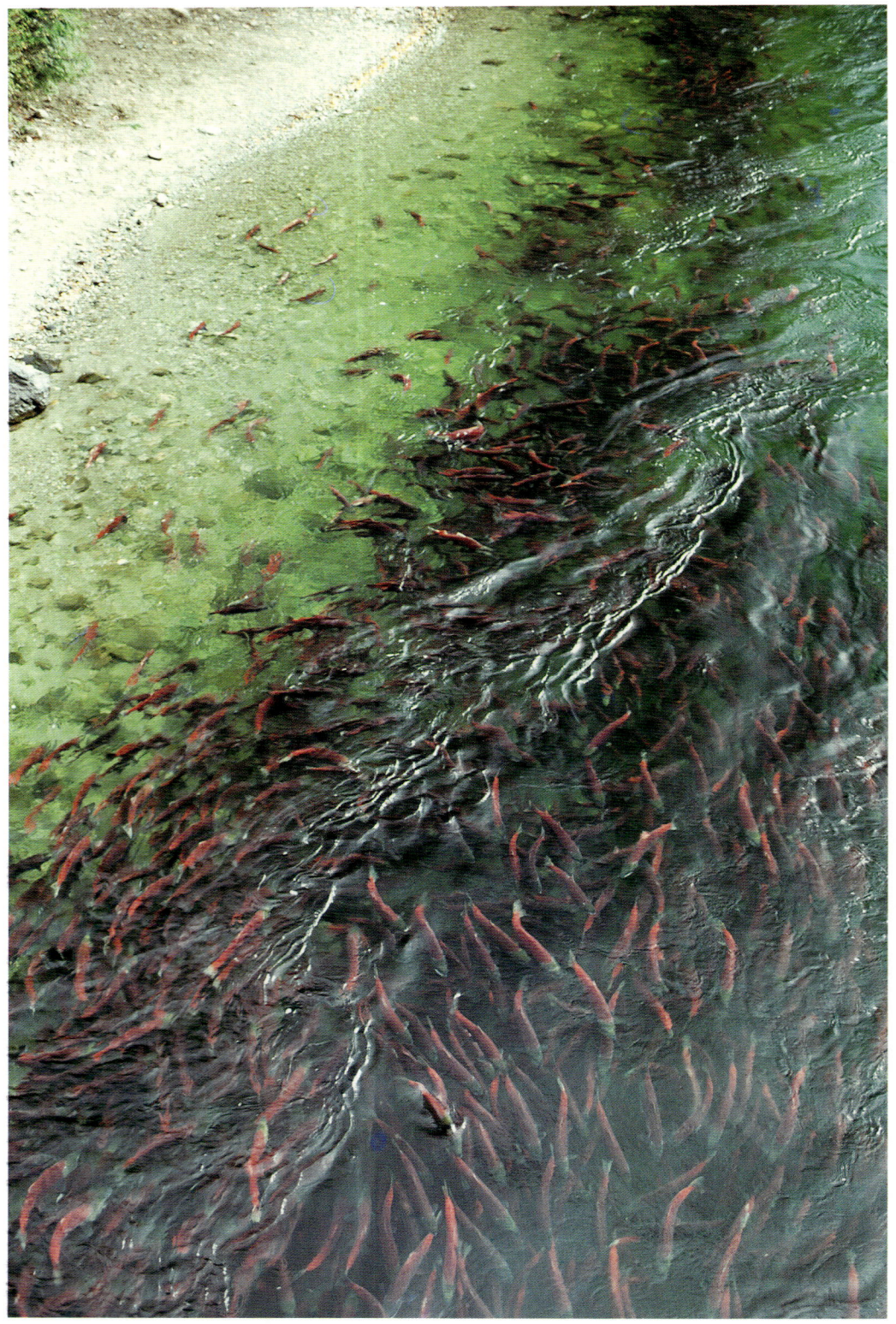

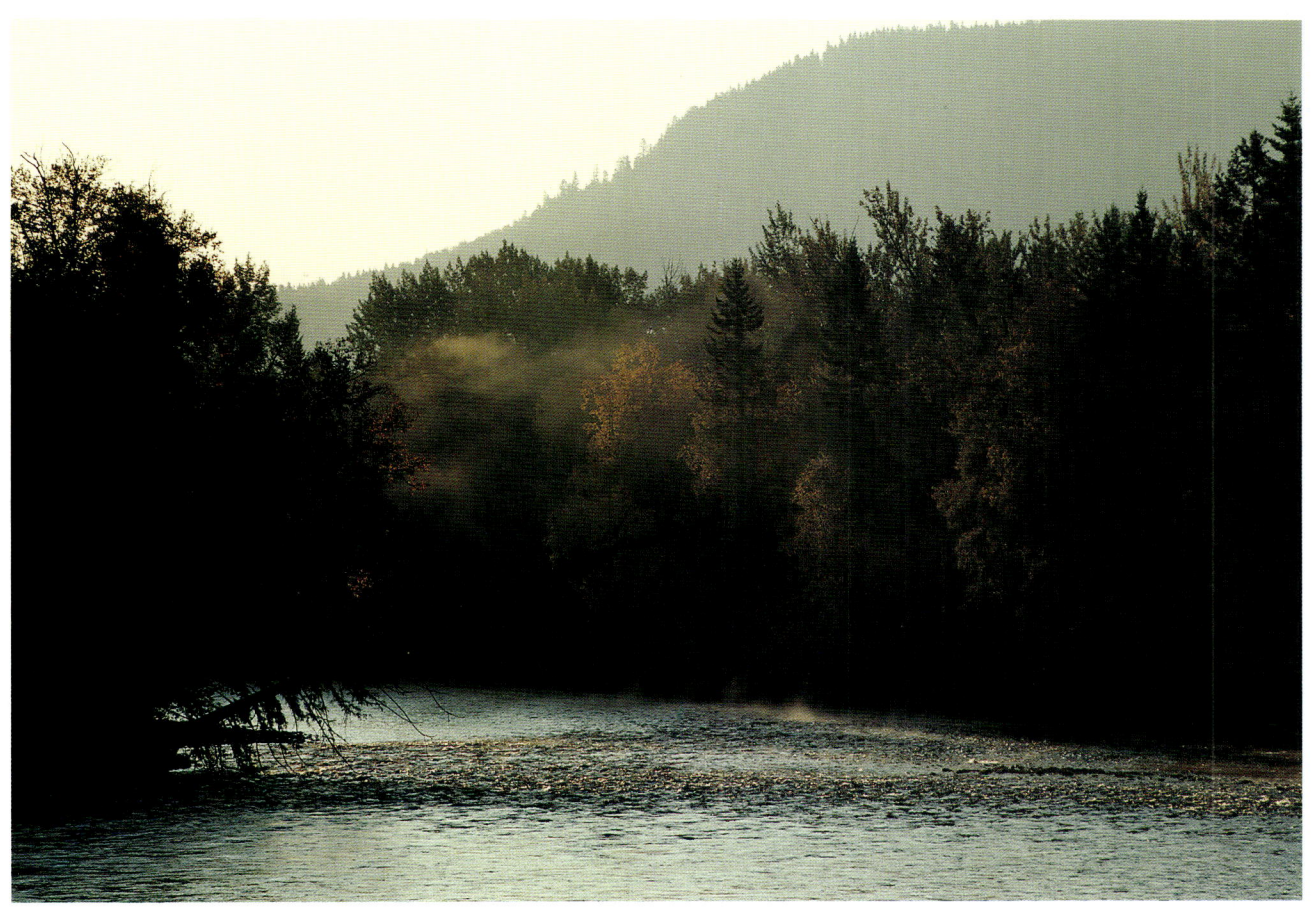

Above: As fall deepens and the air cools, steam rises from the river, while under water the sockeye spread into the higher reaches of the spawning system.

Left: Fish crowd into deep, slow-moving pools for a brief rest on their upstream journey.

Pages 48–49: The sockeye's stamina is extraordinary. On body reserves alone it has battled its way hundreds of kilometres upstream, and its ordeal is far from over.

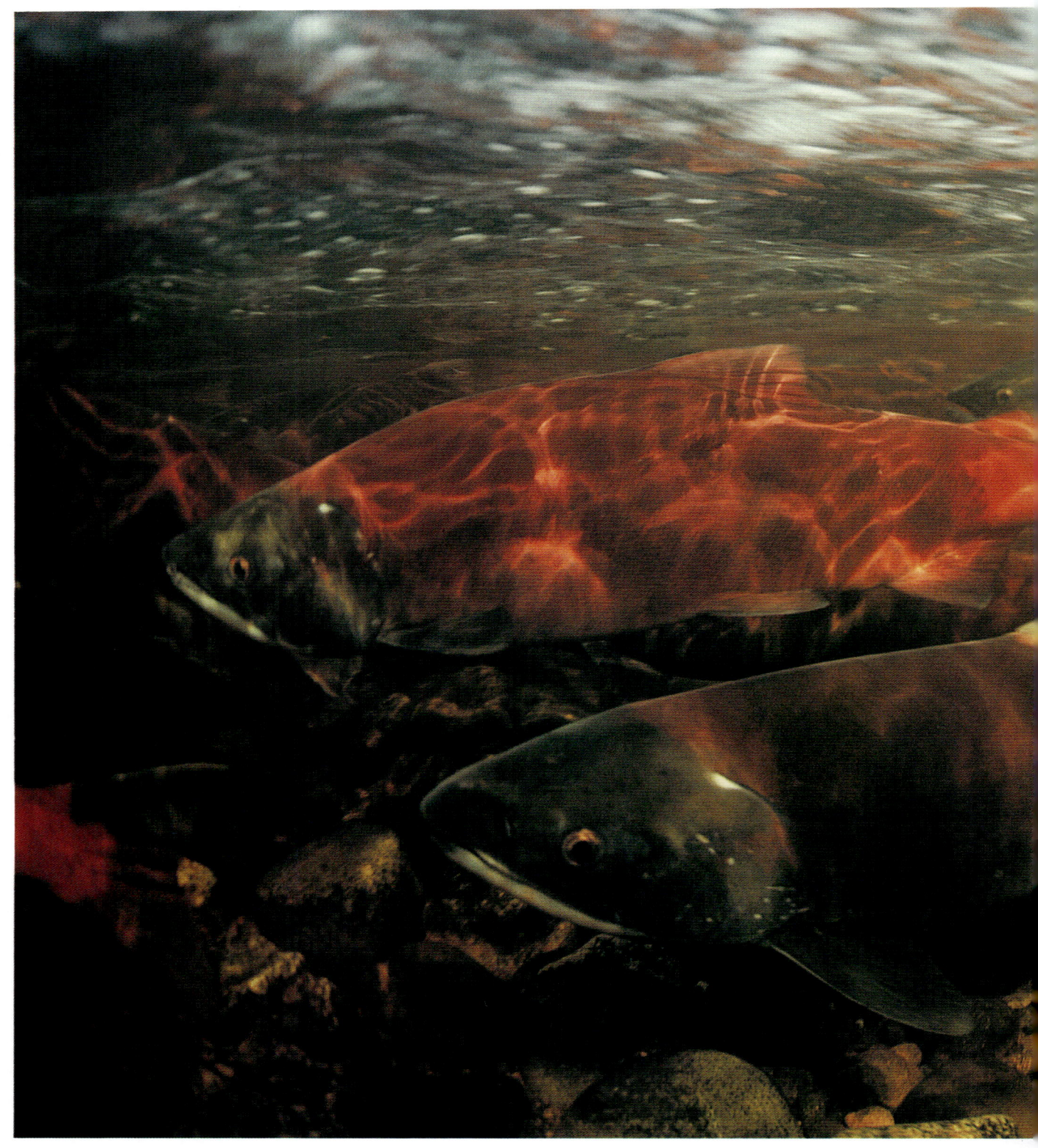

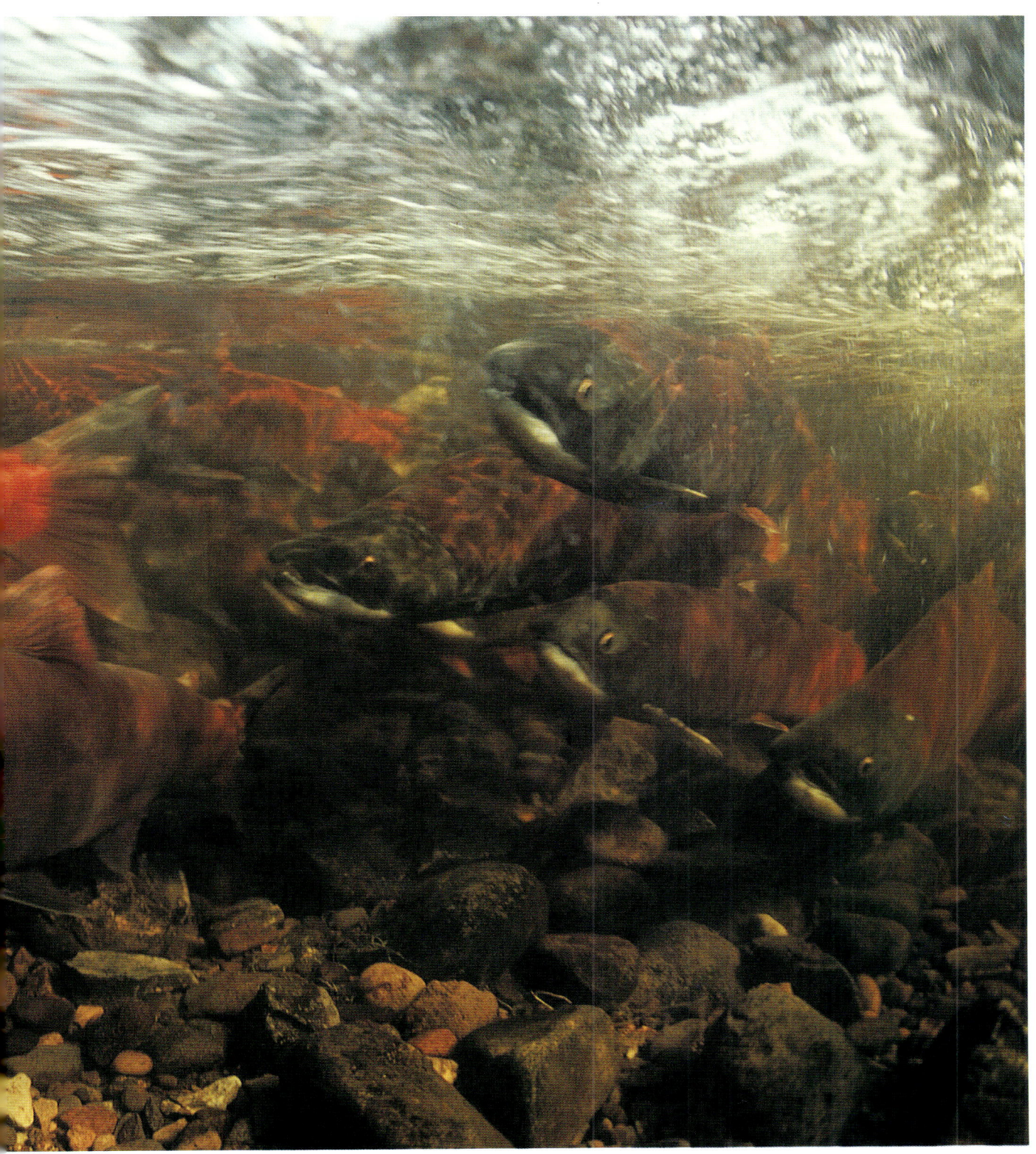

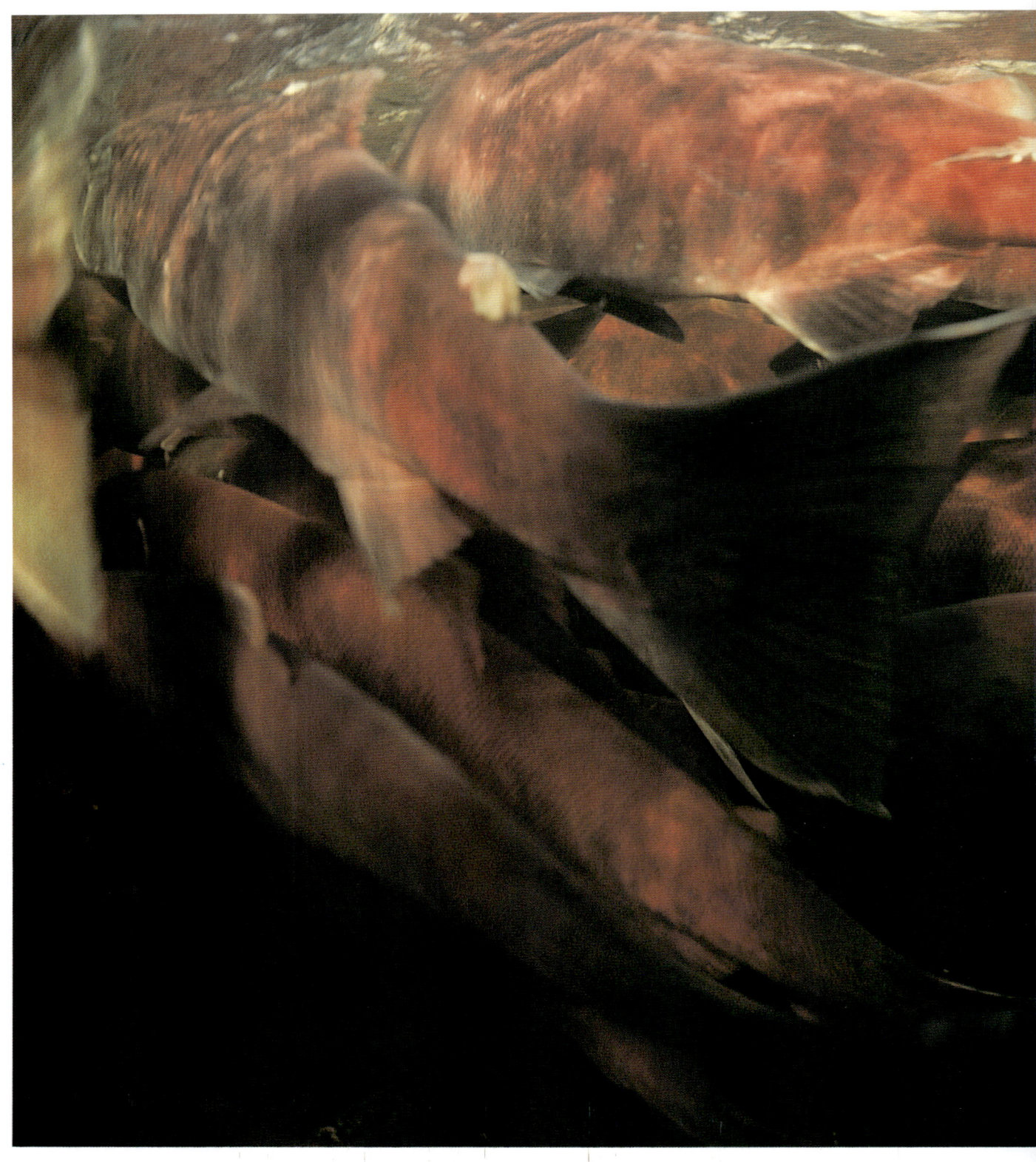

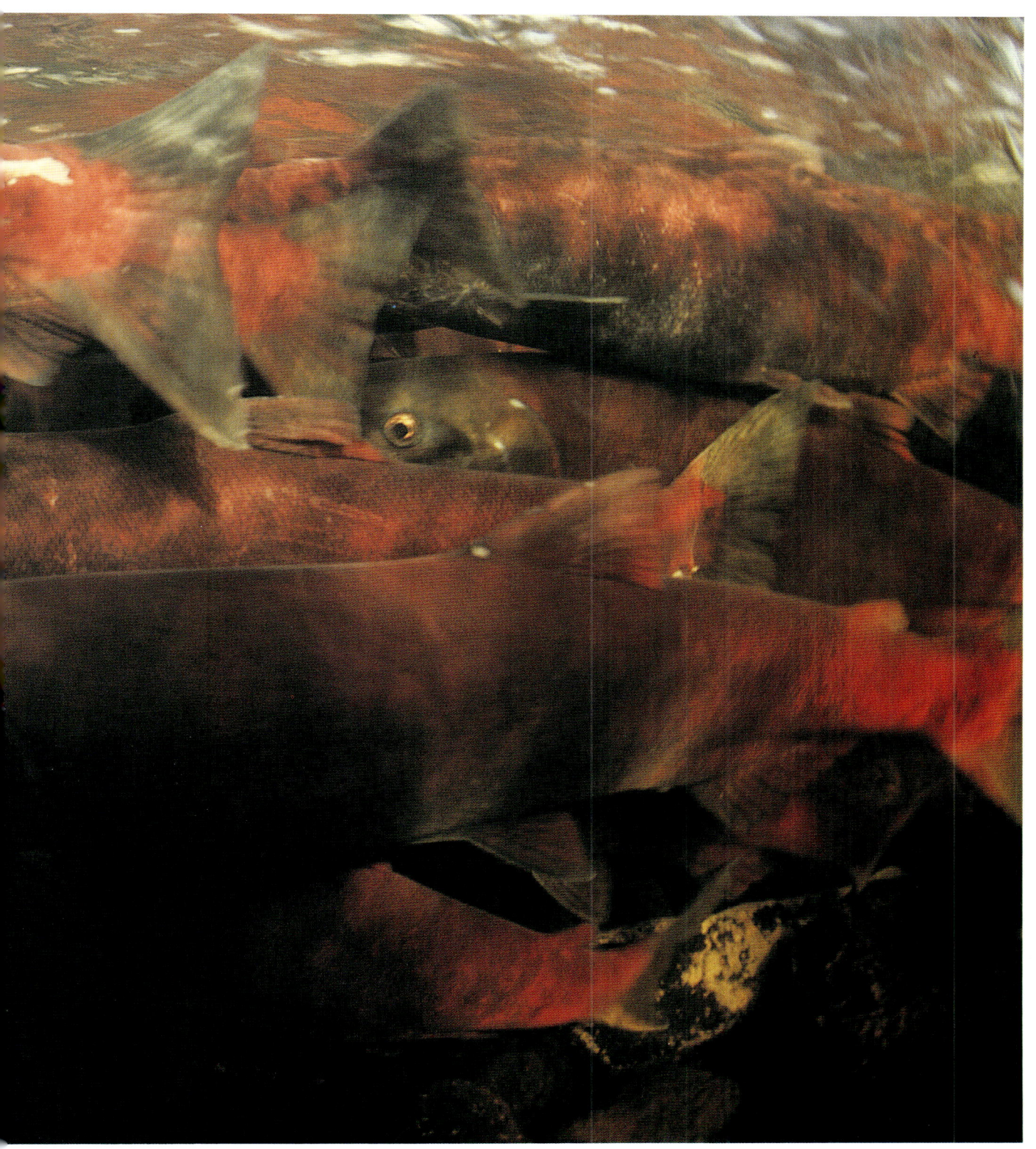

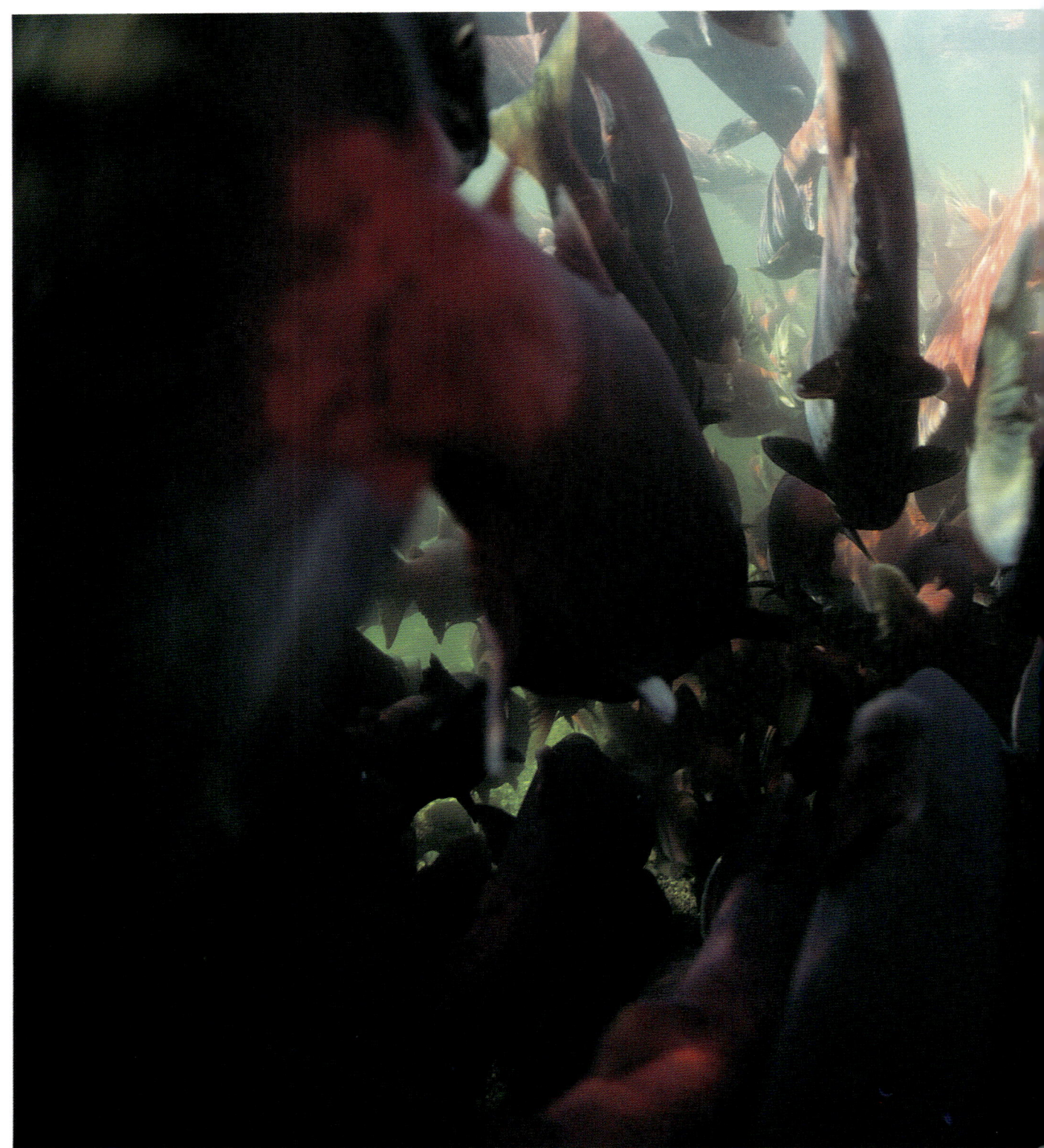

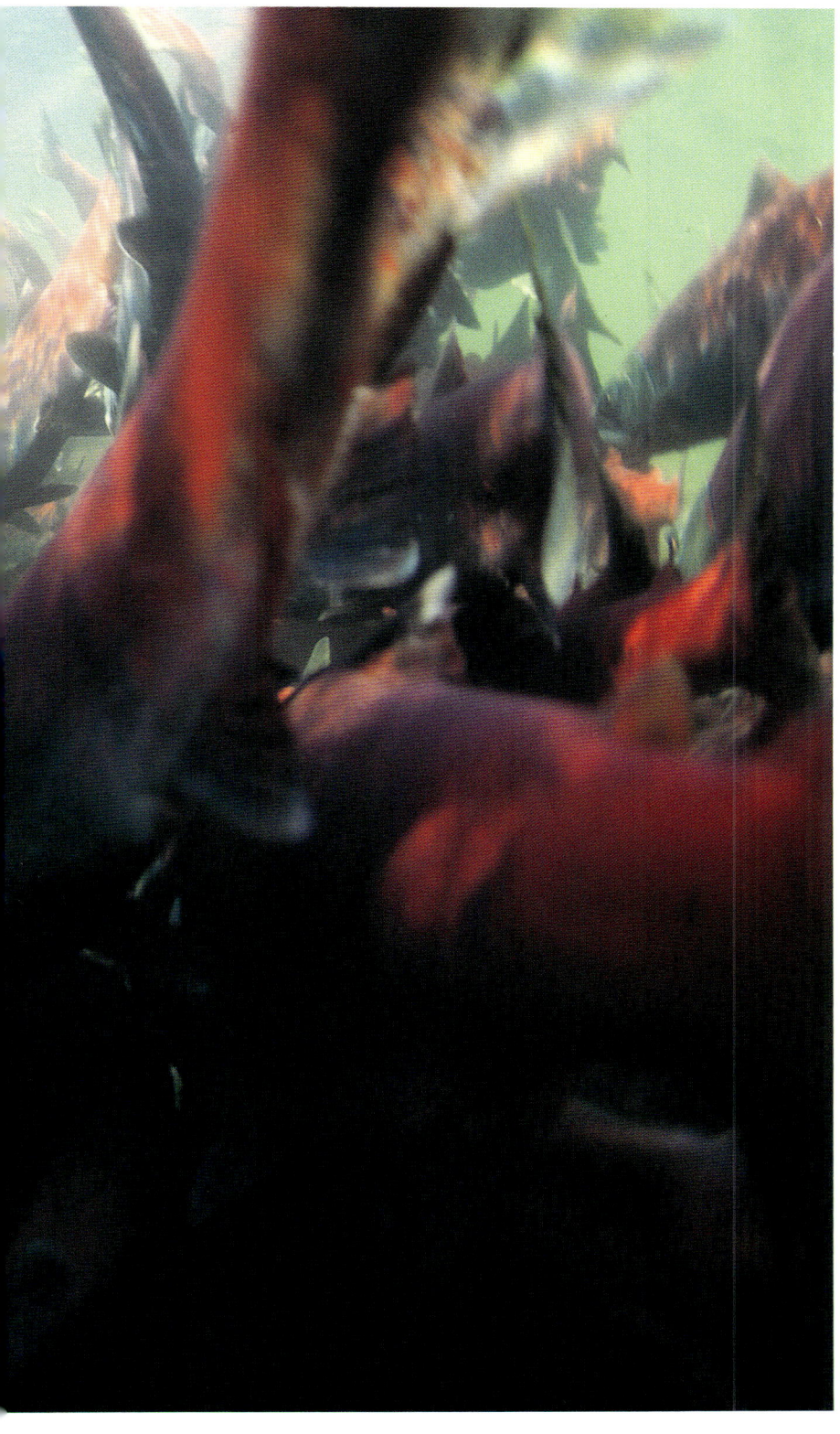

Left: A fish's view of the travelling school under water.

Pages 50–51: Crowding that would not be typical under any other circumstances is ignored by the determined spawners.

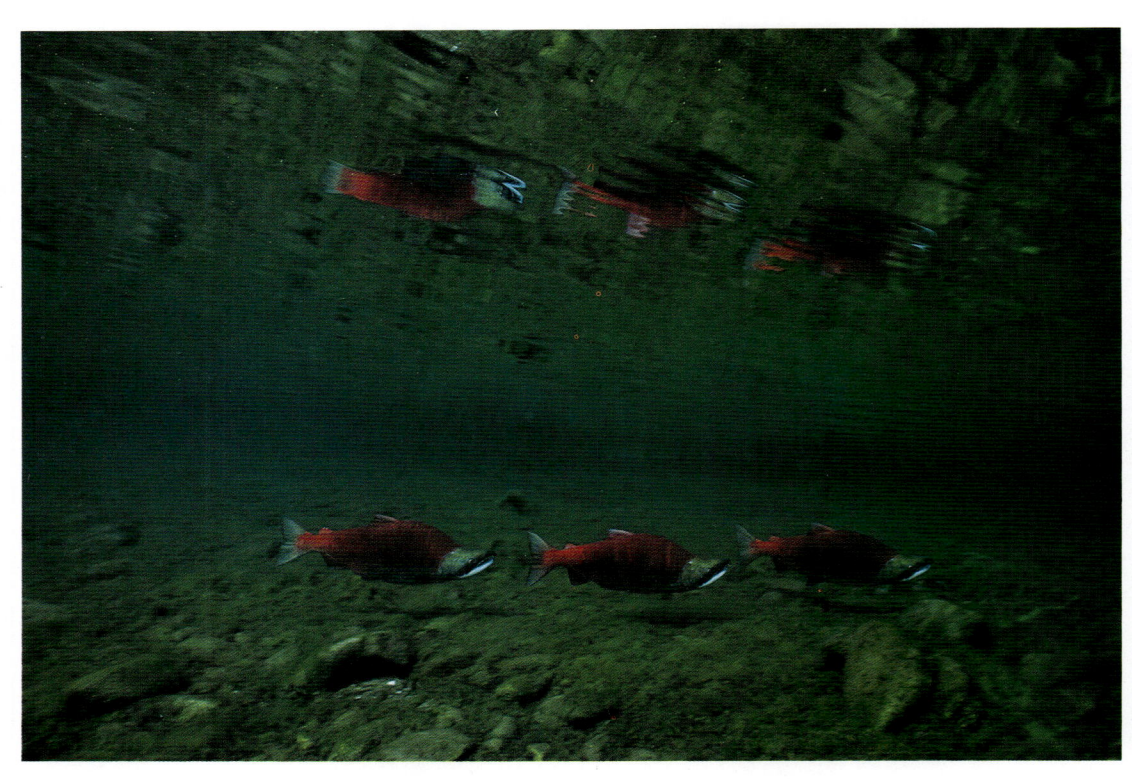

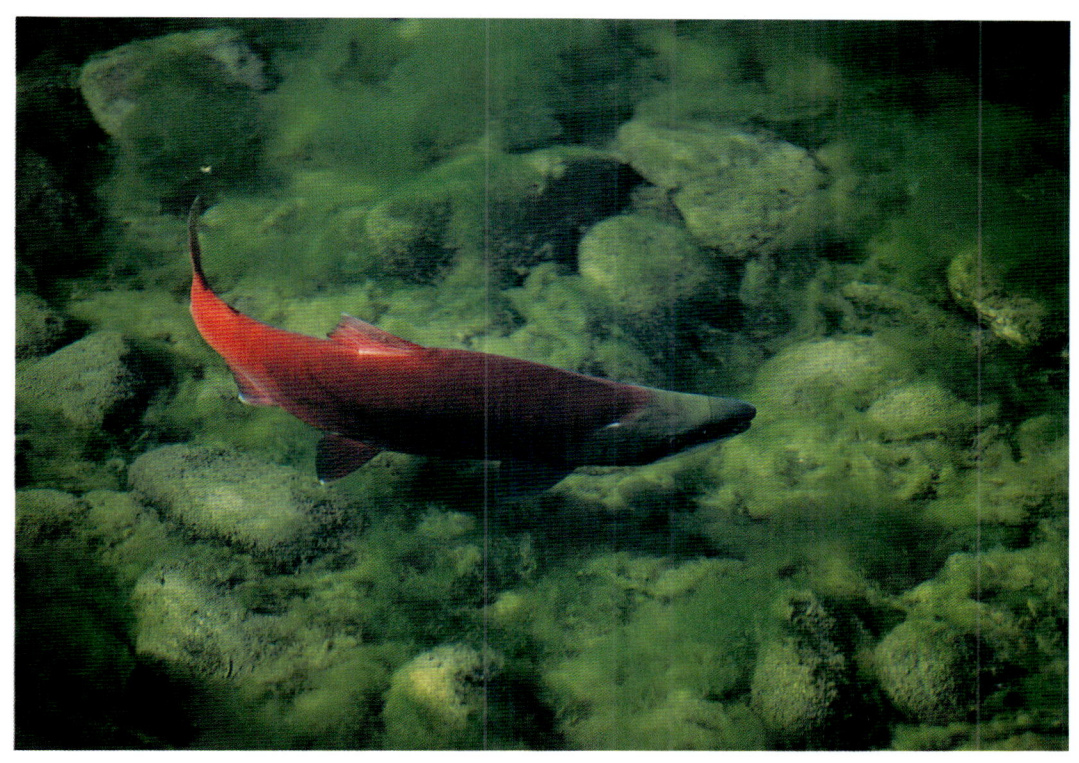

Above and left: Mature males develop humped backs and grotesque hooked snouts known as kypes.

Pages 56–57: A group of sockeye mills in a quiet pool. Reflections of the fish's brilliant red mingle with the gold of fallen leaves.

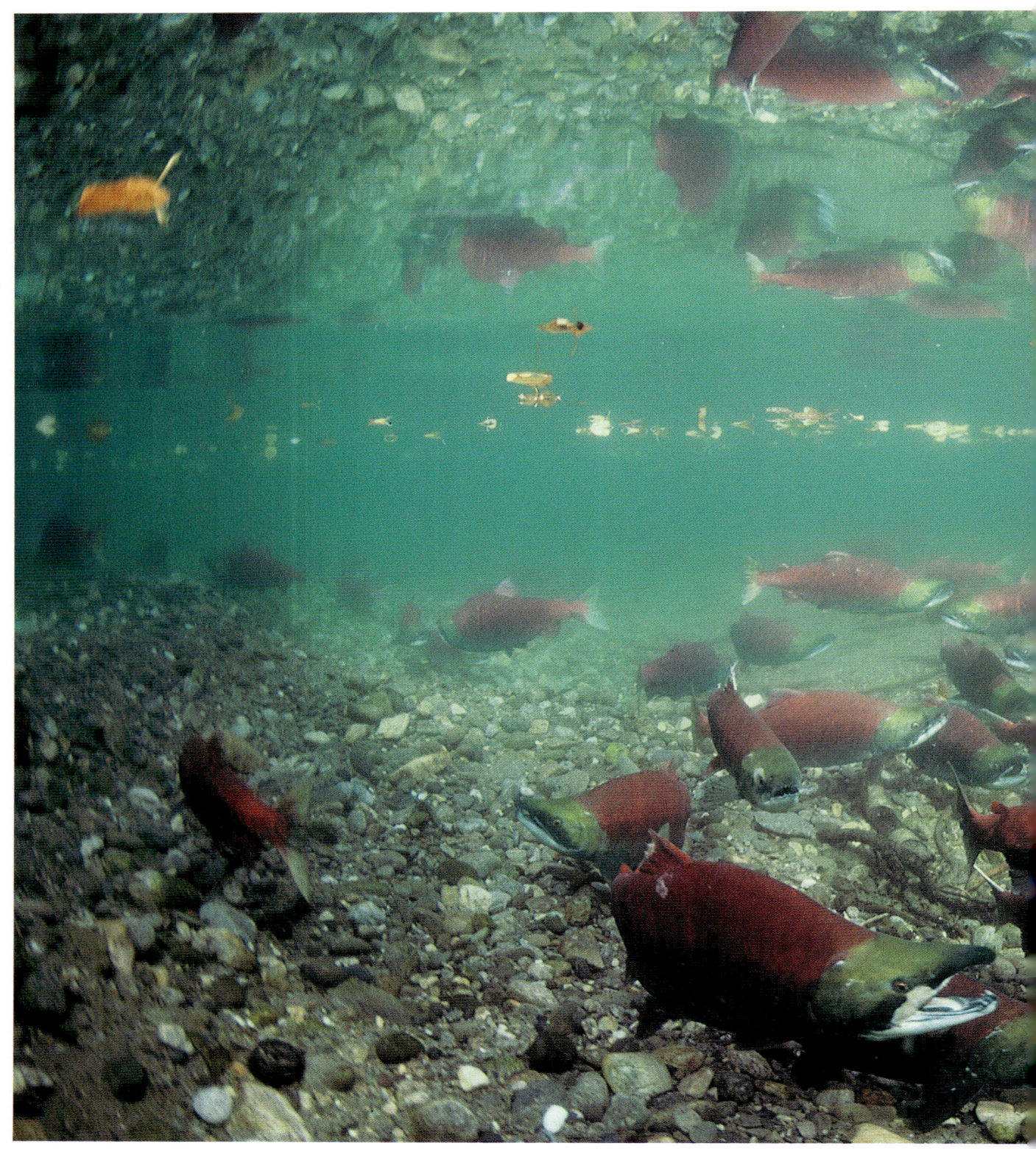

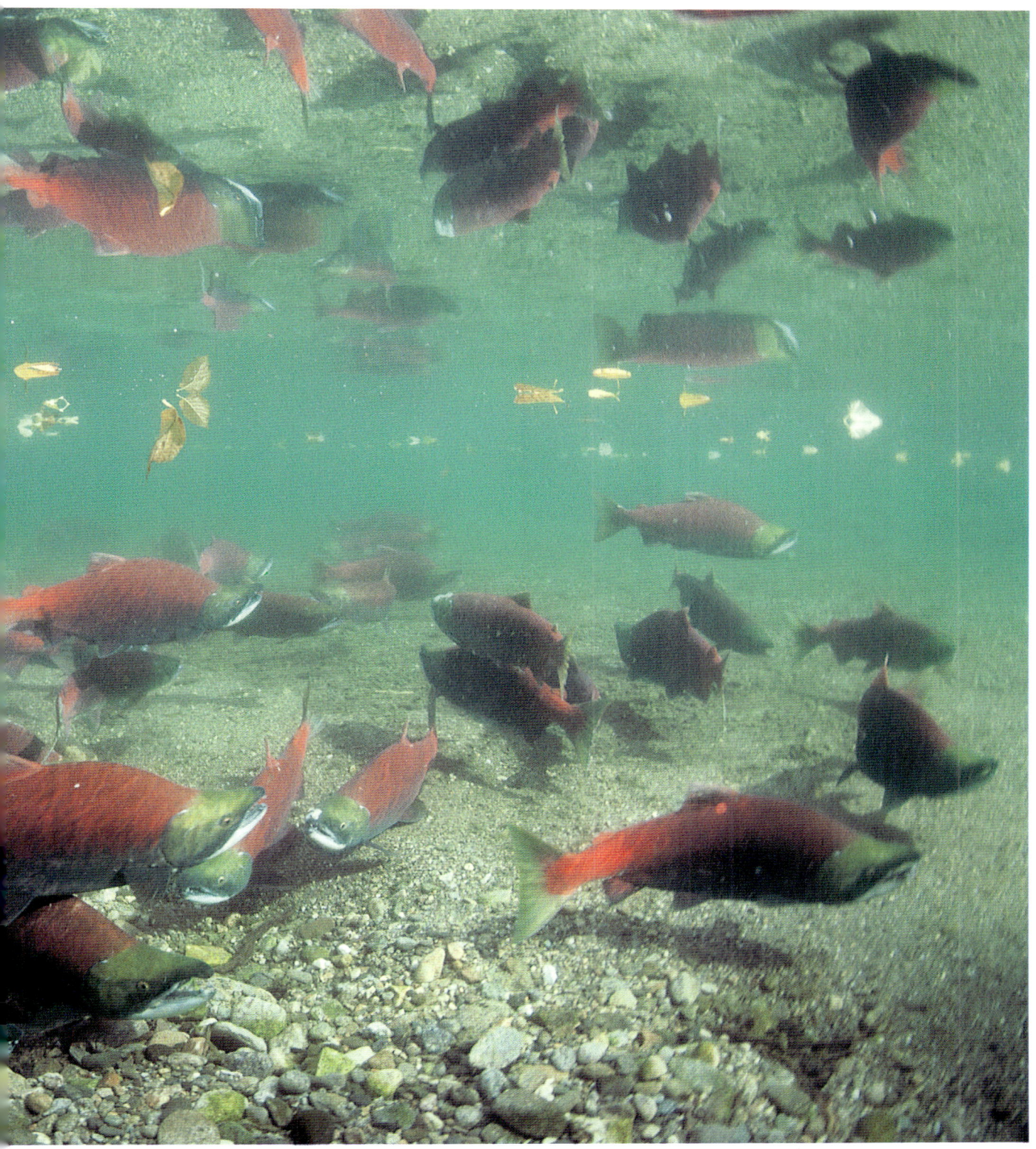

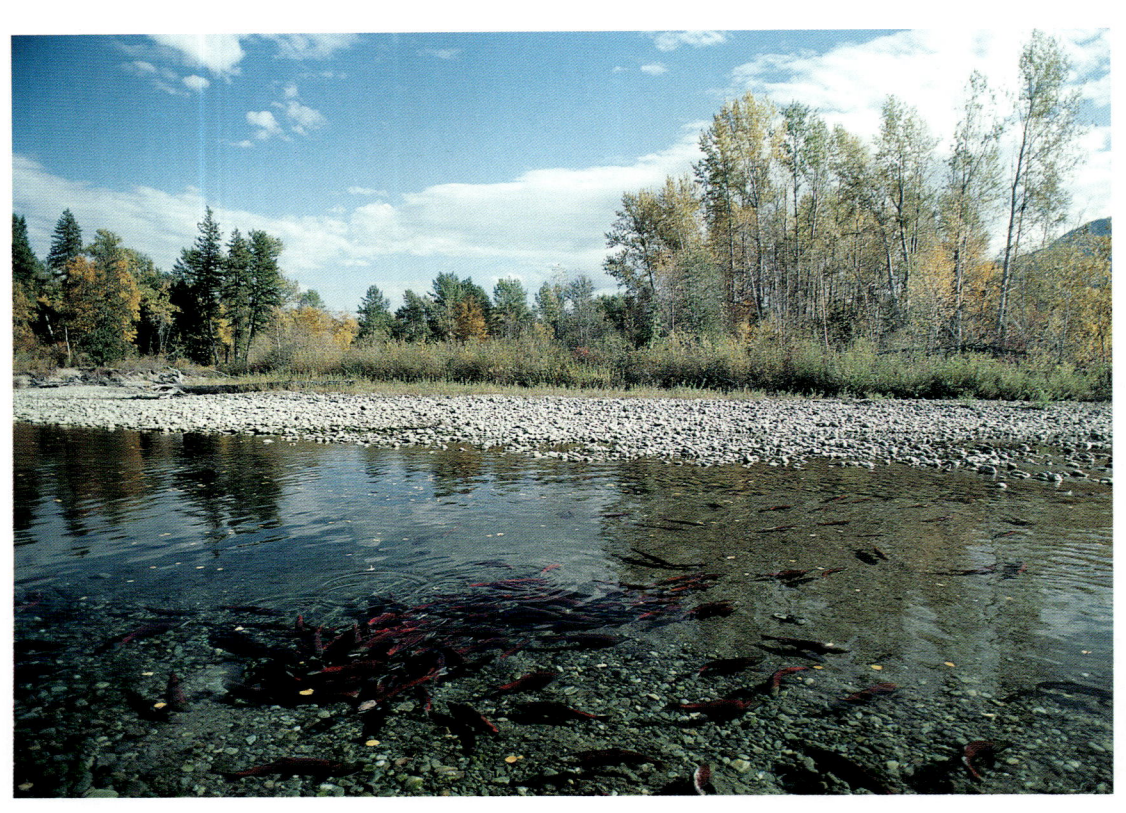

Above and right: Healthy salmon spawning habitat is a clear flowing stream protected by lush forests and not slowed or sullied by dams and artificial effluent.

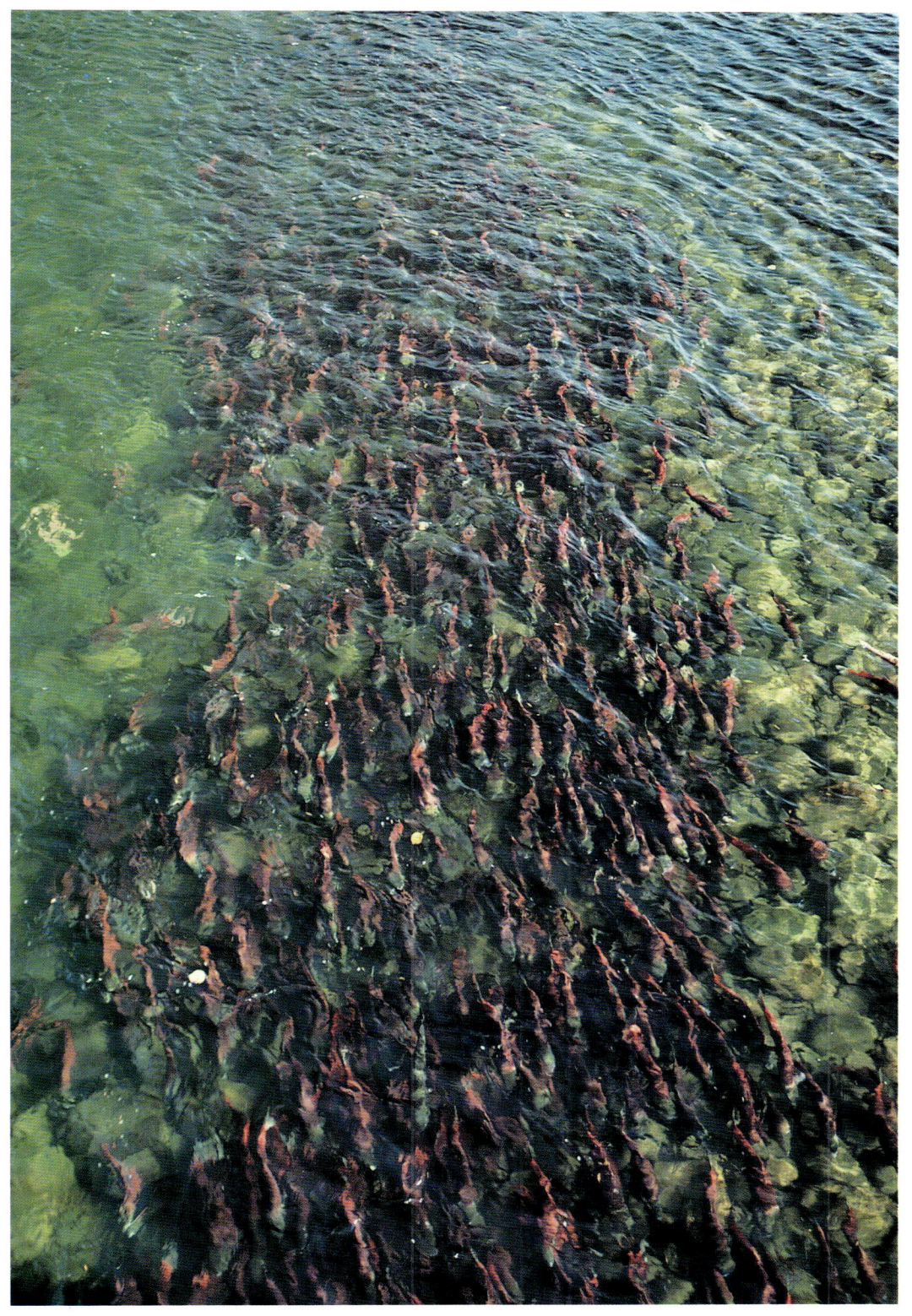

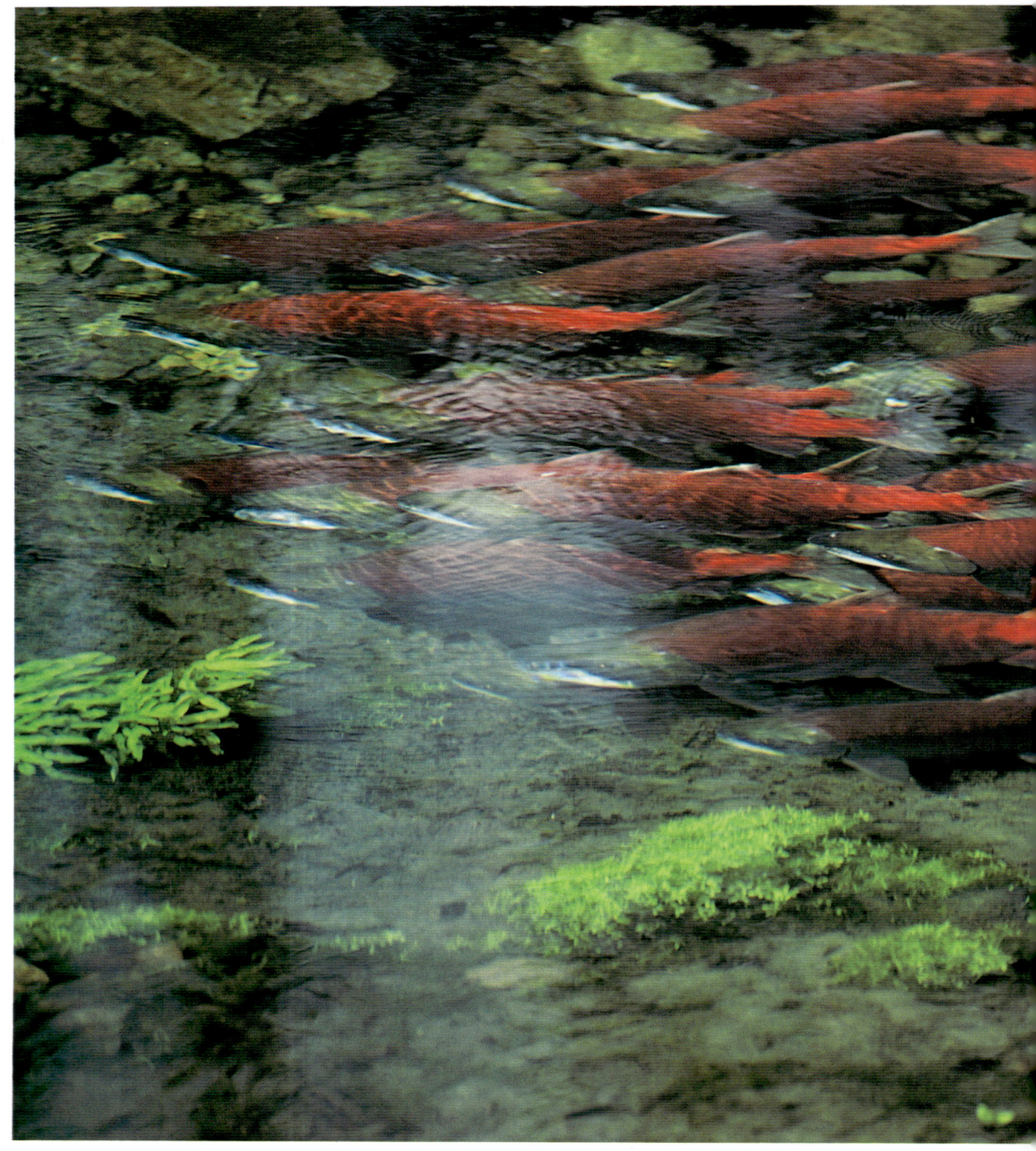

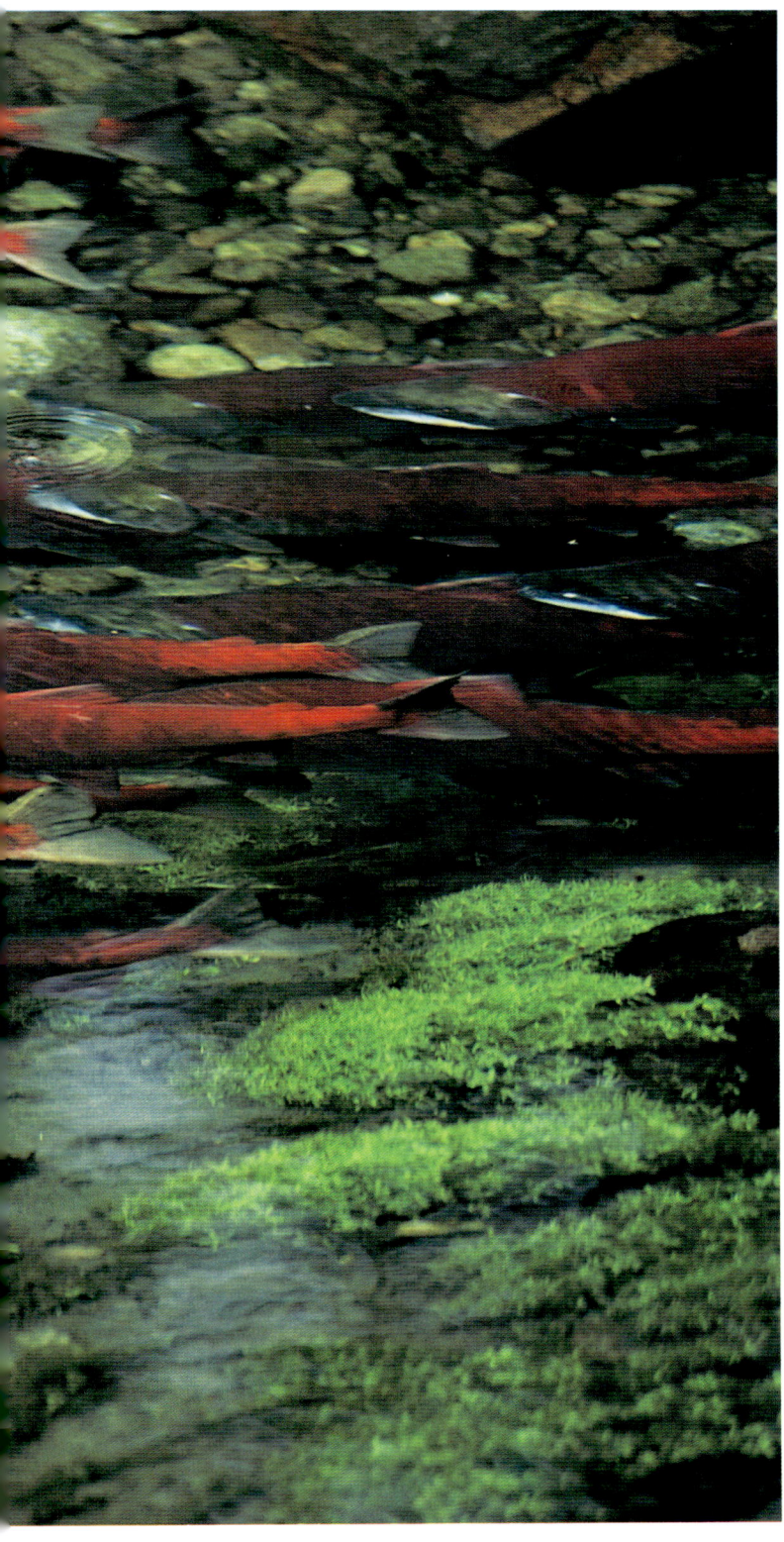

The spawners represent only a fraction of the fish that originated in this stream. During the previous four years, the others were killed by predators, human fishers, disease or physical hazards.

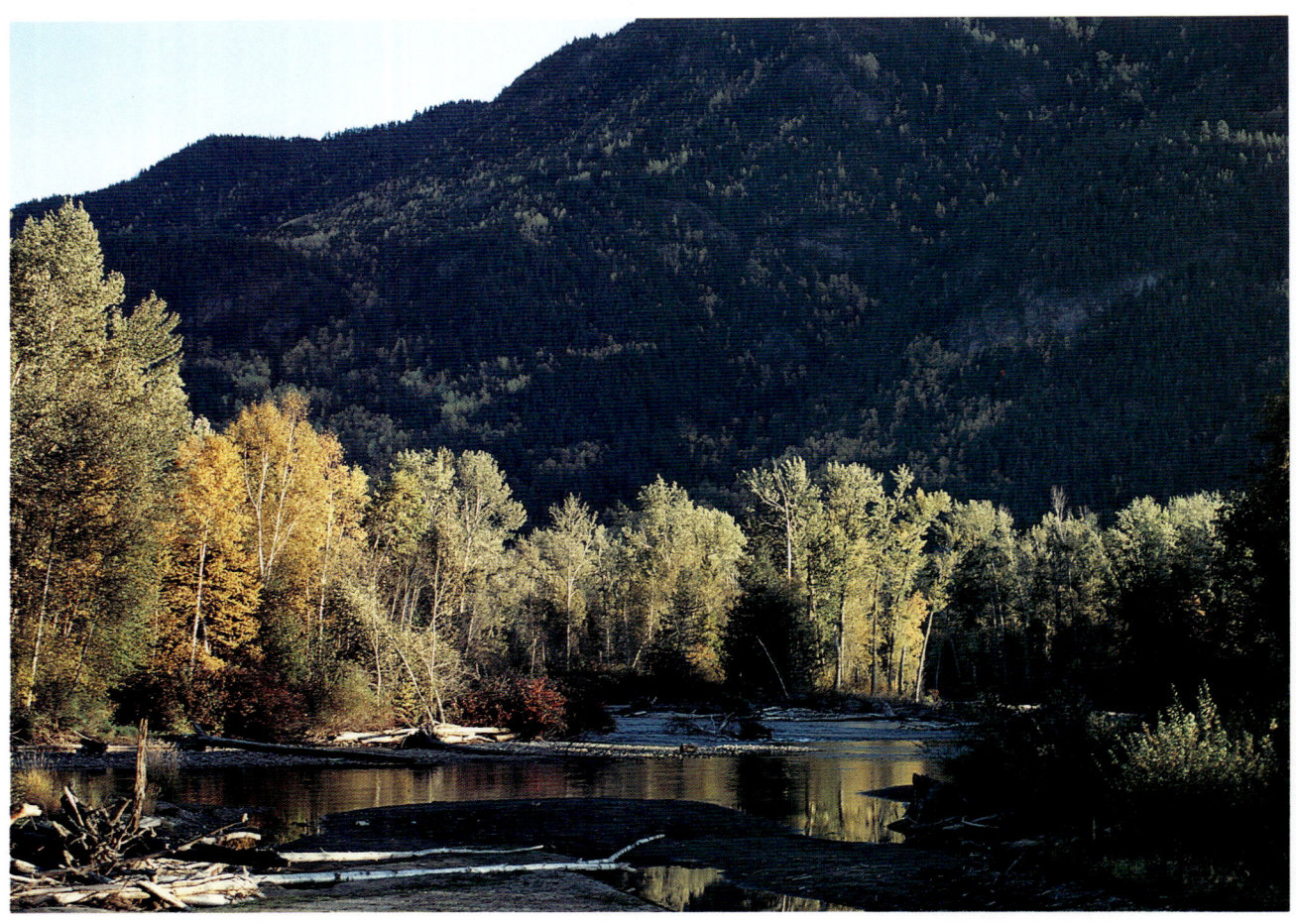

Above: As the weeks pass, fish move farther upstream into the complicated network of rivulets, tributaries and streams that feed the main-stem rivers.

Right: Within a few short weeks, every fish in this stream will be dead.

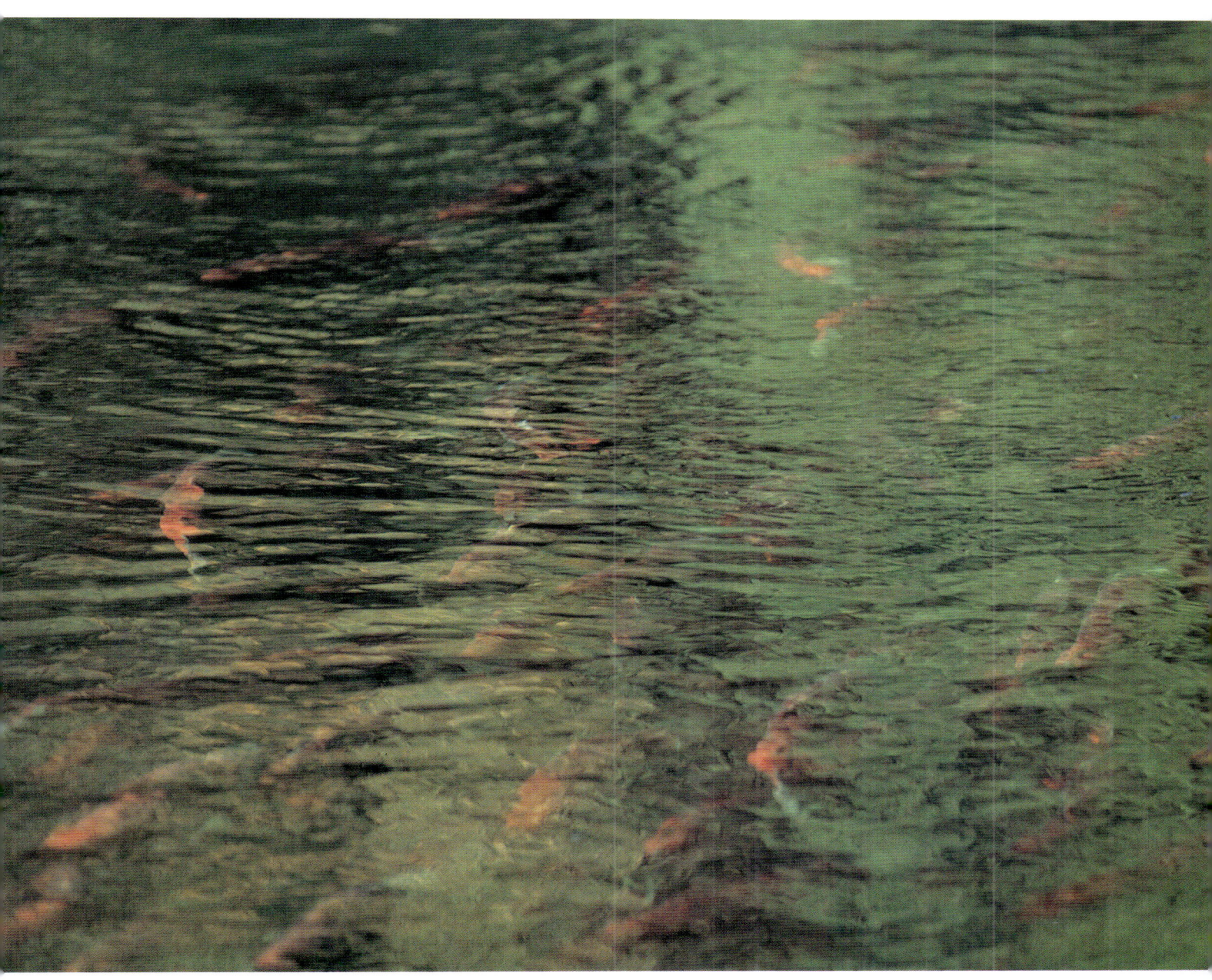

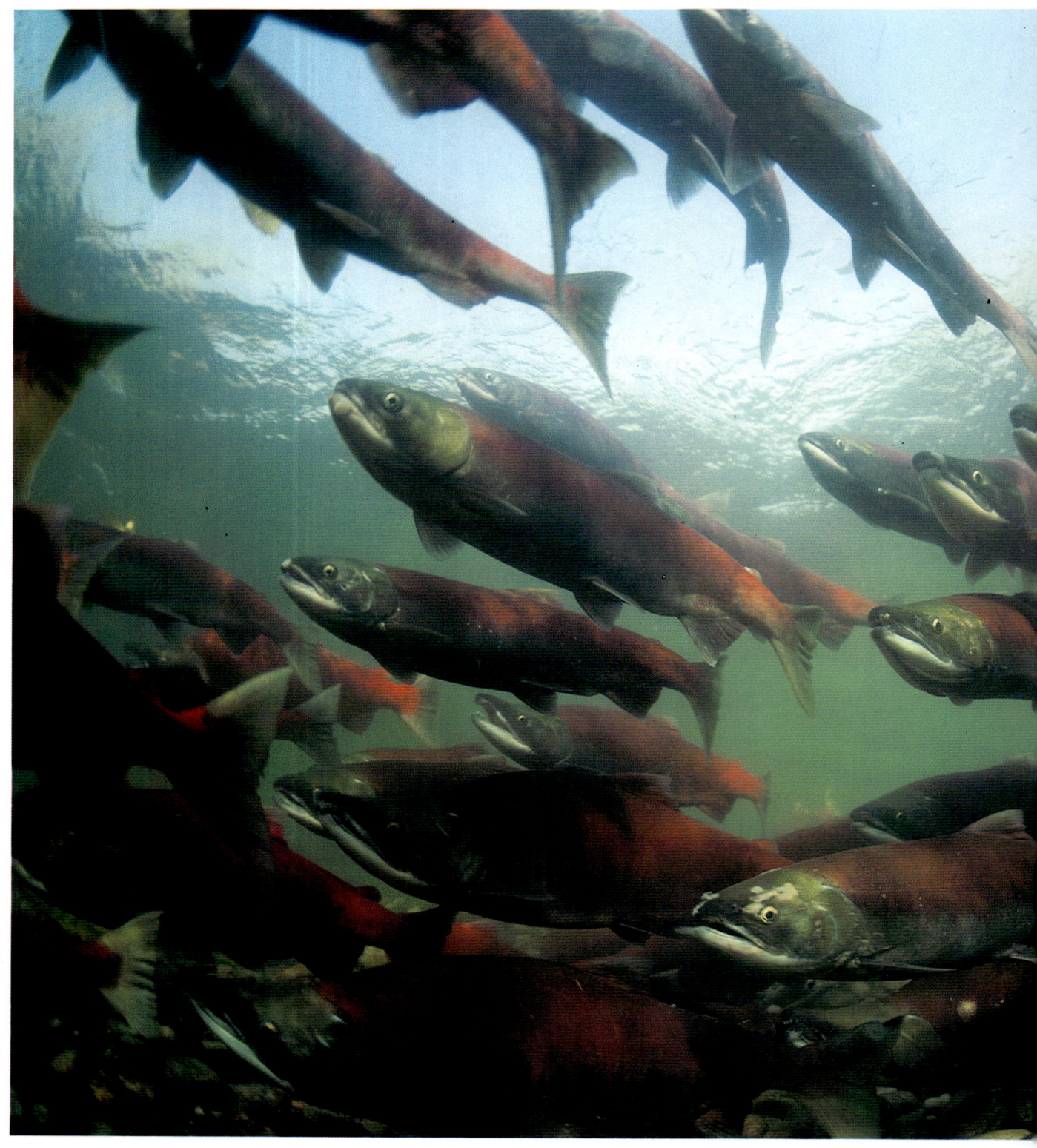

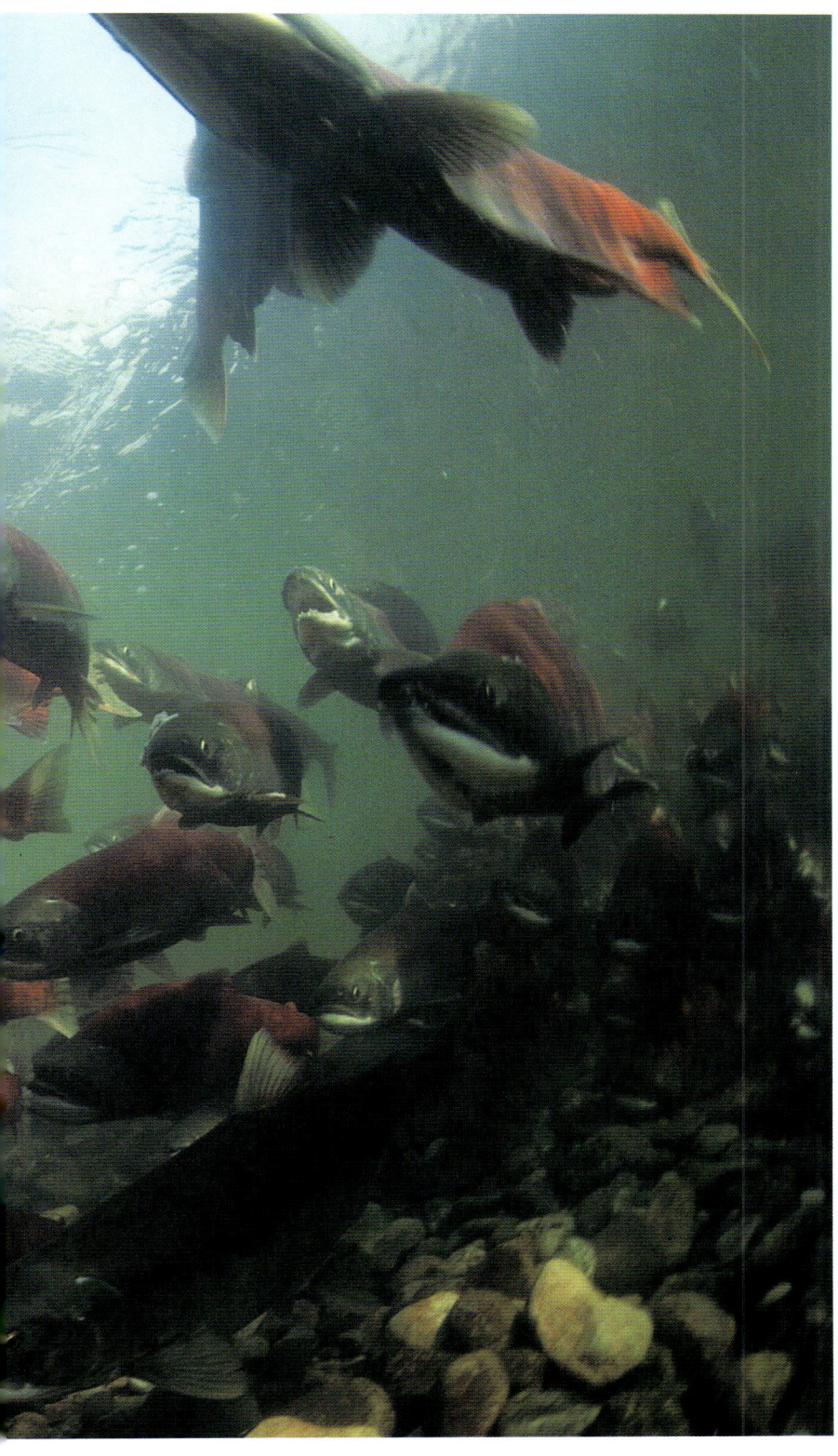

In a mixed group, females are easily distinguished from the males by their streamlined shape and pointed rather than hooked snouts.

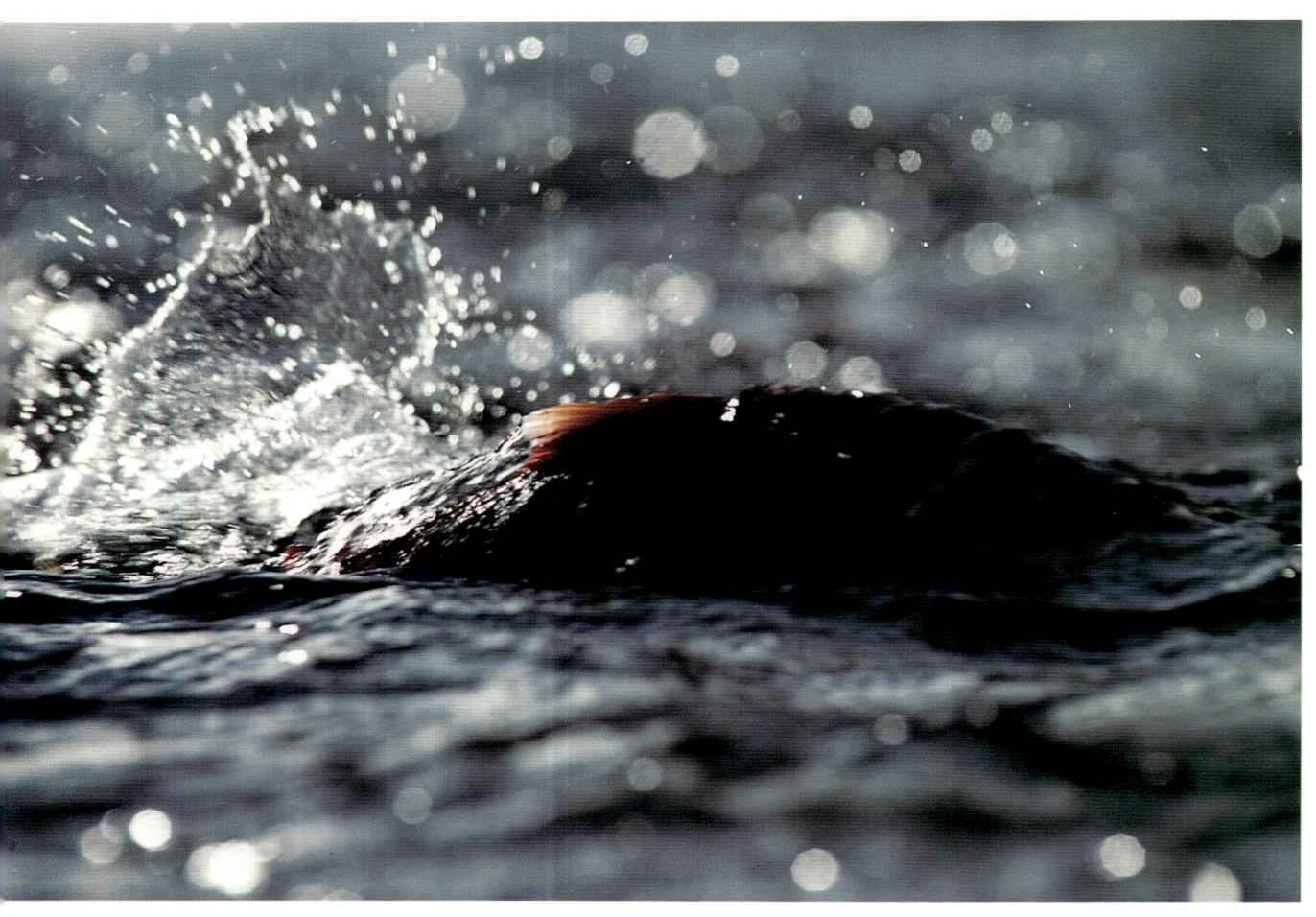

In their determination to spawn, adult salmon leave the protection of deeper water to speed through riffles so shallow that their backs are exposed.

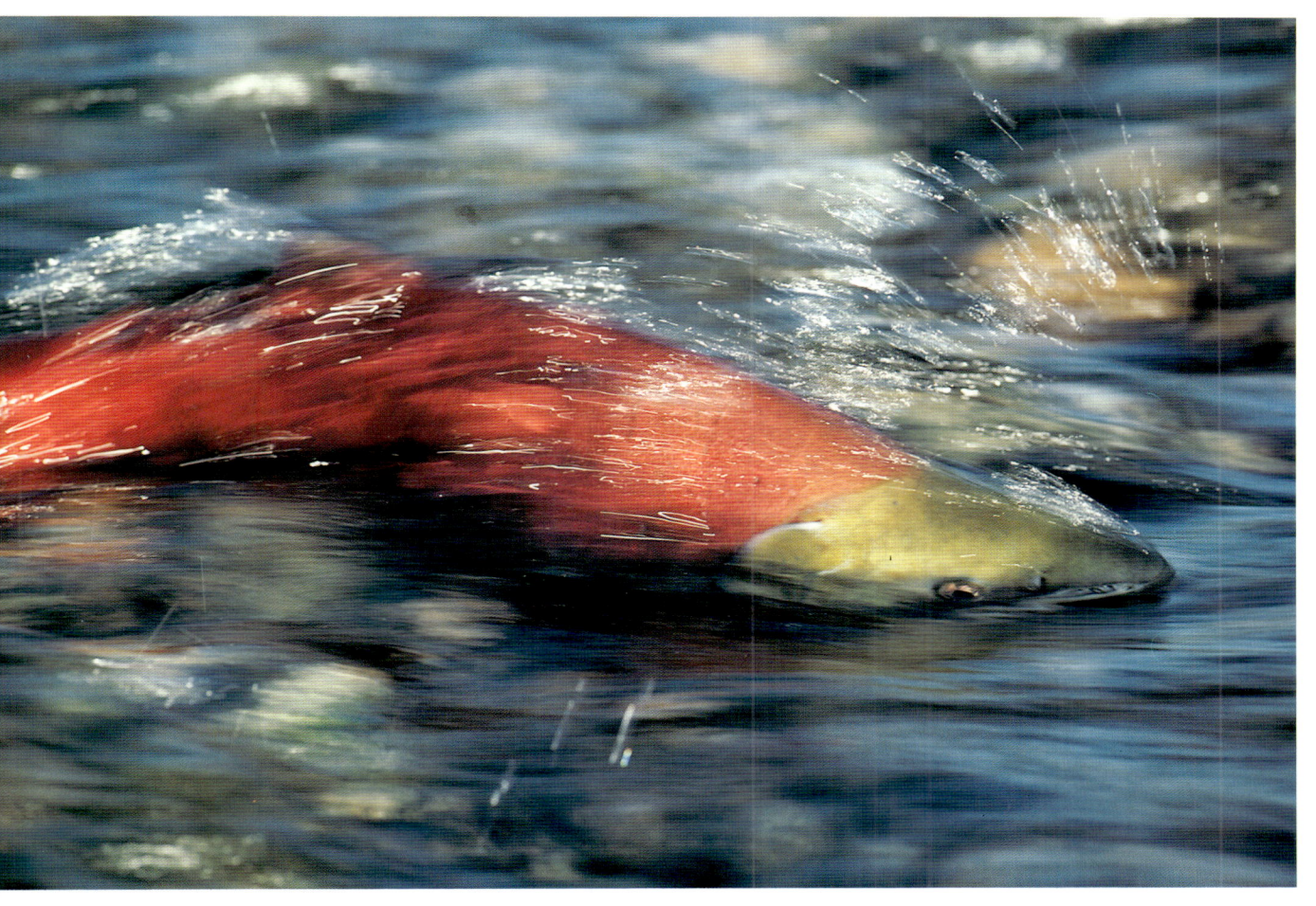

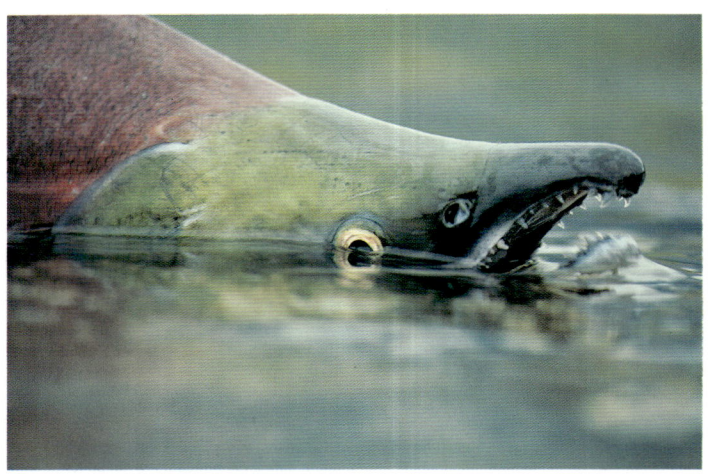

Above: A mature male displays his weapons of battle—a great hooked nose and prominent teeth.

Right: A female sockeye battles the relentless current by hugging the bottom of the rapids as she moves upstream.

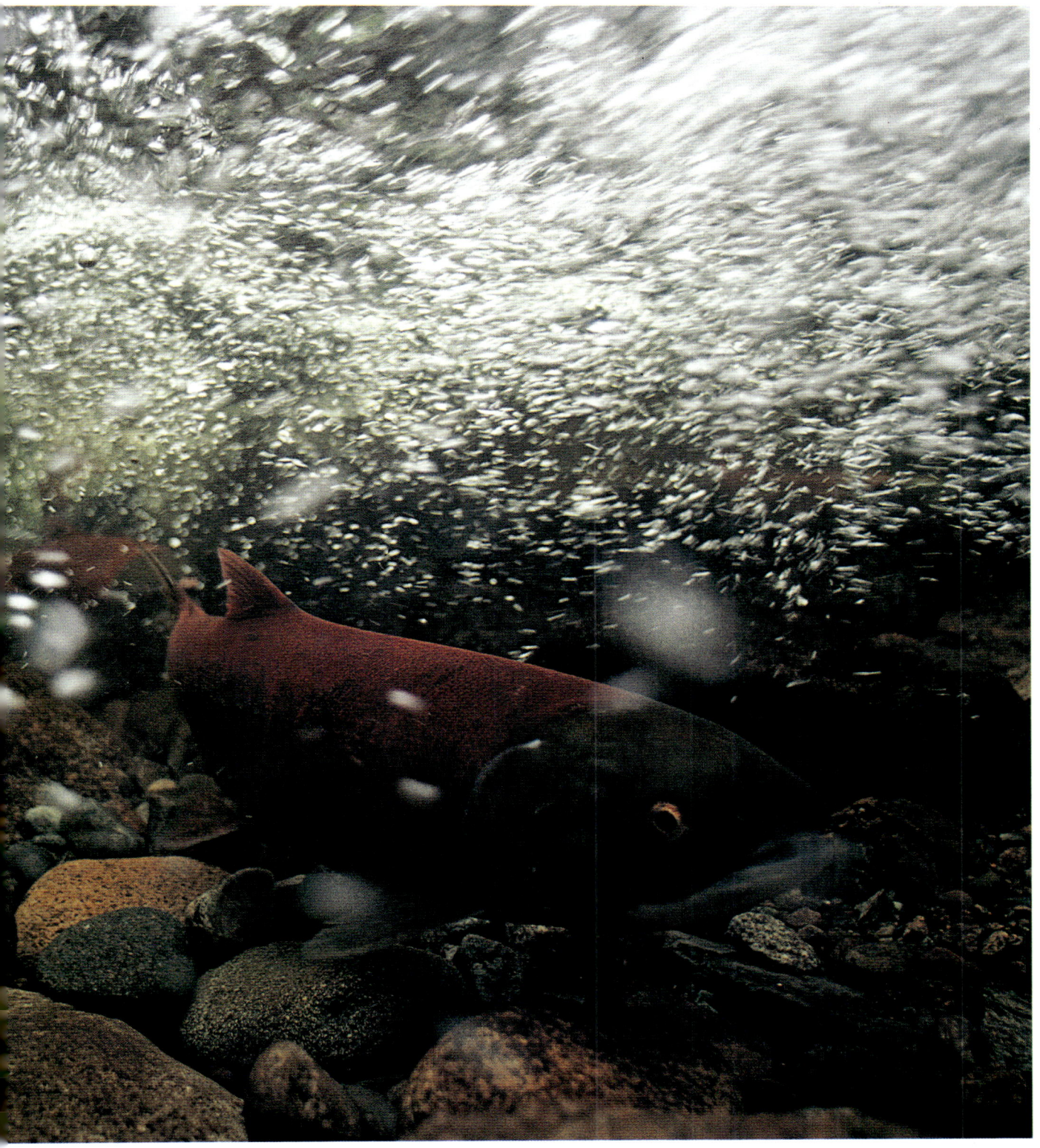

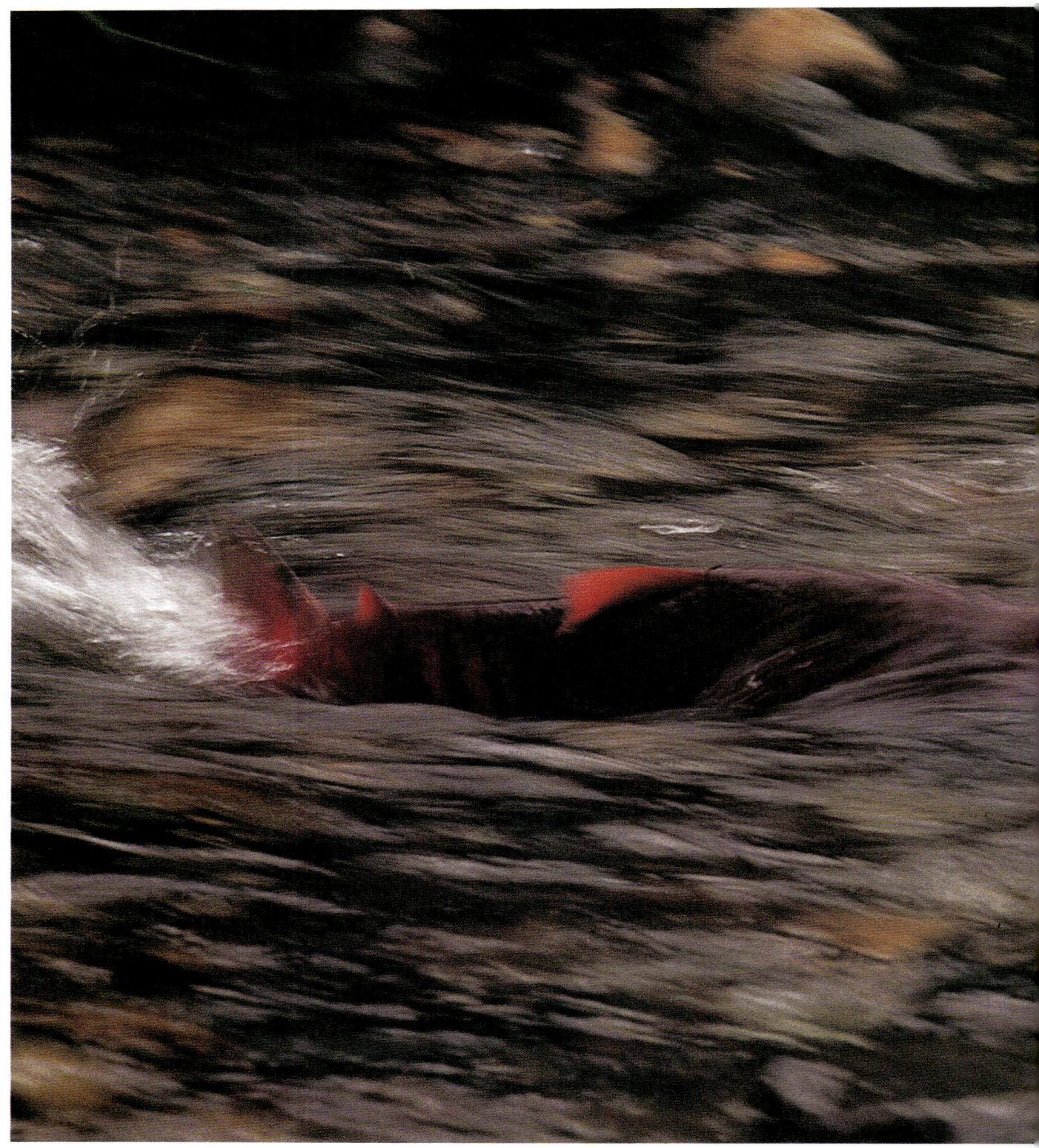

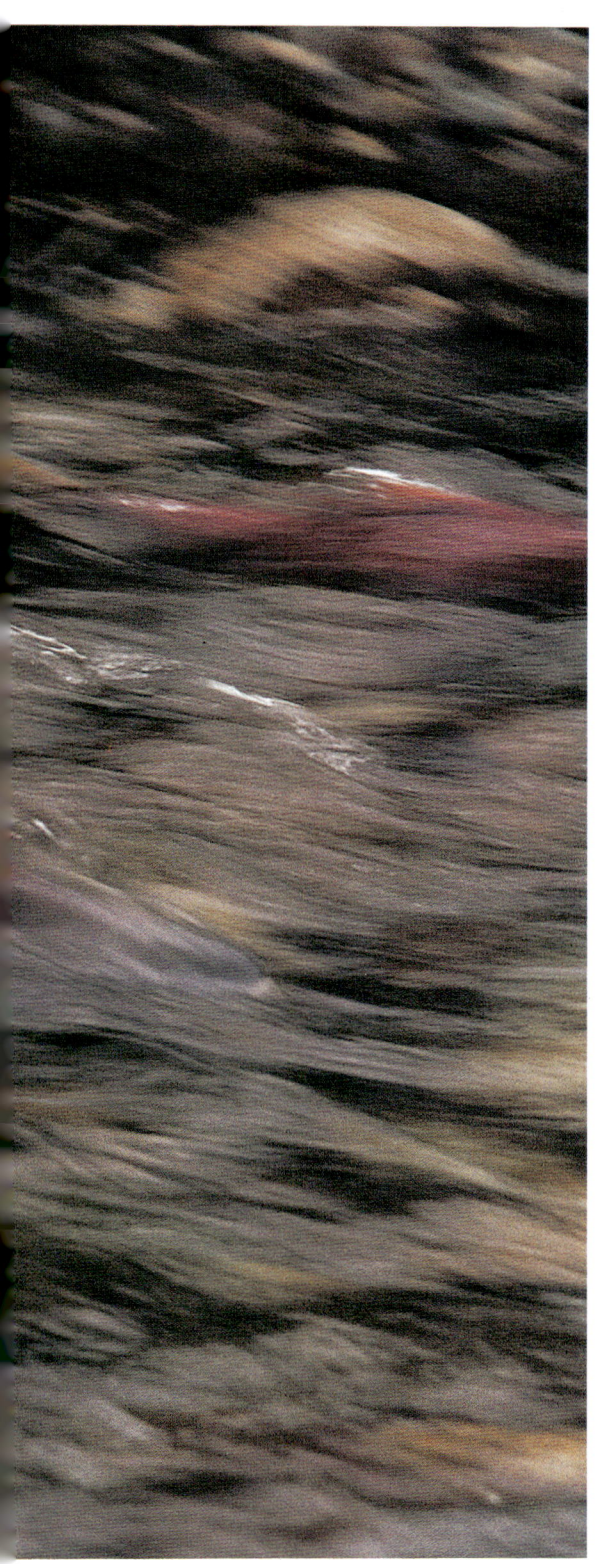
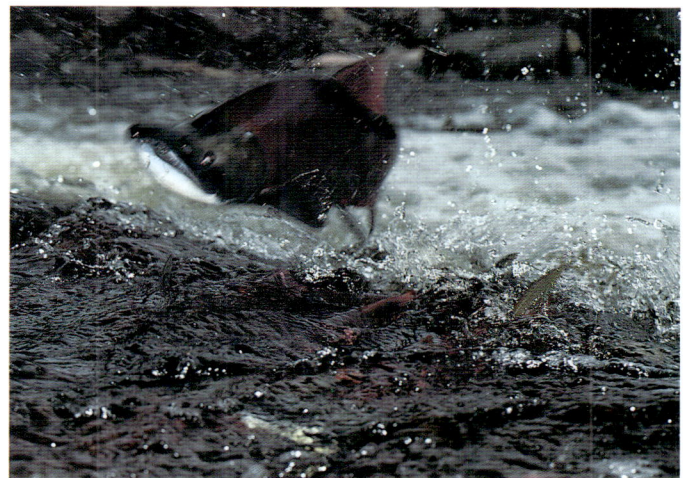

Above and left: Determined to make headway against the current, salmon make flying leaps clear of the water in their push upstream.

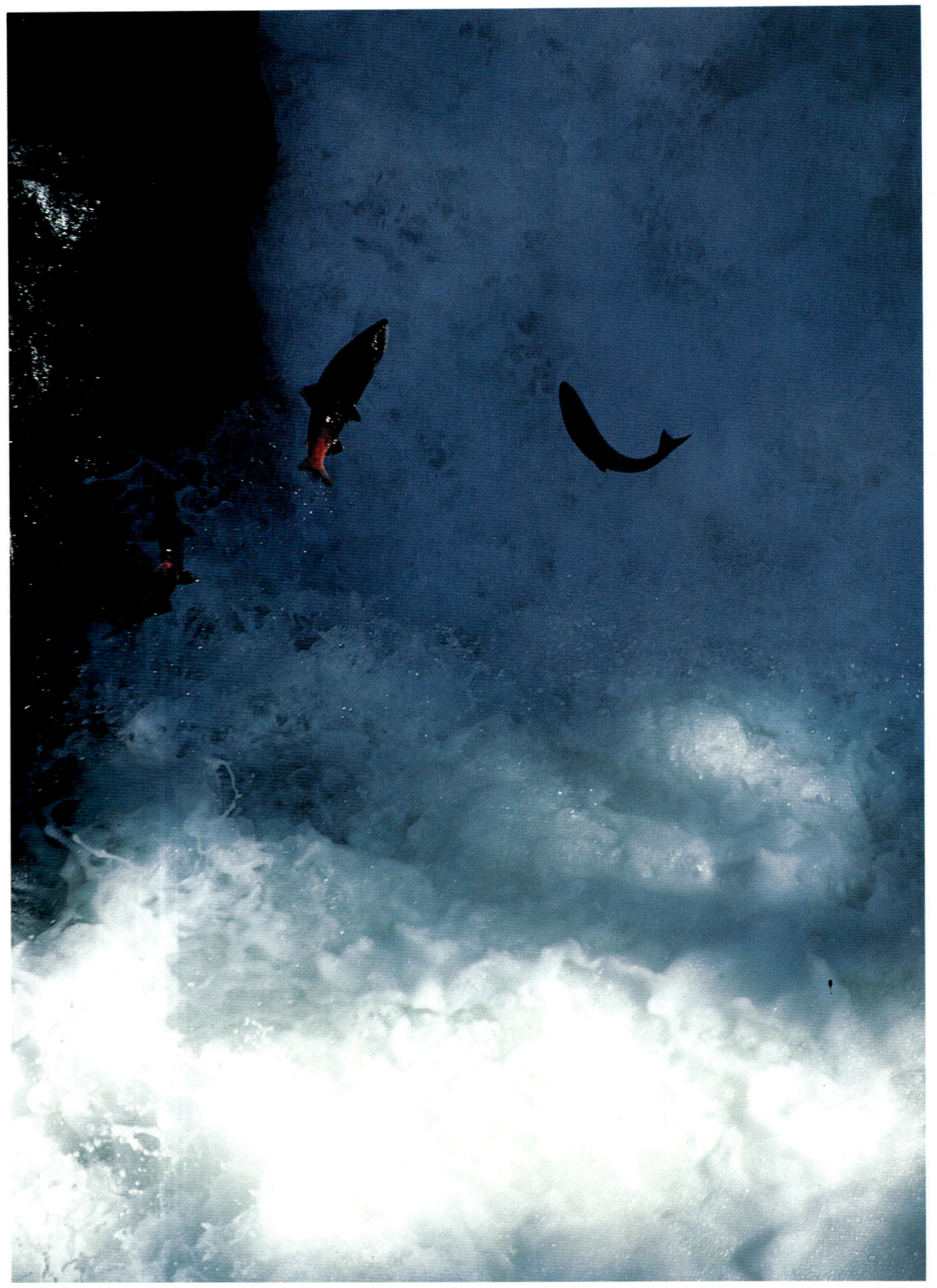

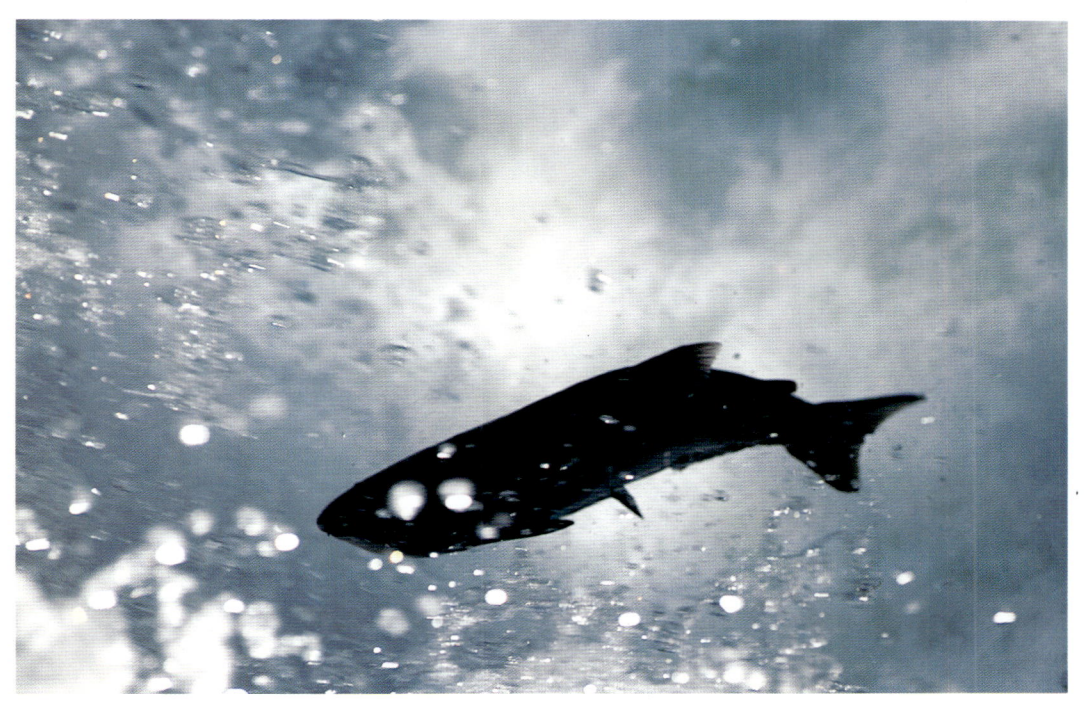

A salmon needs a surprisingly short distance in which to generate enough power to hurl itself up and over the falls.

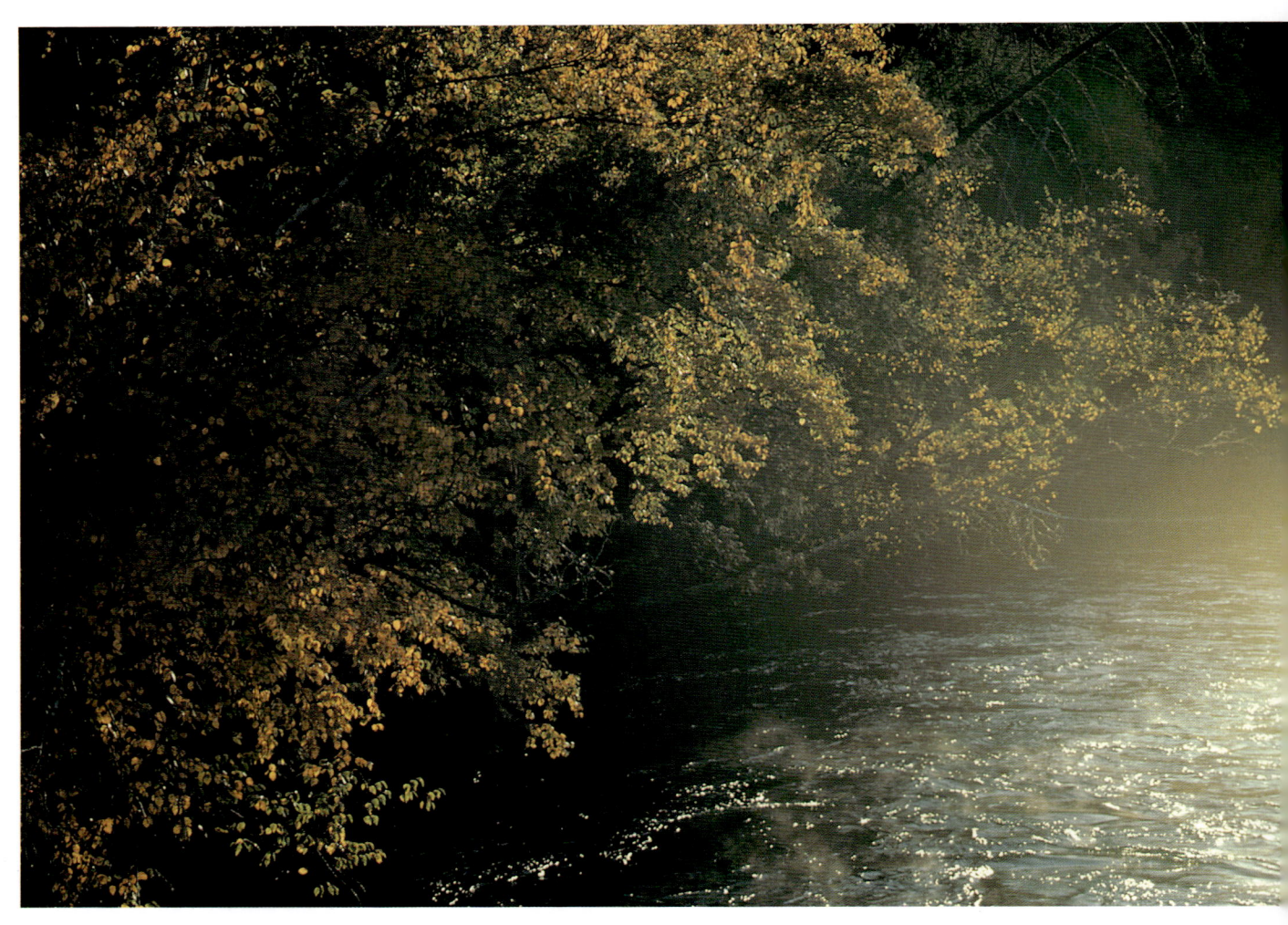

*As the summer's lush green canopy turns to bright gold in the fall,
it continues to provide shade, keeping the spawning stream cool.*

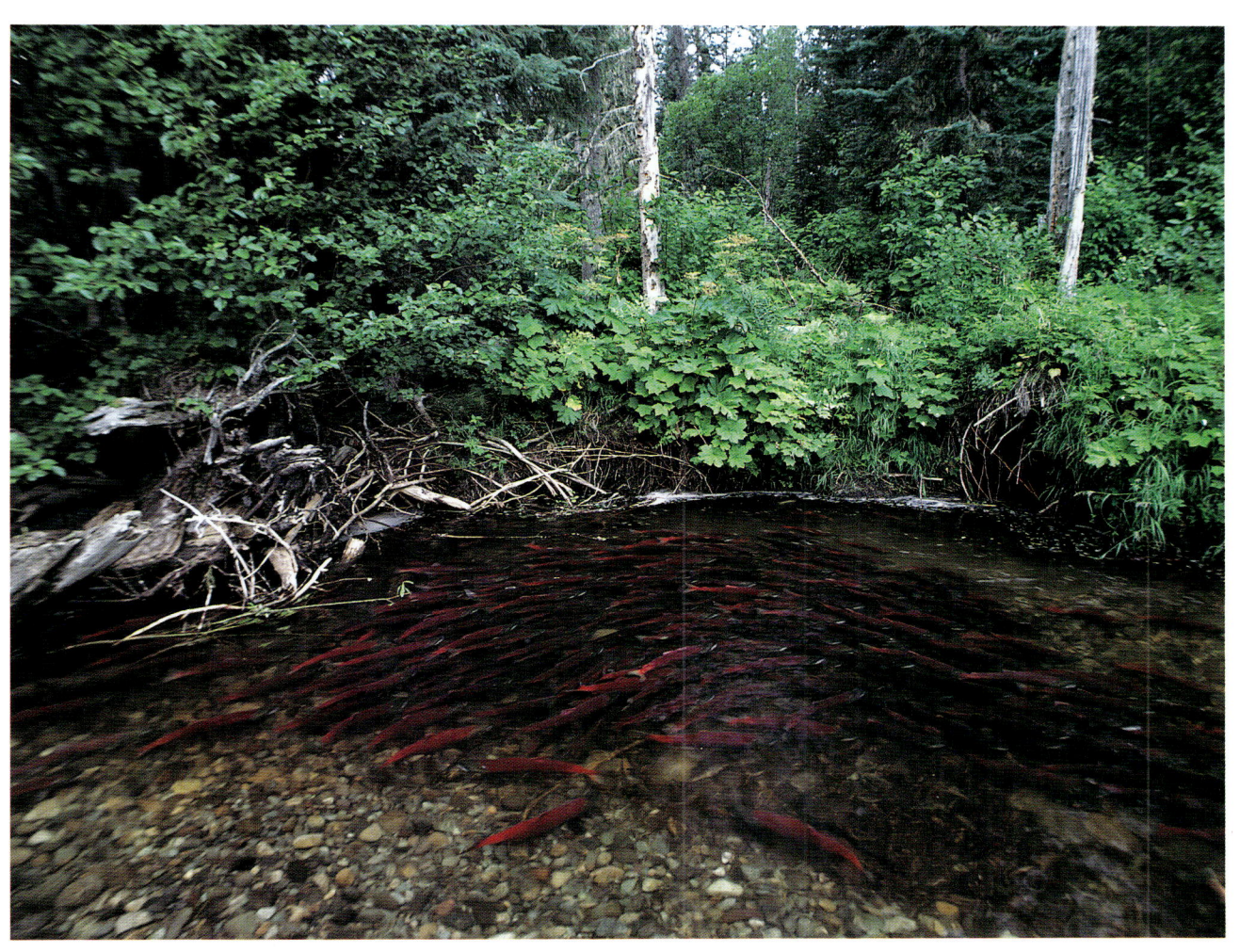

Luxuriant foliage, cool, clear water and a blaze of crimson sockeye reflect a vibrant, healthy habitat.

Finally arriving at their destination, the salmon can begin pairing, building their nests and spawning.

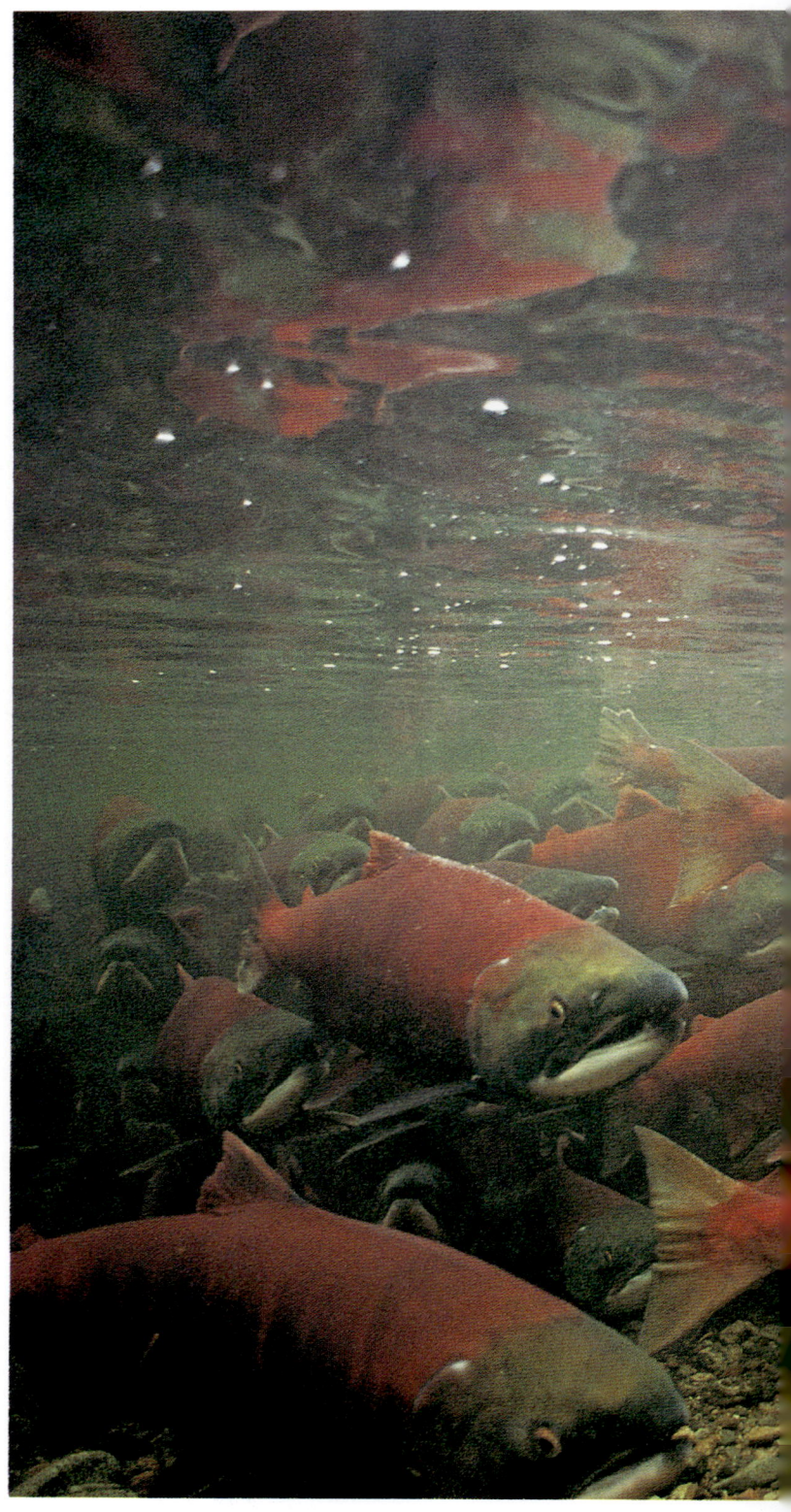

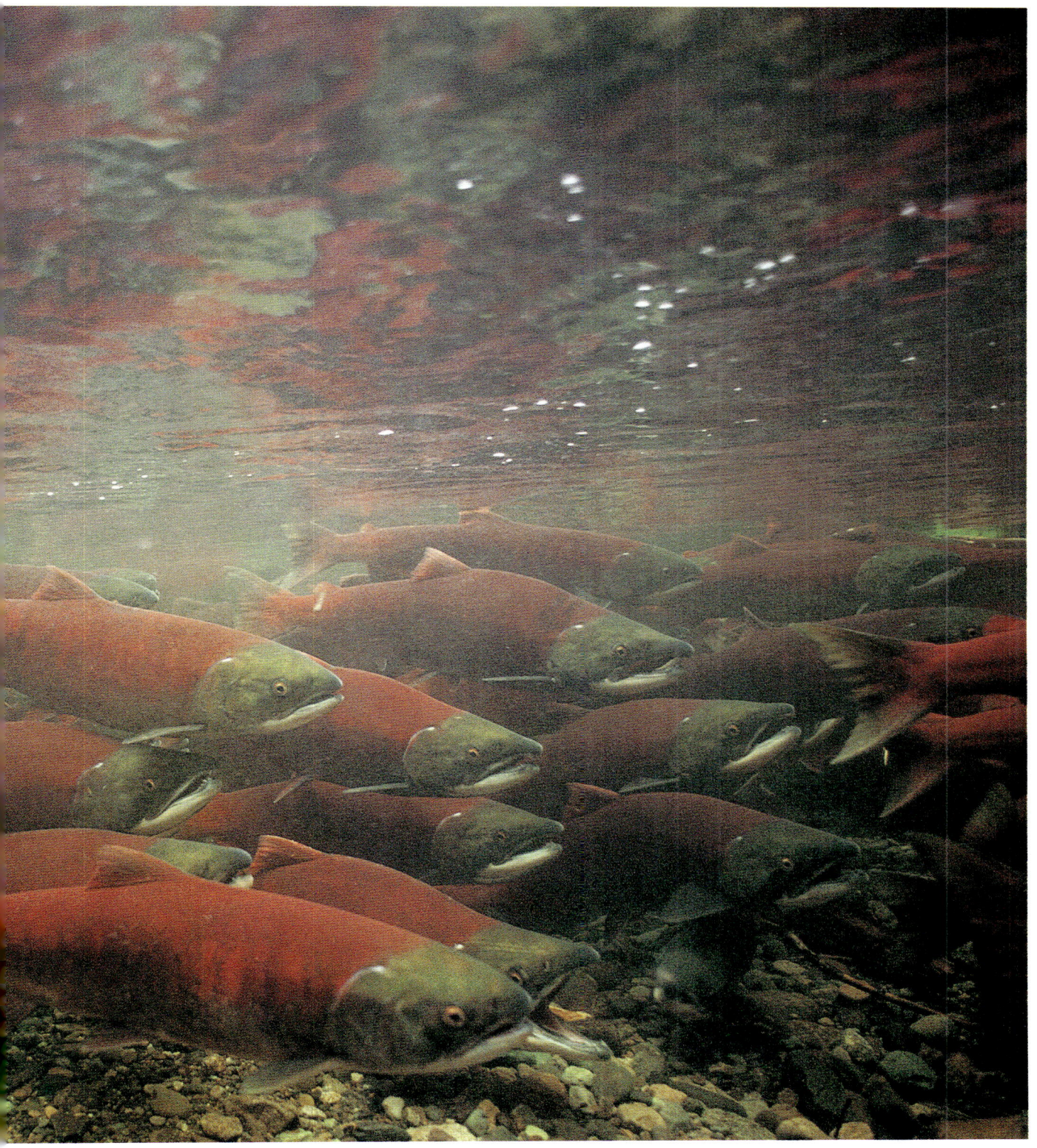

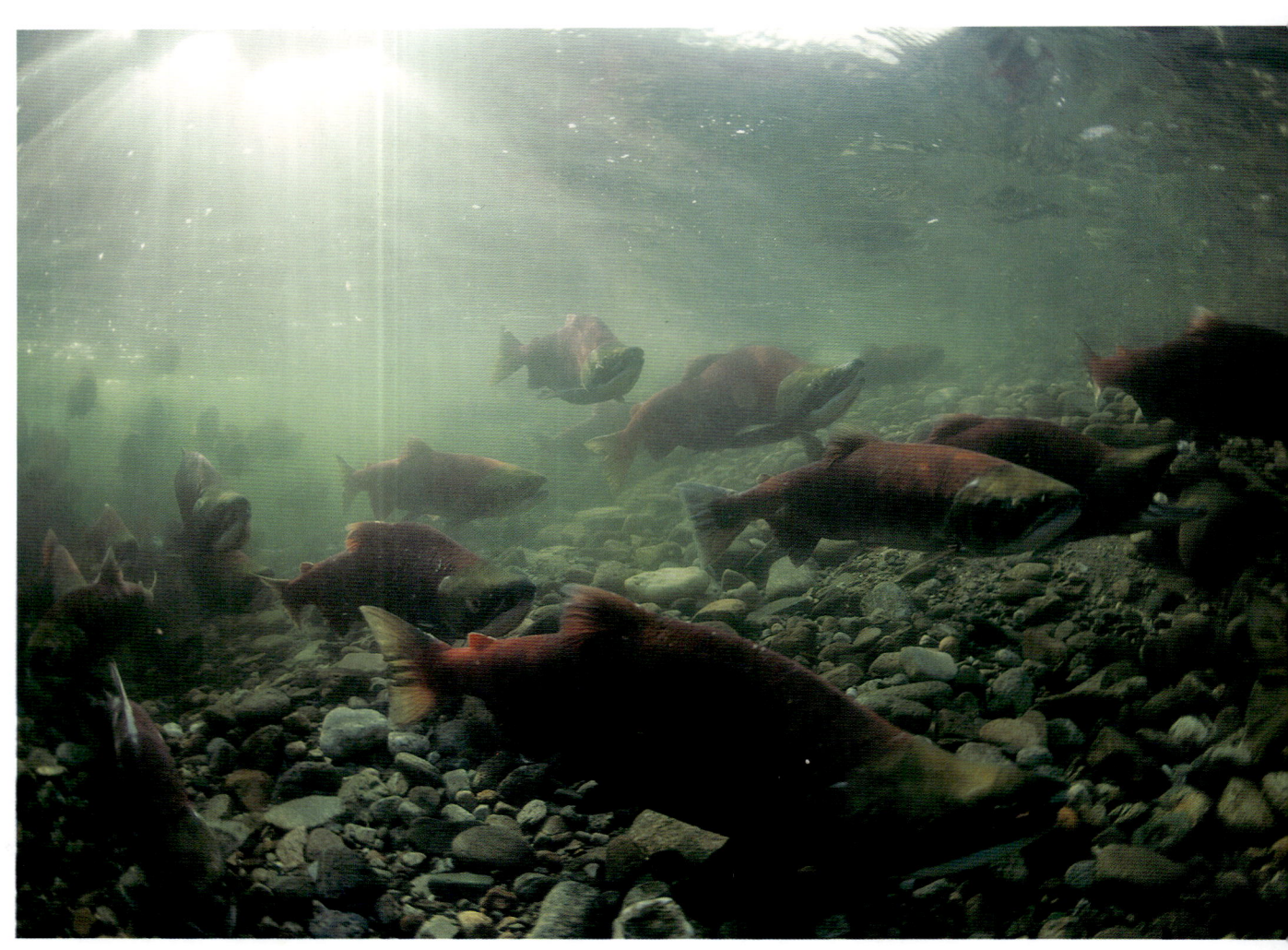

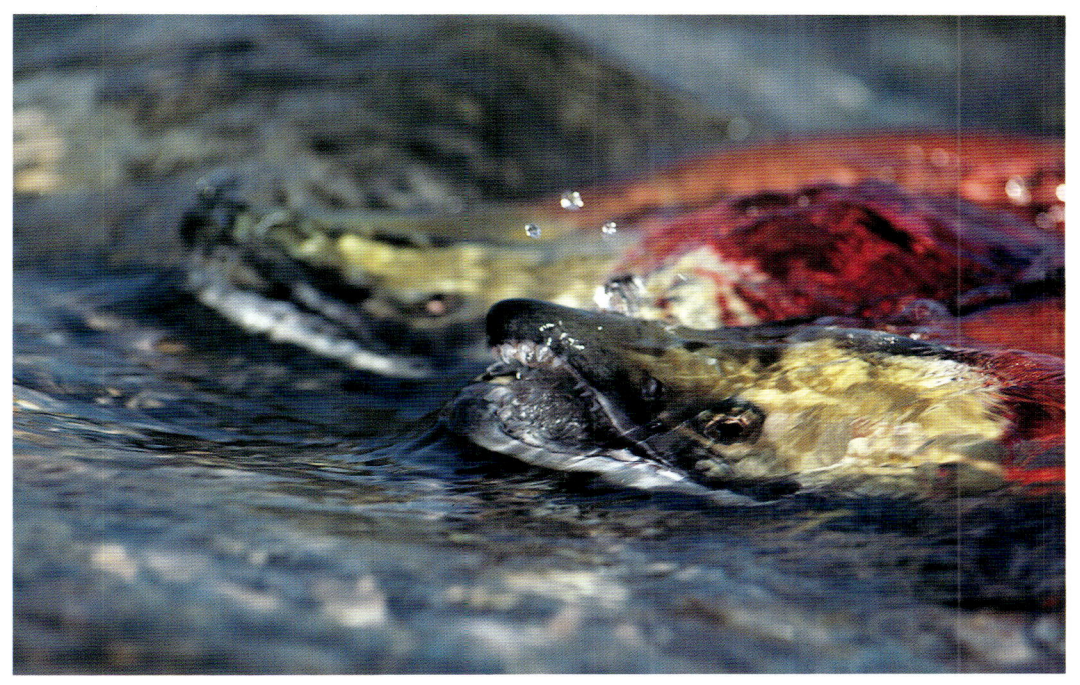

Above: Males establish dominance by displaying their long white lower jaws and hooked noses.

Left: Sockeye spread over the gravel bed looking for nest sites.

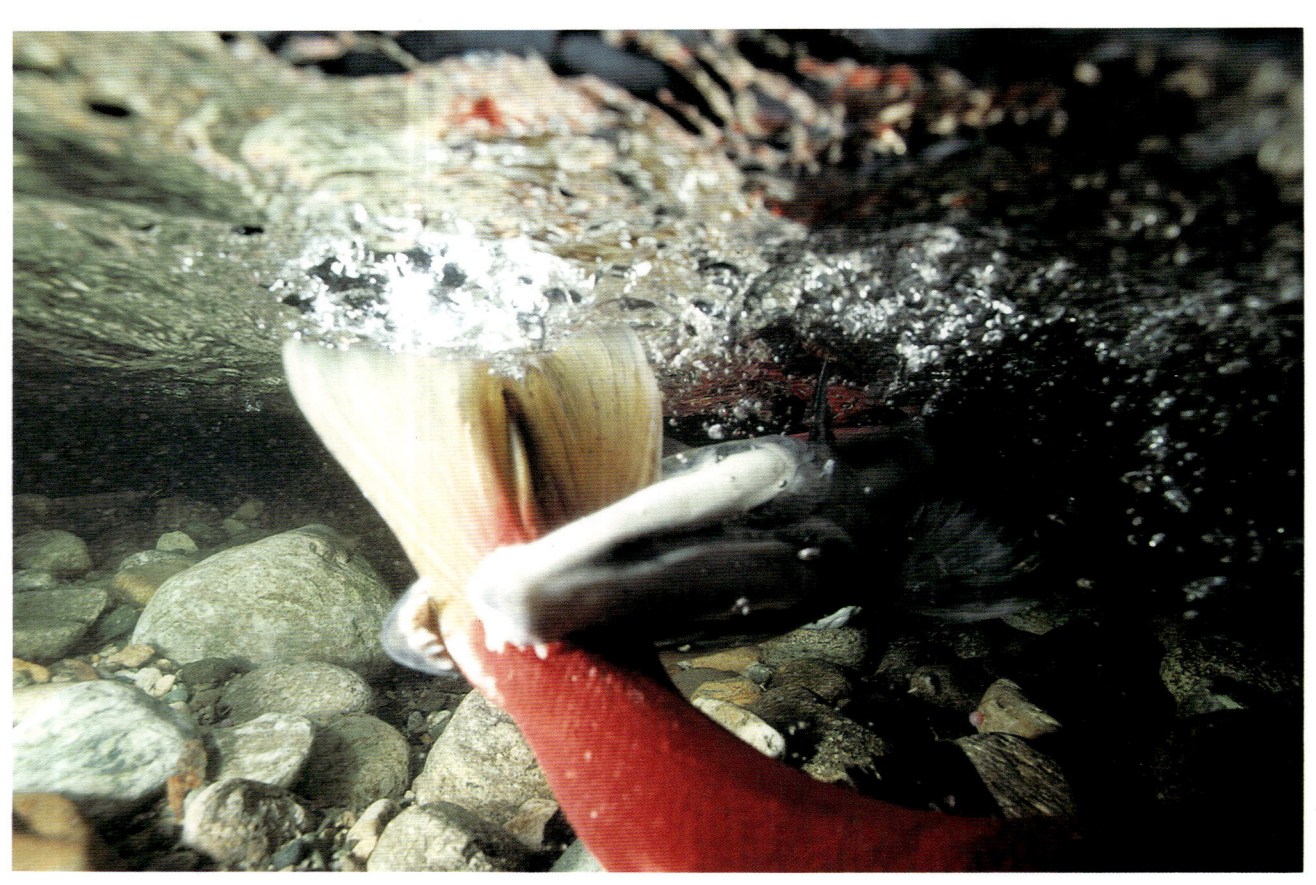

One male bites hard on the base of his rival's tail.

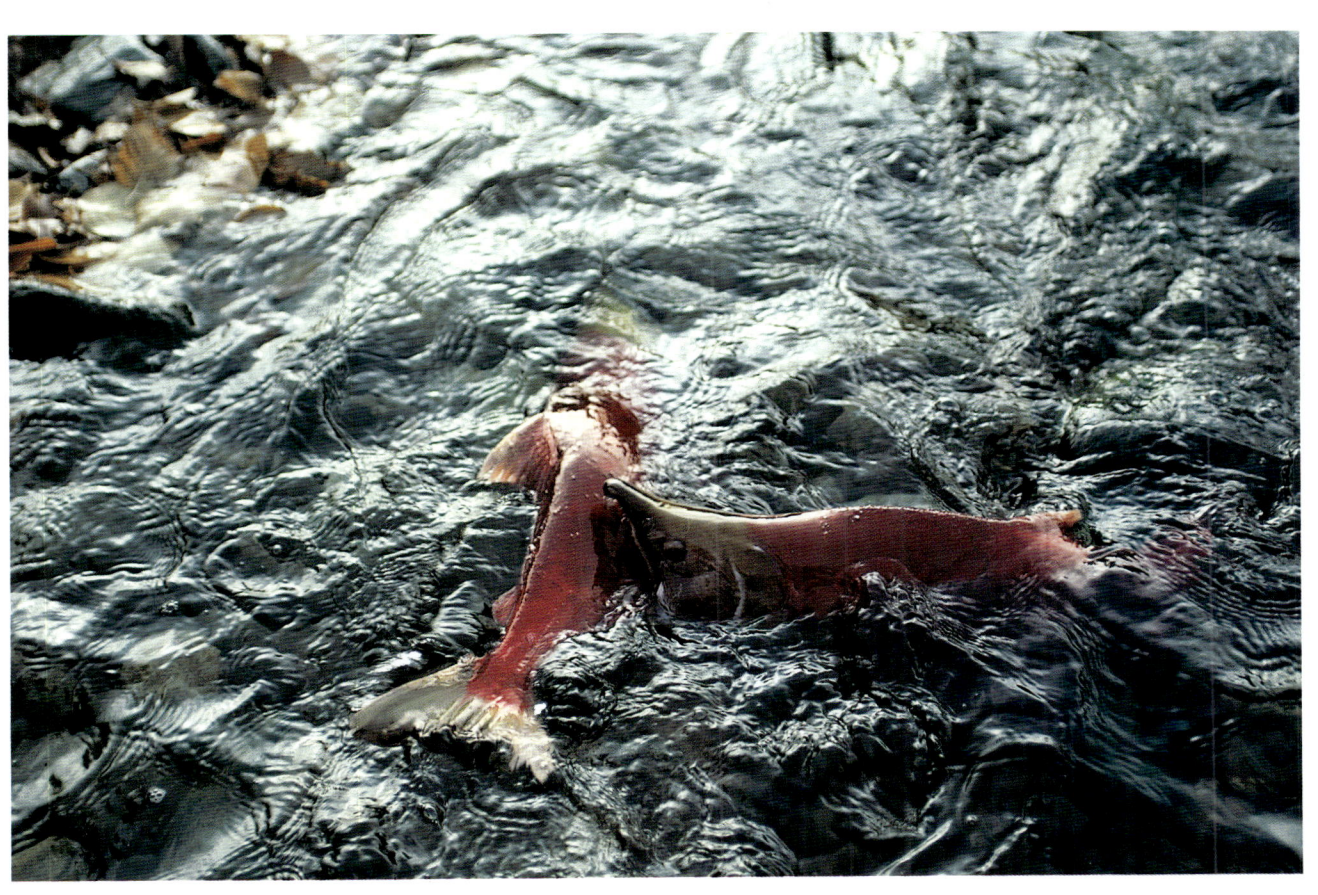

Short and surprisingly violent confrontations between males are seldom fatal.

Typically, only males of equal size and strength do battle.

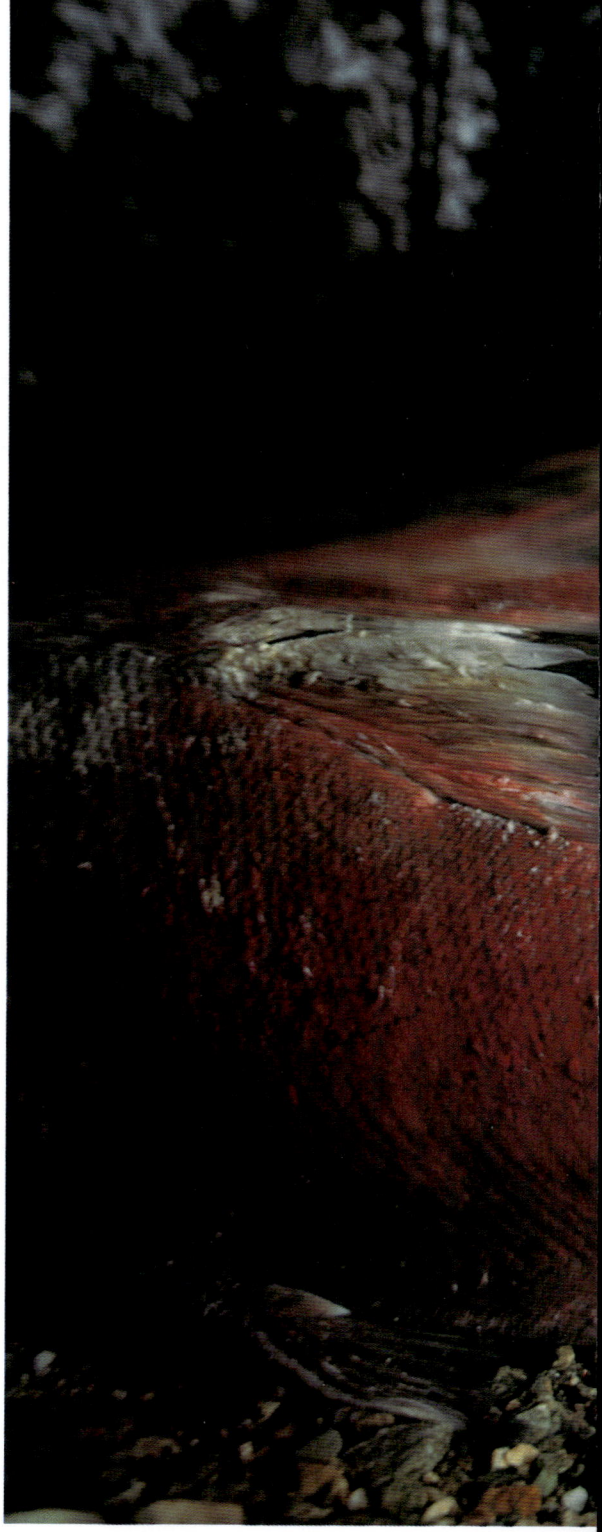

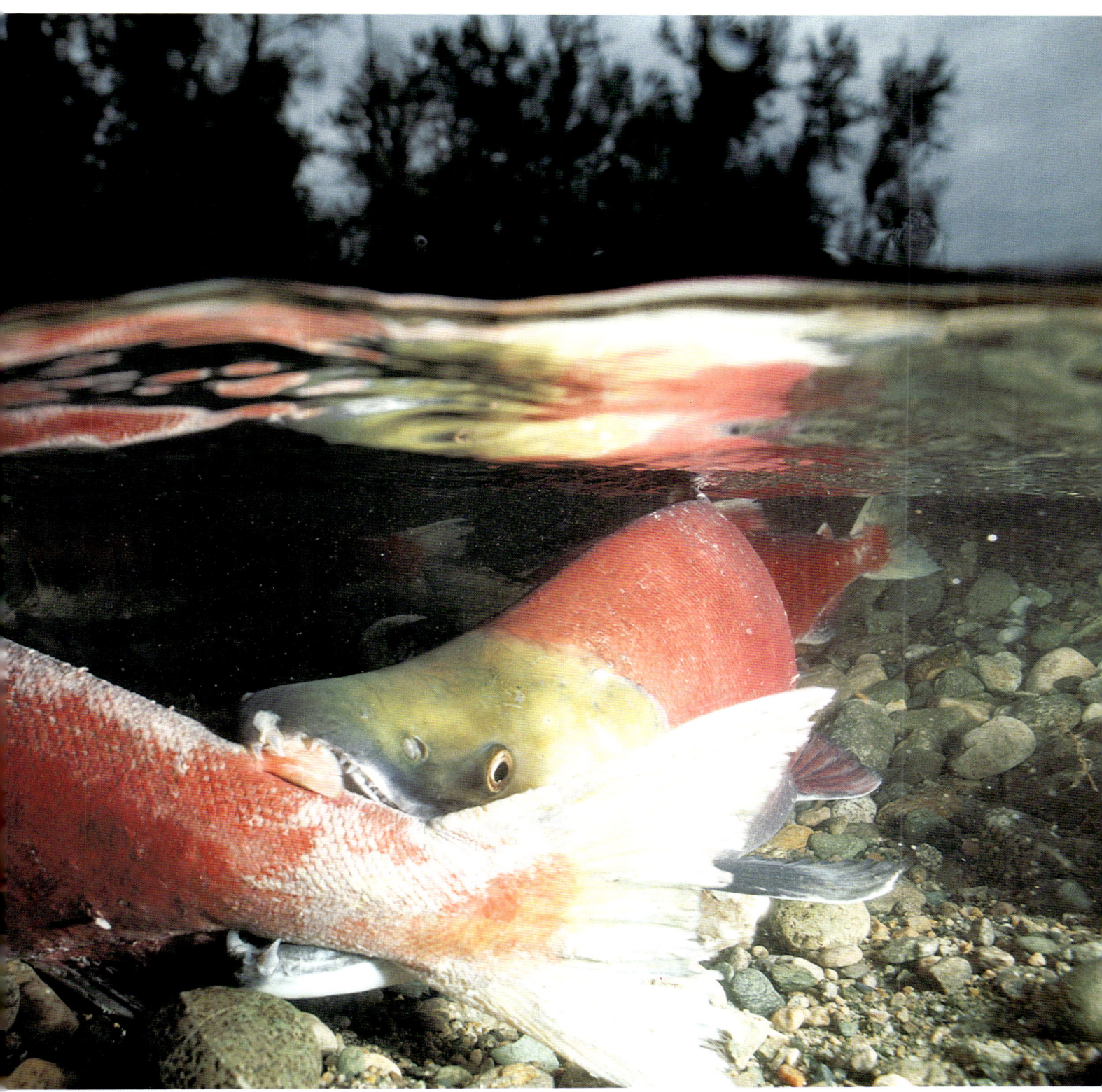

Even when a male has paired with a female, he will continue to joust and spar with intruding males as he protects not only his mate but also the spawning site that she has chosen.

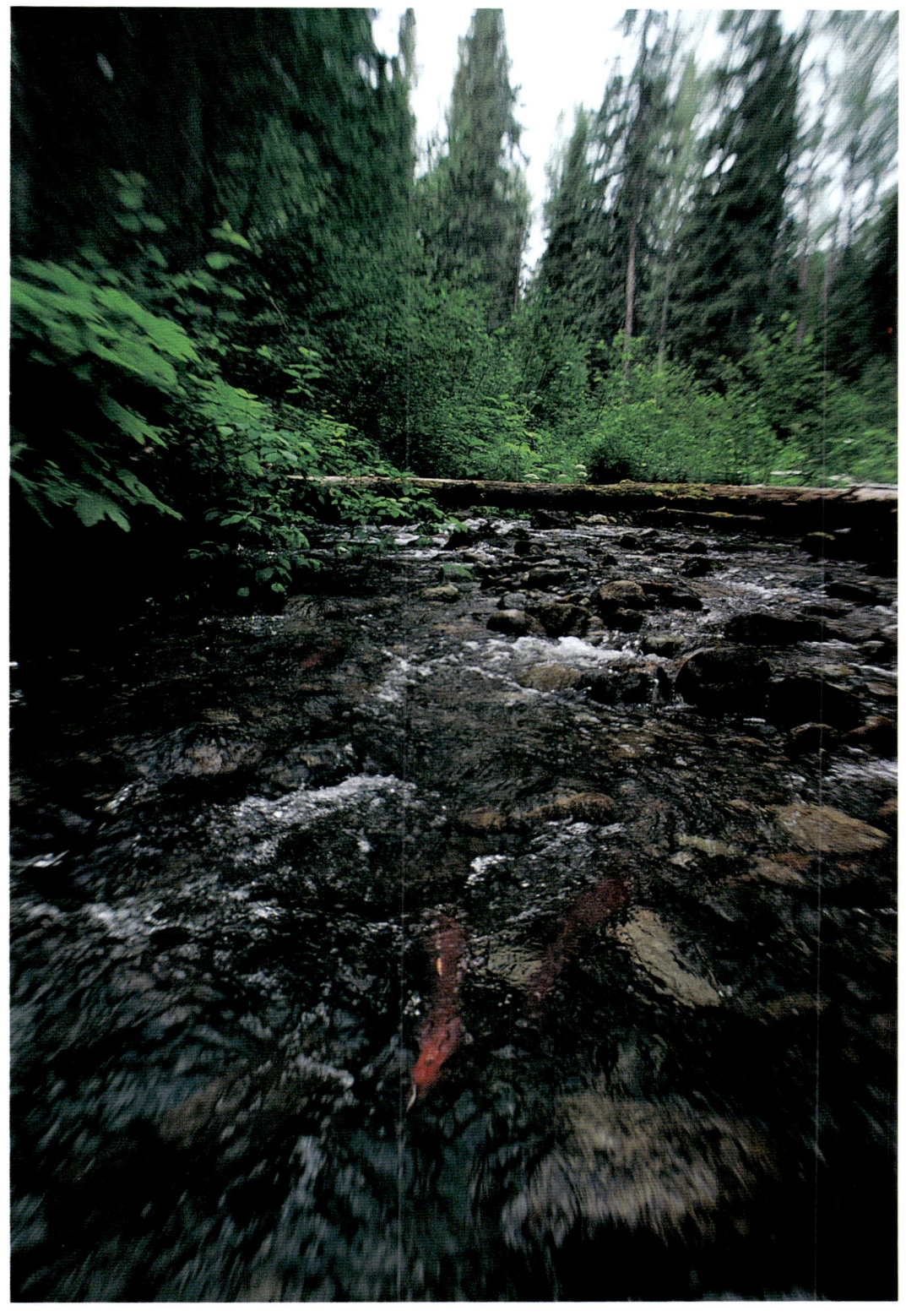

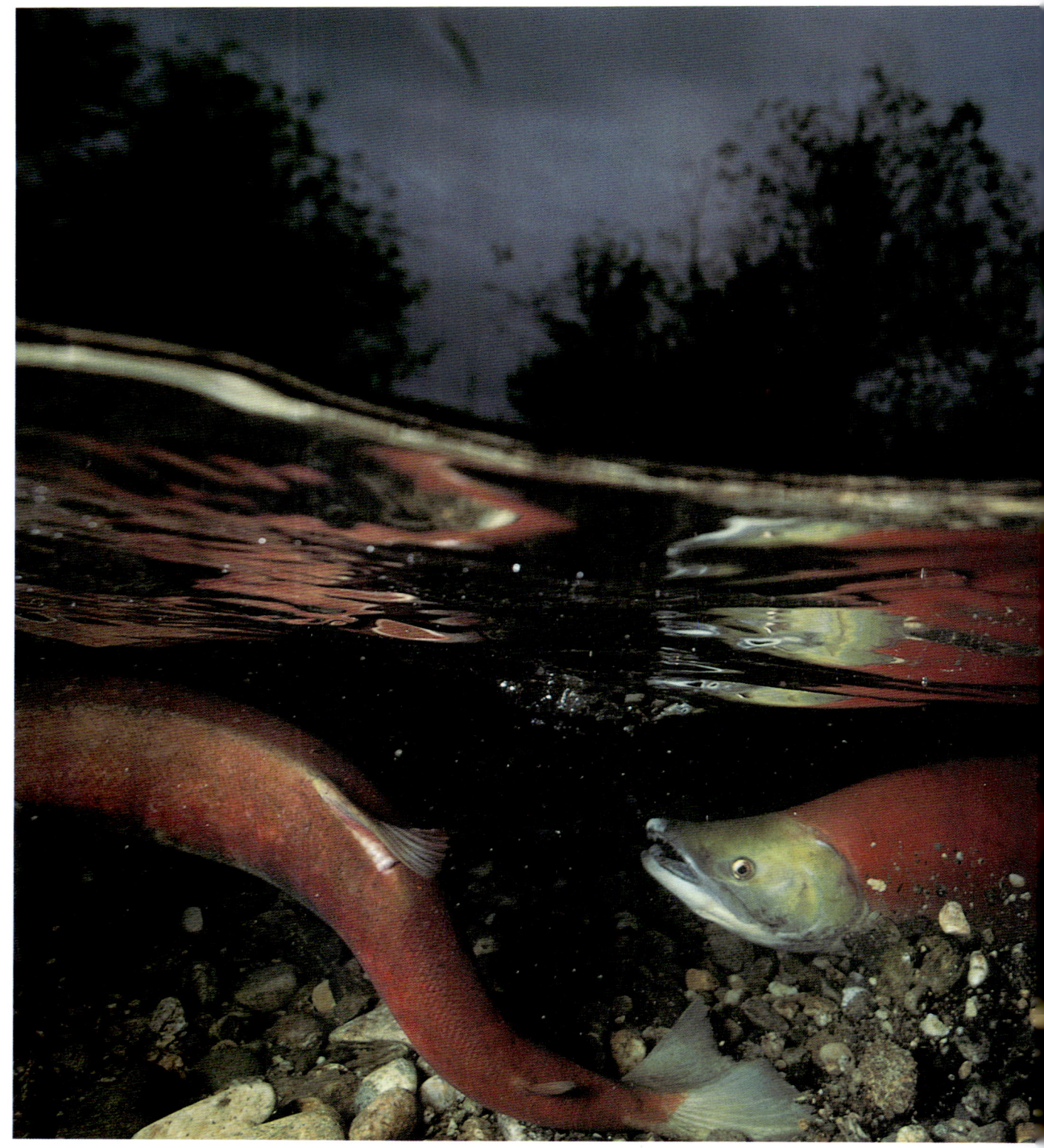

With powerful thrusts of her tail, a female throws gravel into the stream as she digs the nest, or redd.

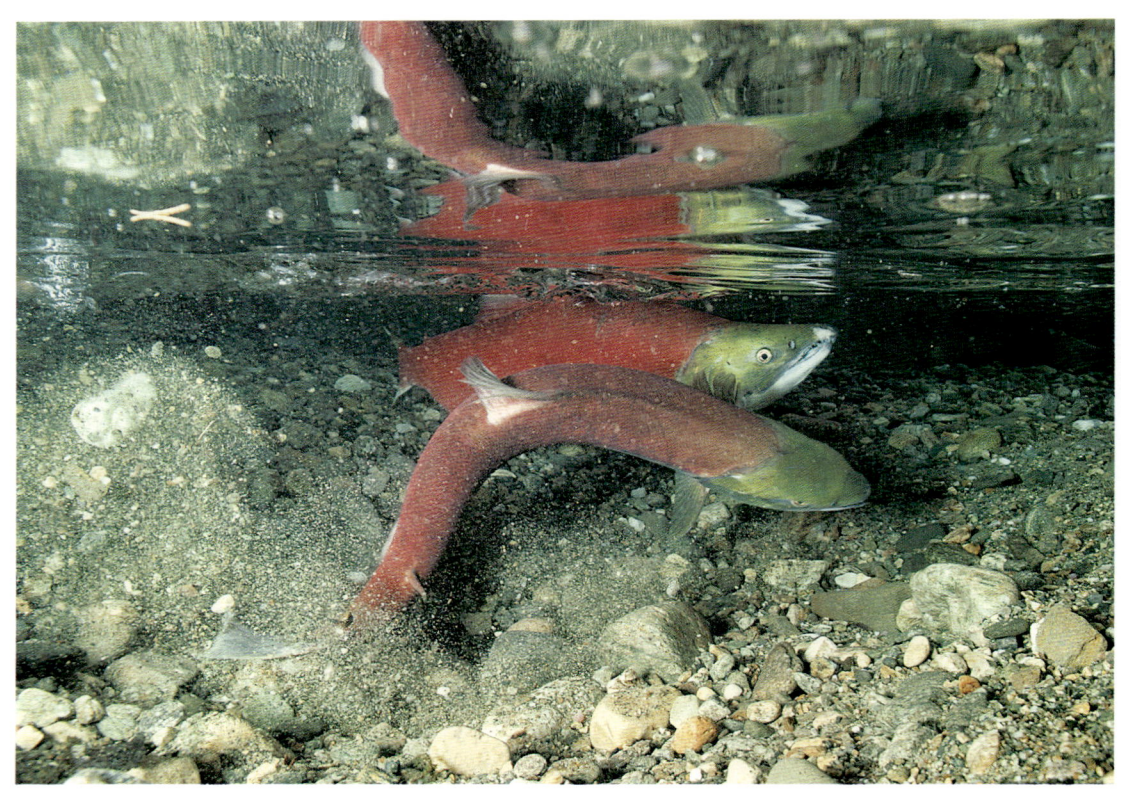

Except for periodic bursts of digging to mark a chosen site and female, the male stands guard while his mate undertakes the arduous task of excavating a depression for the nest.

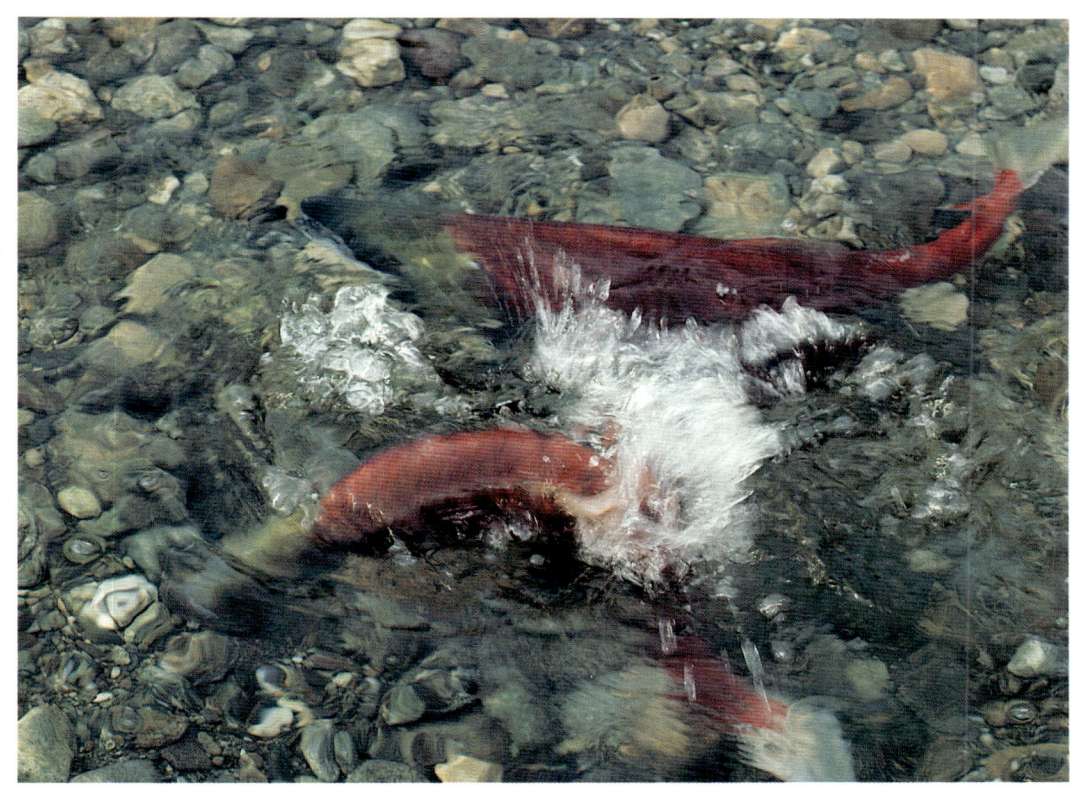

The female digs, stops and hovers over the depression, carefully measuring its size with her fins, then digs and measures again until she is satisfied that the redd is perfect.

Actual spawning lasts only seconds each time. A cloud of milt from the male is released as the female deposits her eggs.

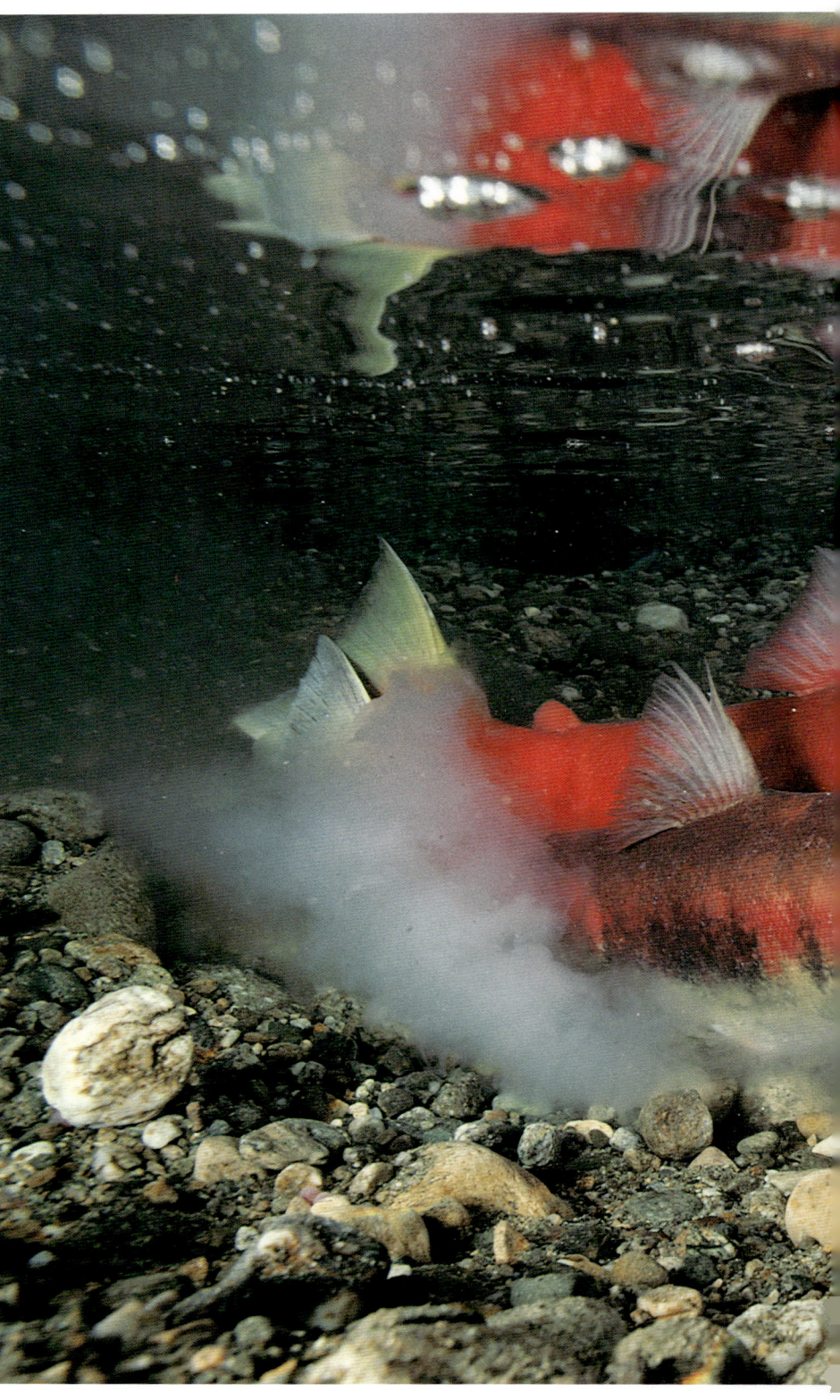

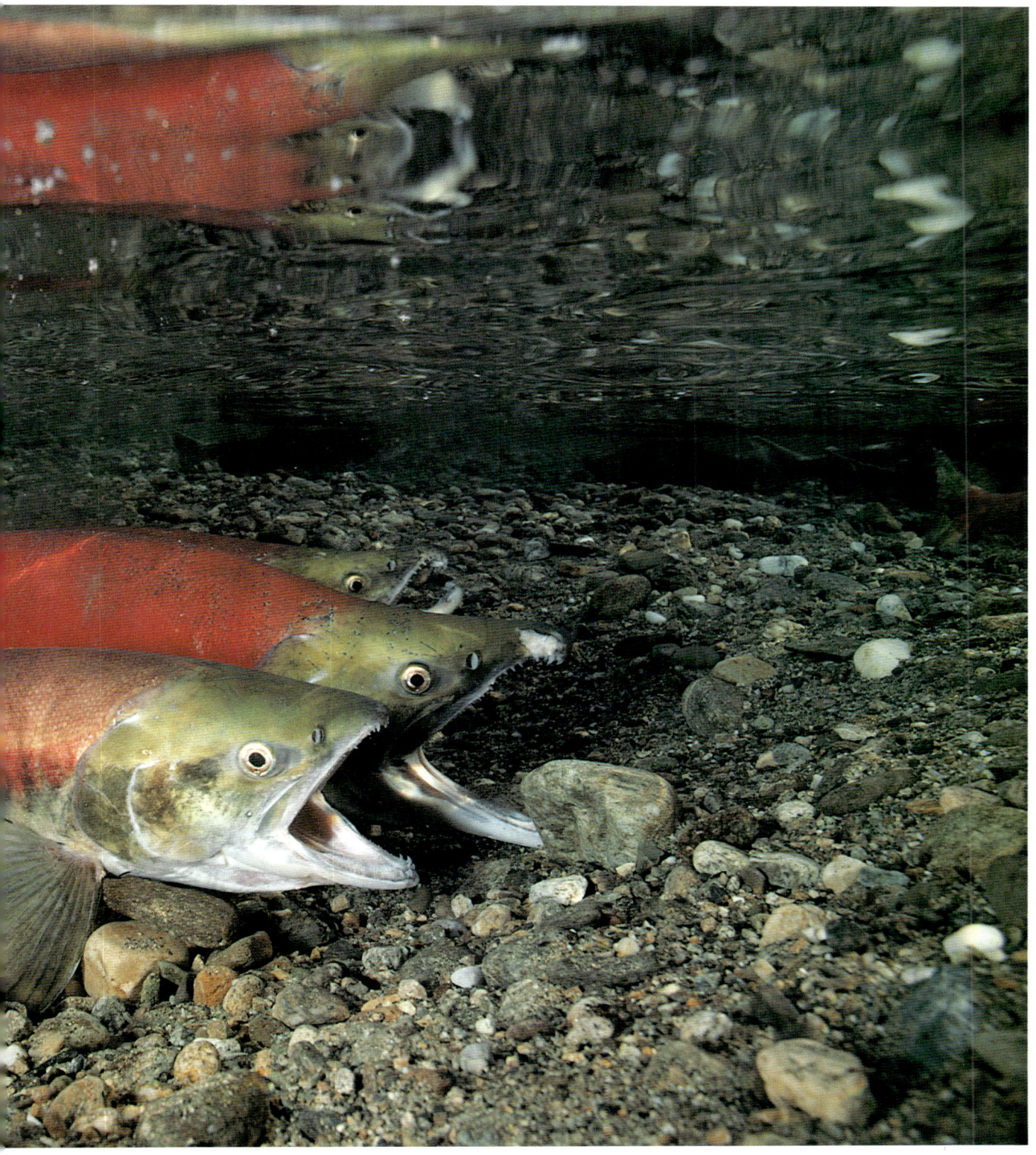

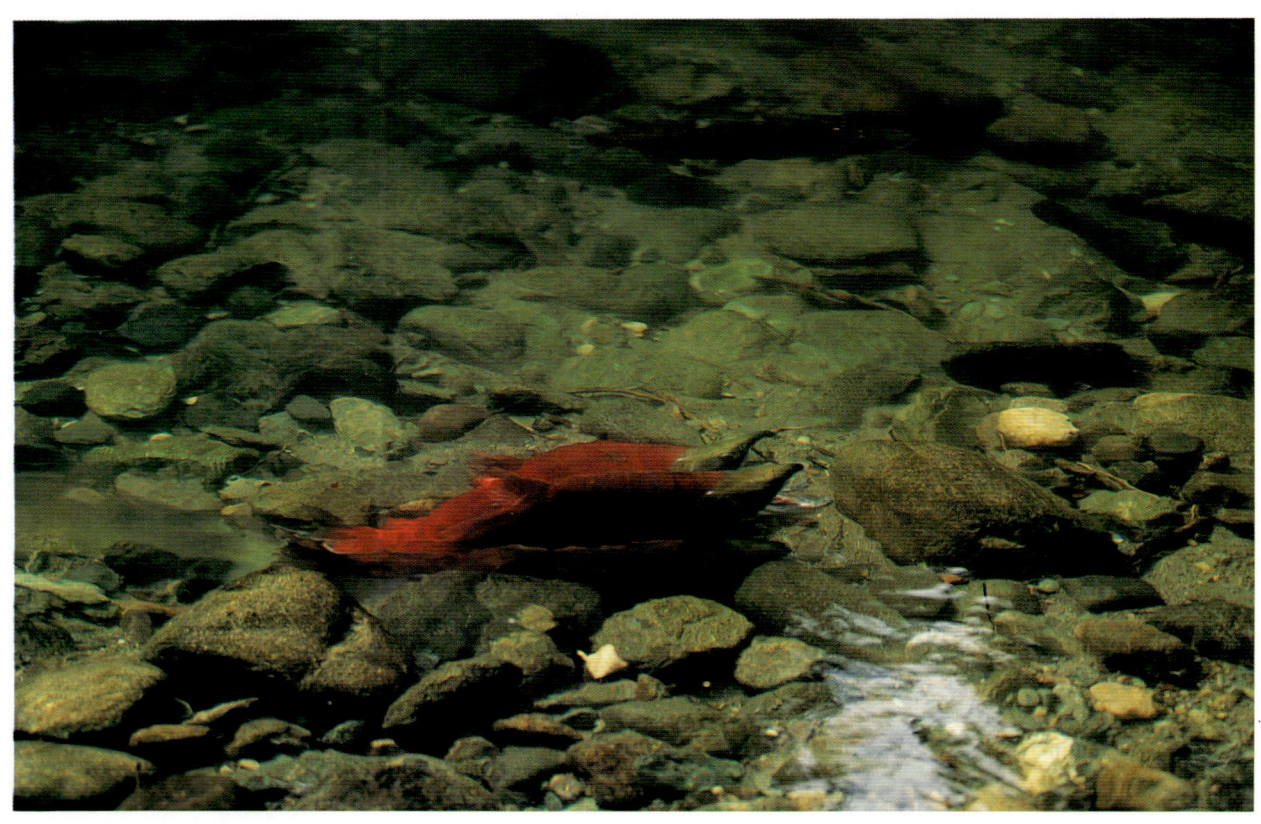

A three-way spawn occurs when a smaller subordinate male quickly slips beside the pair. Both males release sperm simultaneously to fertilize the female's eggs.

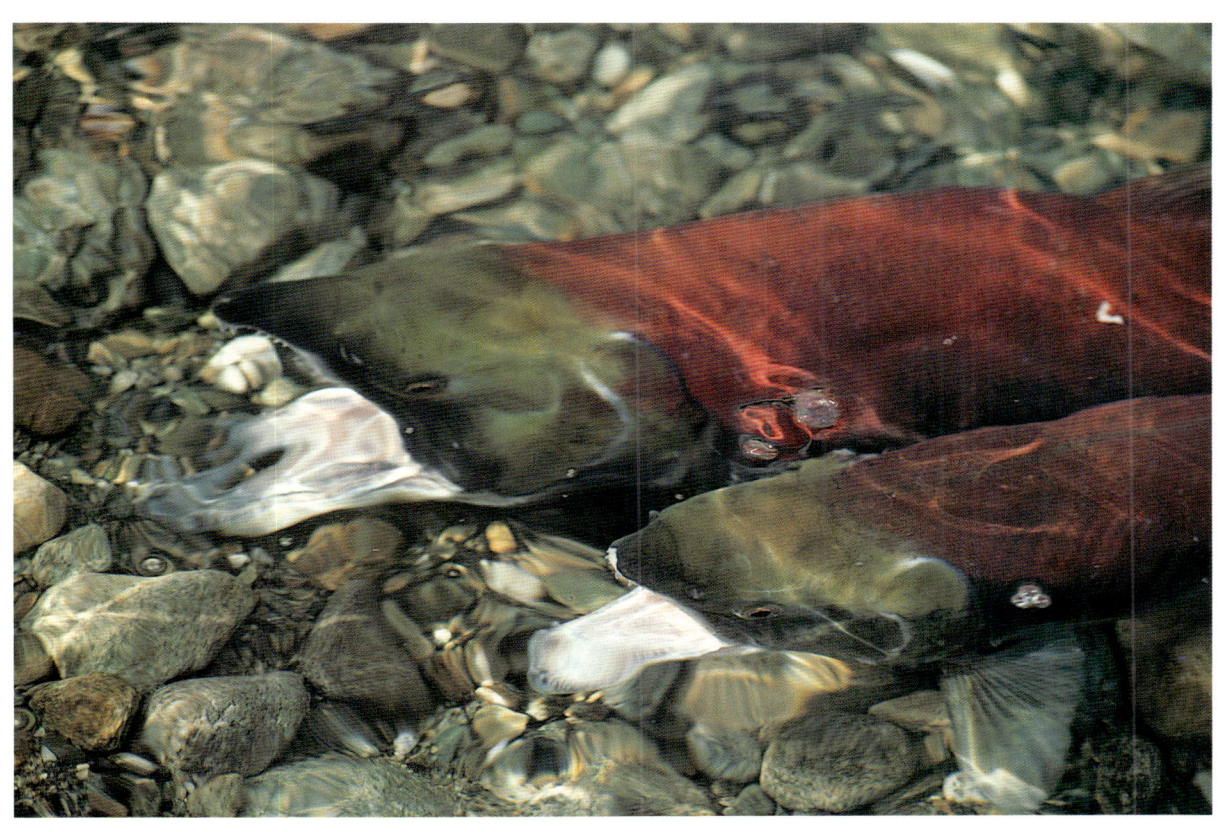

The partners settle into the redd, bodies quivering and mouths agape as spawning takes place.

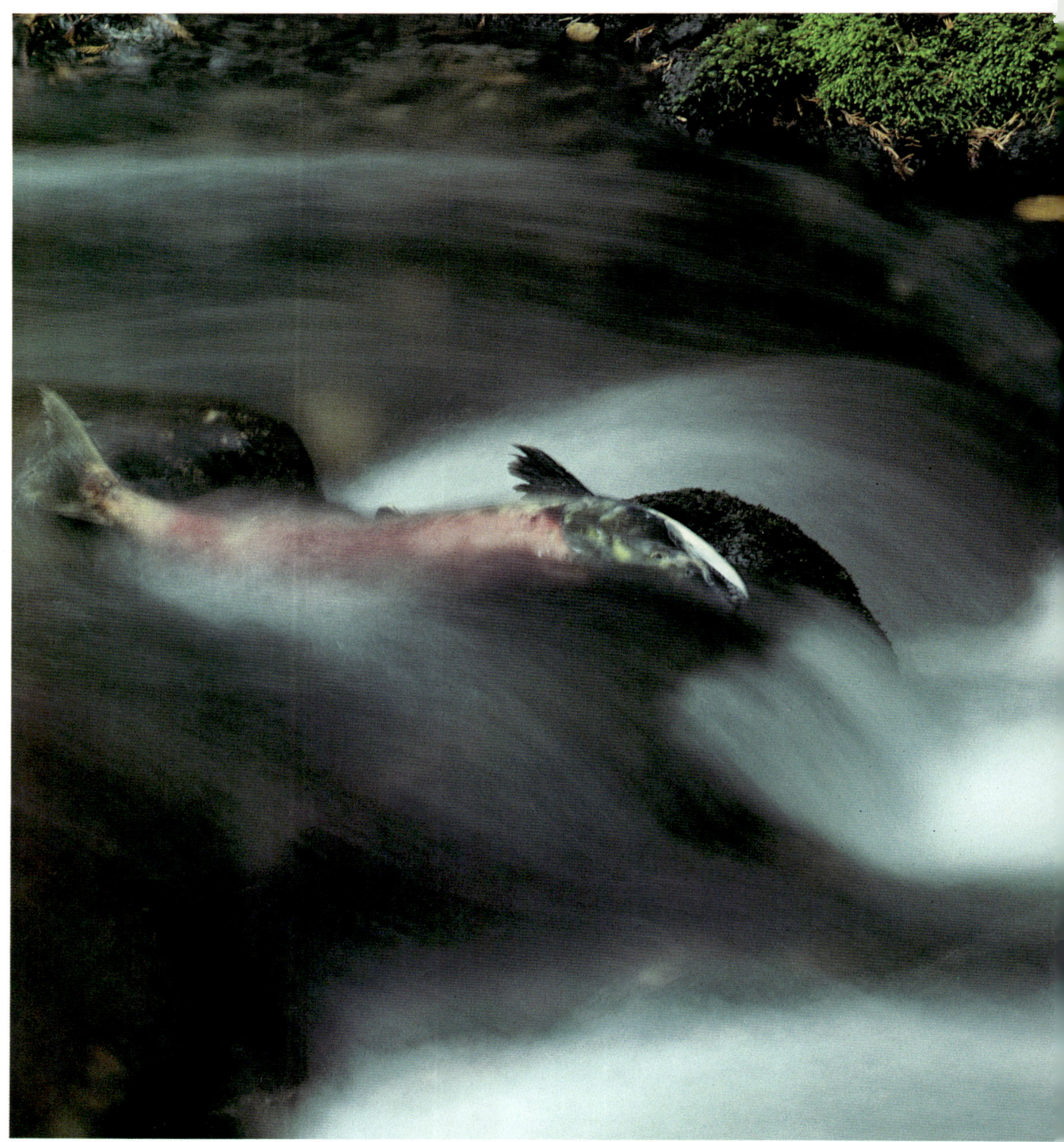

Death comes quickly after spawning. The body of a spawned-out male lies stranded in the stream where his own life began.

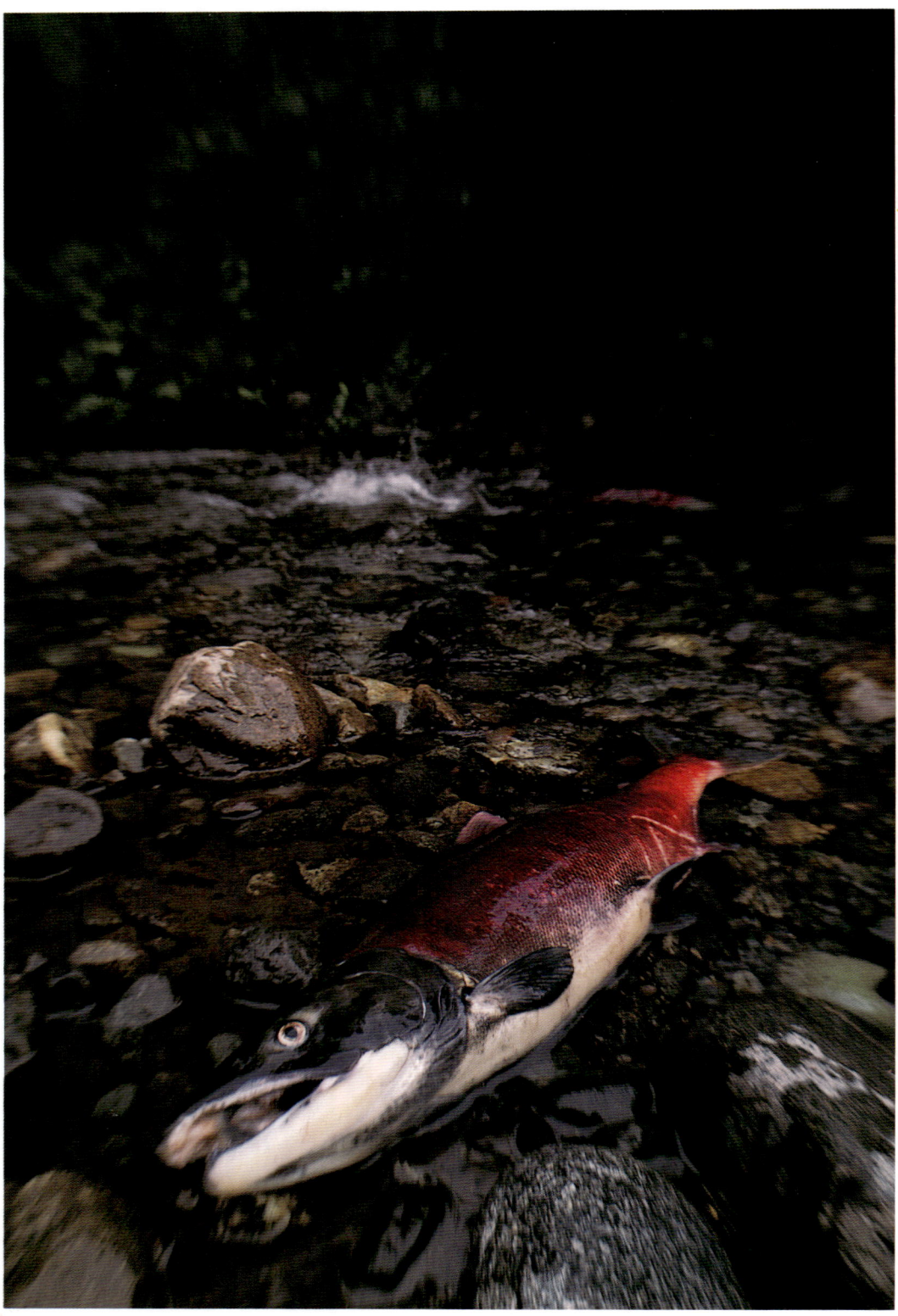

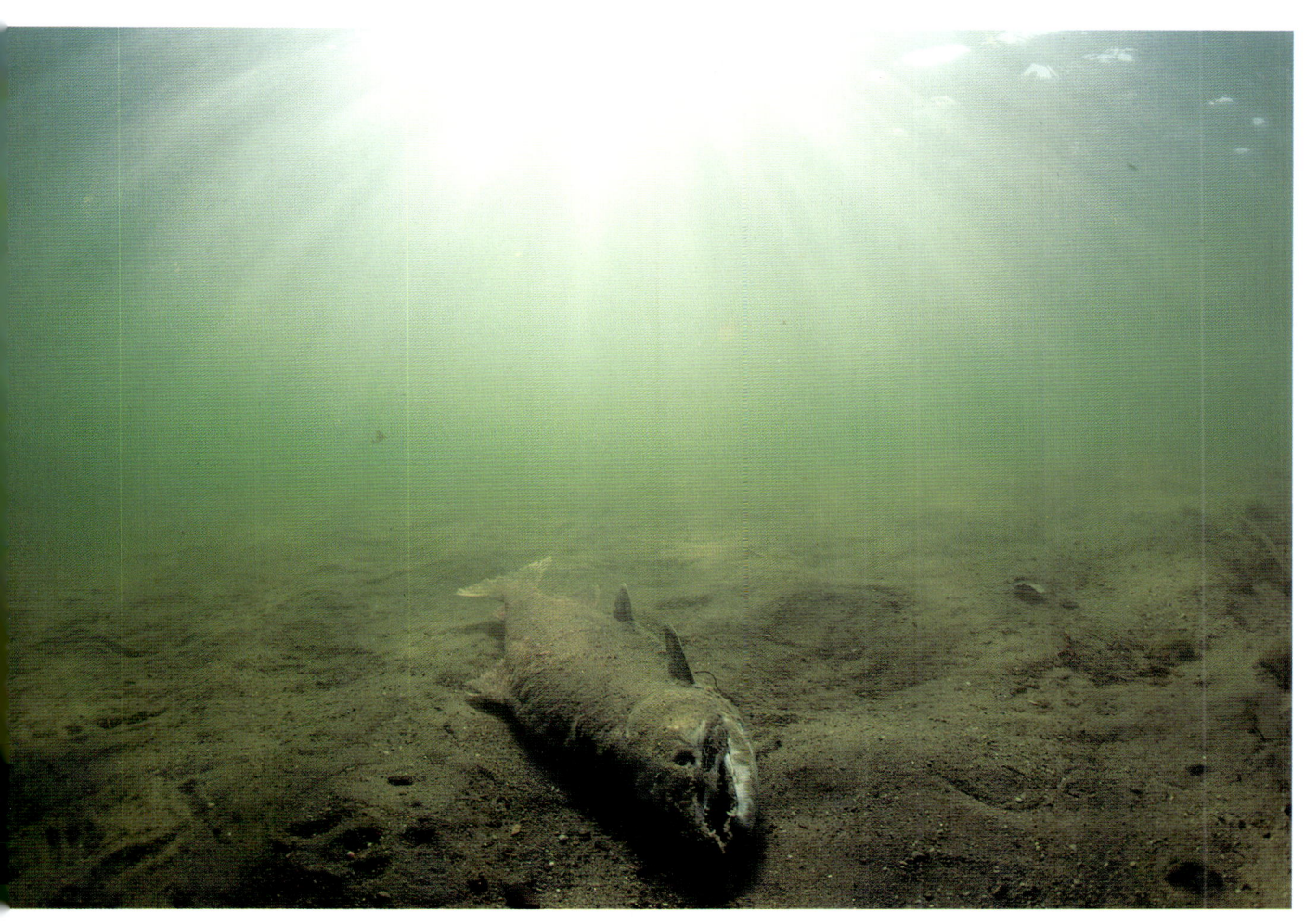

Above: The adult's life is over, but the promise of future generations lies buried in gravel nests.

Left: A late spawner makes his way upstream past a carcass on the stream bank.

Nutrients from the decomposing bodies of dead salmon are taken back into the intricate food web of the nursery lake.

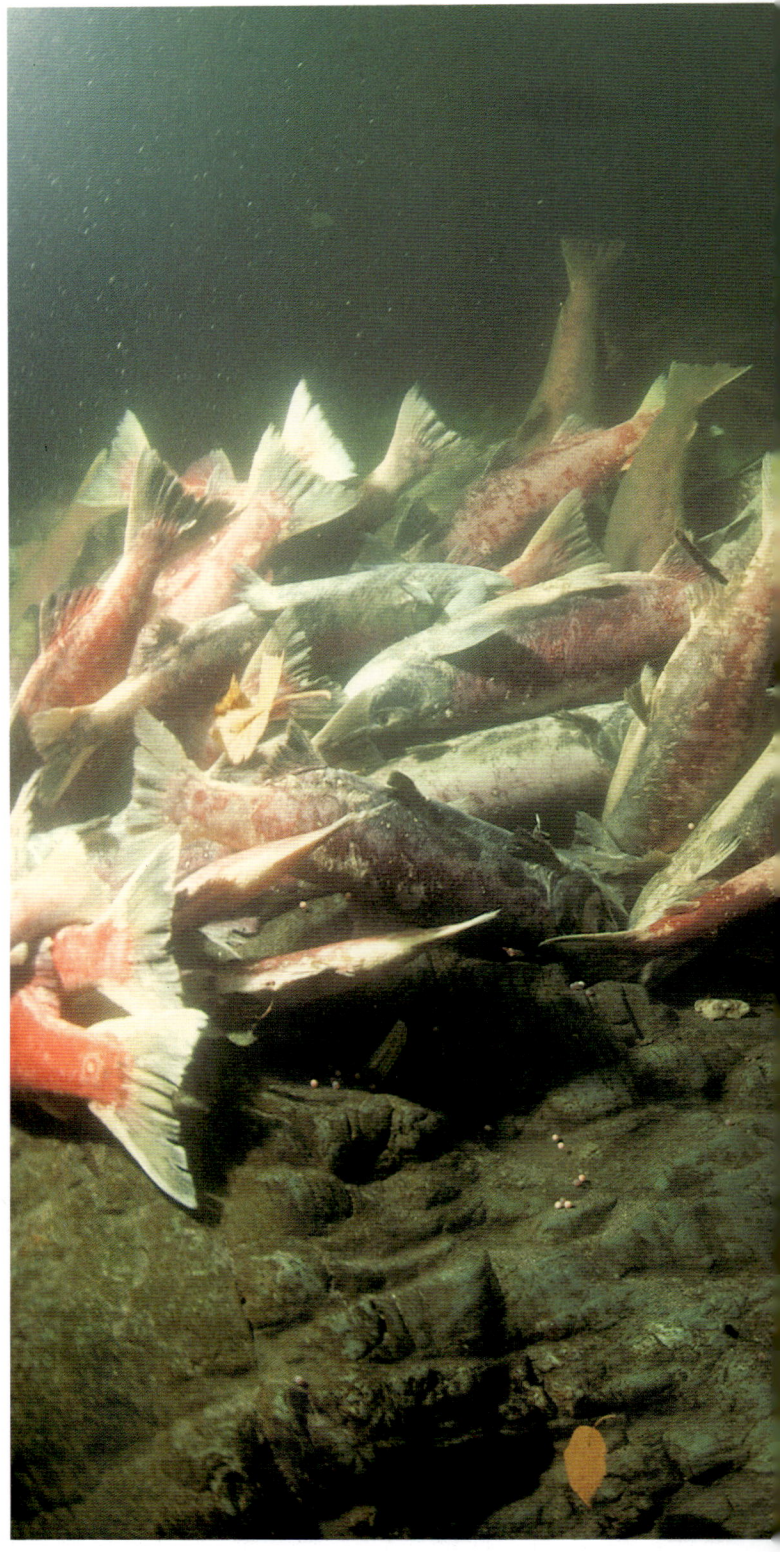

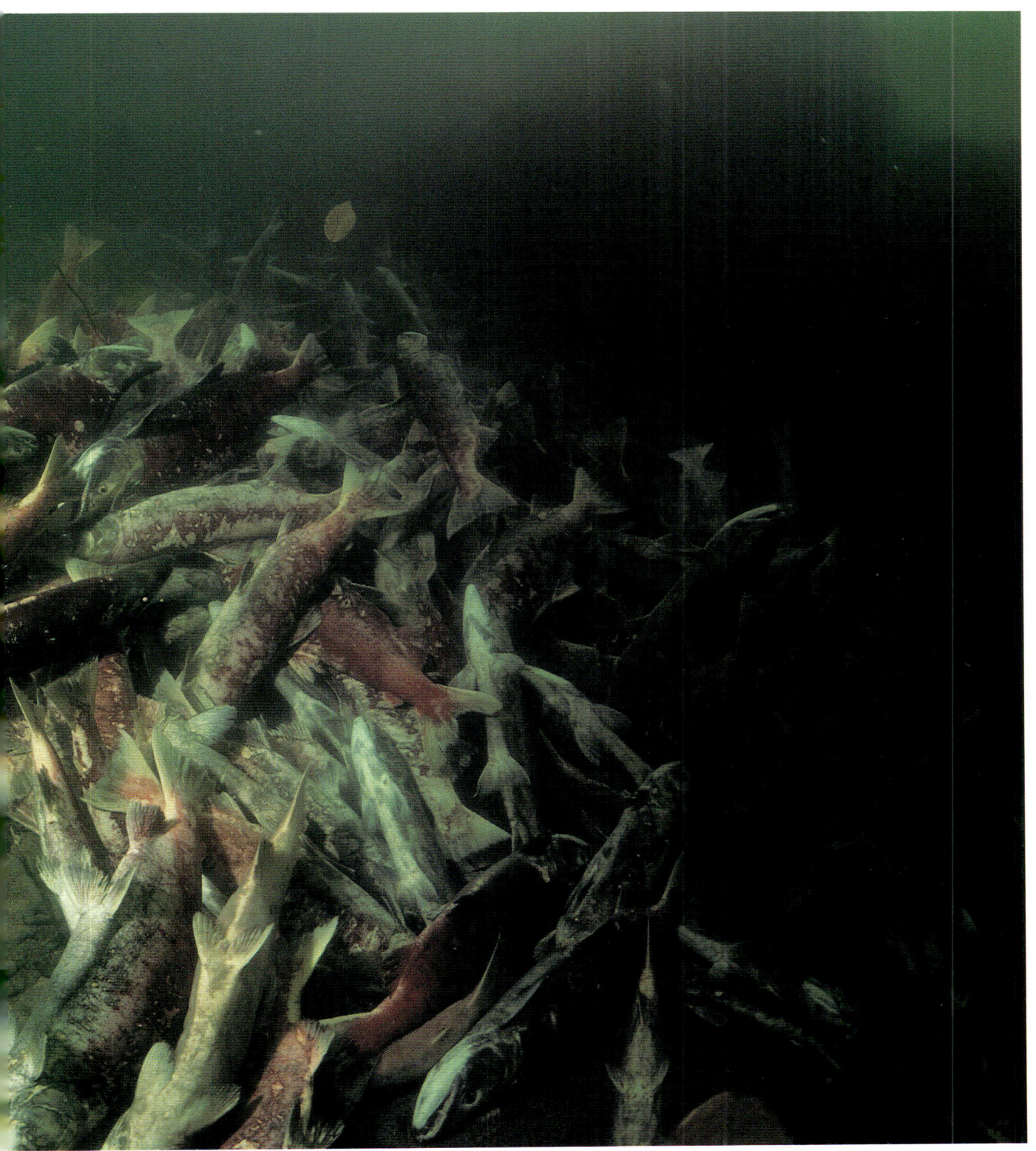

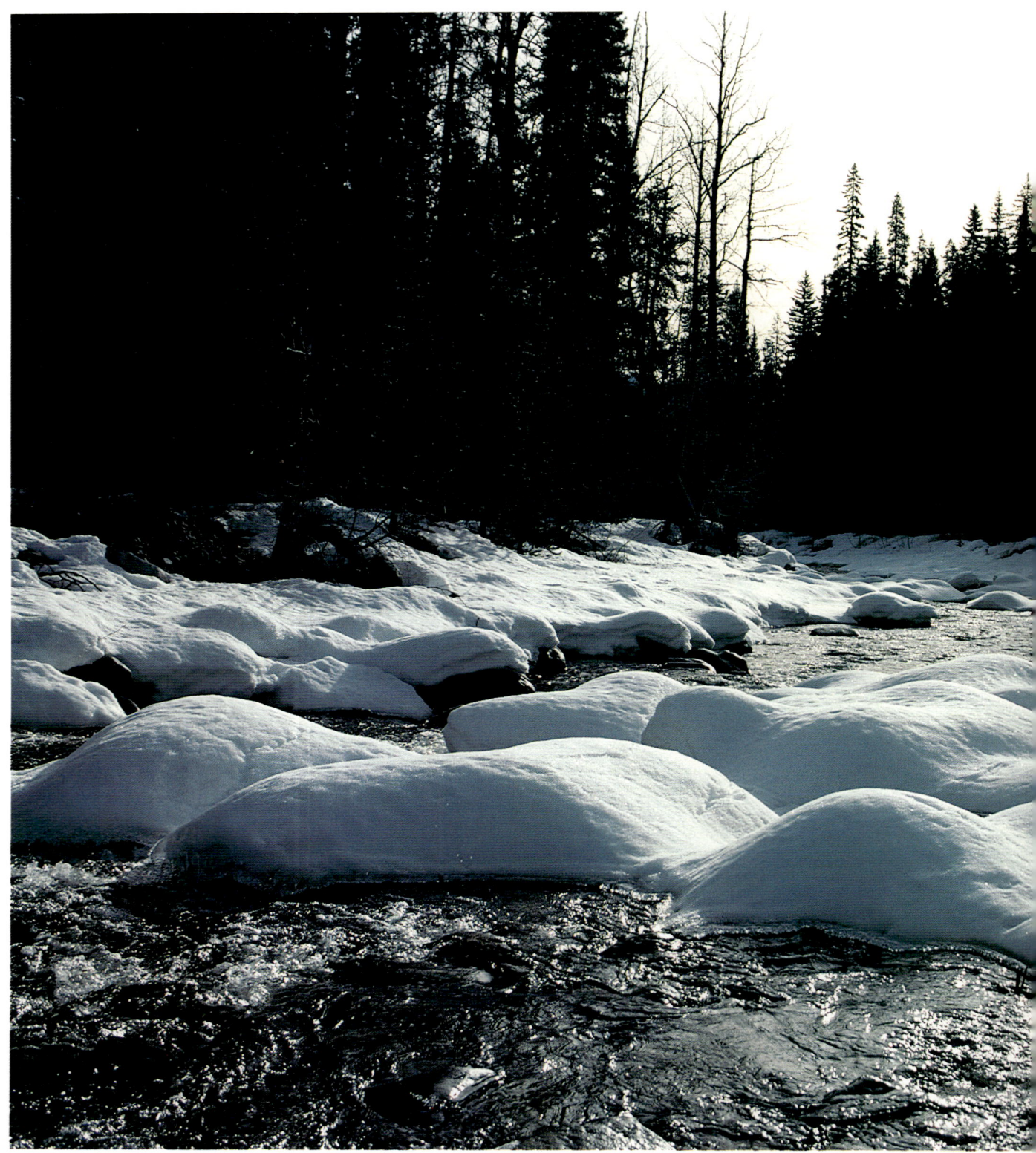

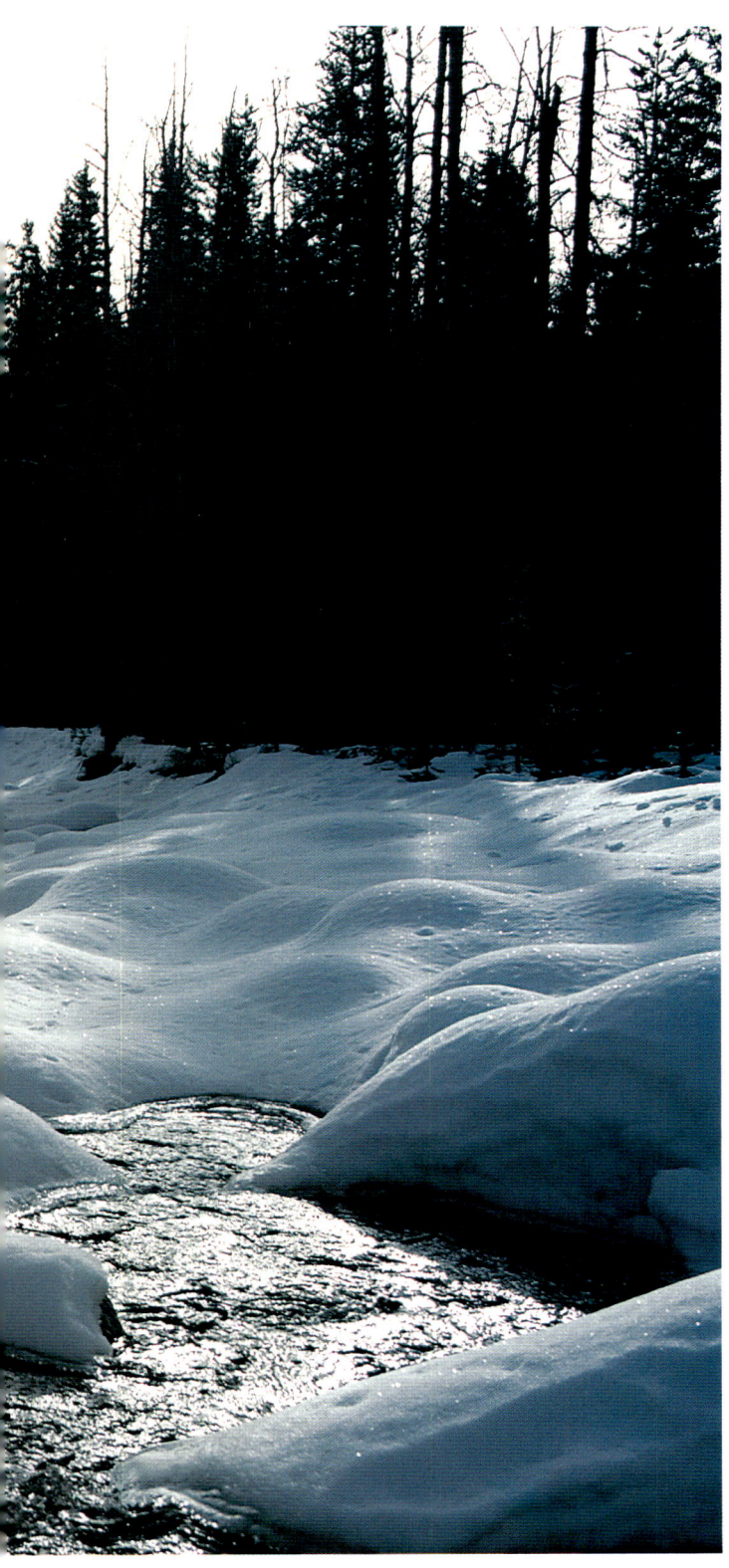

Beneath a winter blanket of snow and ice, oxygen-rich water bathes the developing eggs in the stream bed.

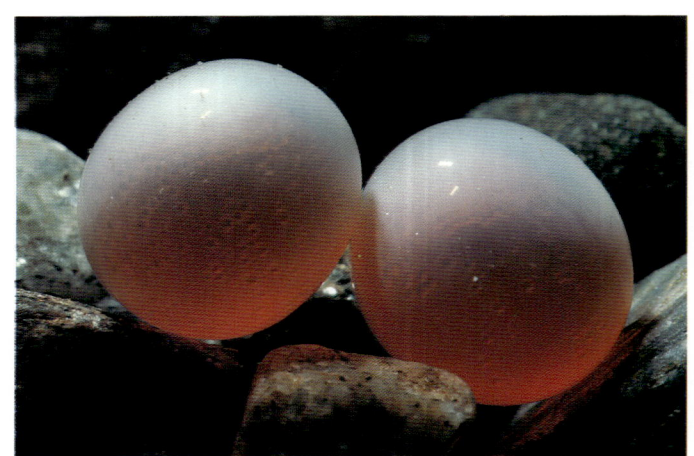 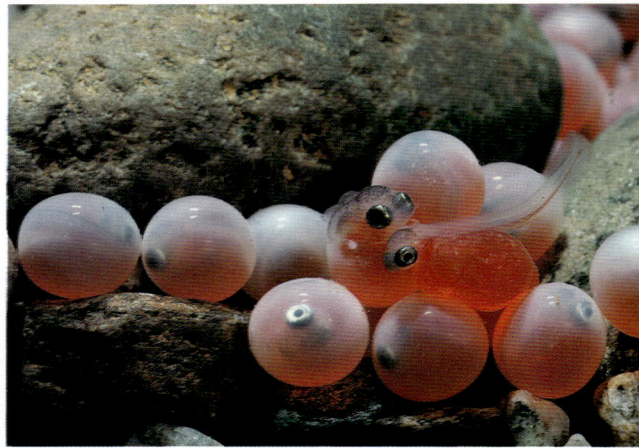

Each tiny orange globe will eventually develop into a splendid animal with a complex life history.

Tiny black and silver eyes appear in the developing embryo.

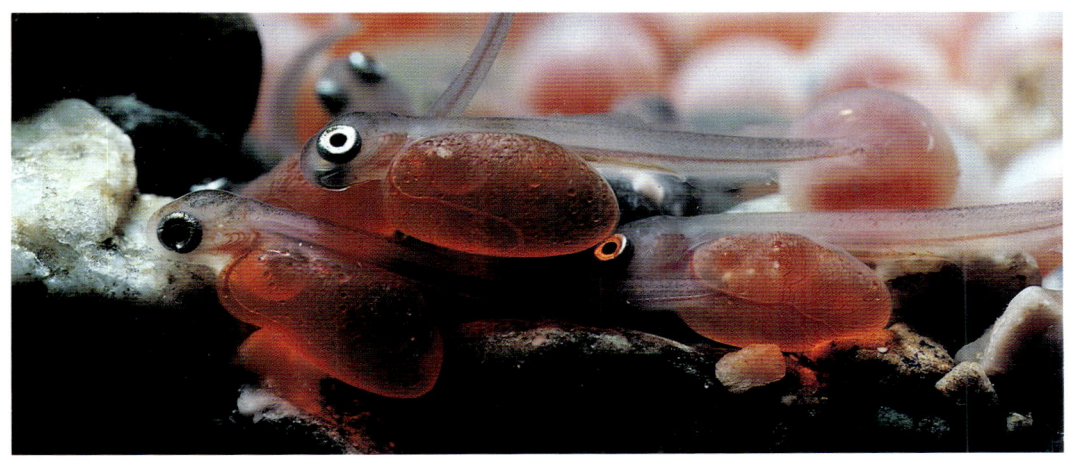

Newly hatched salmon, known as alevins, remain in the gravel, drawing nourishment from their orange yolk sacs.

All eyes and yolk sac, this alevin bears no resemblance to the fish it will someday become.

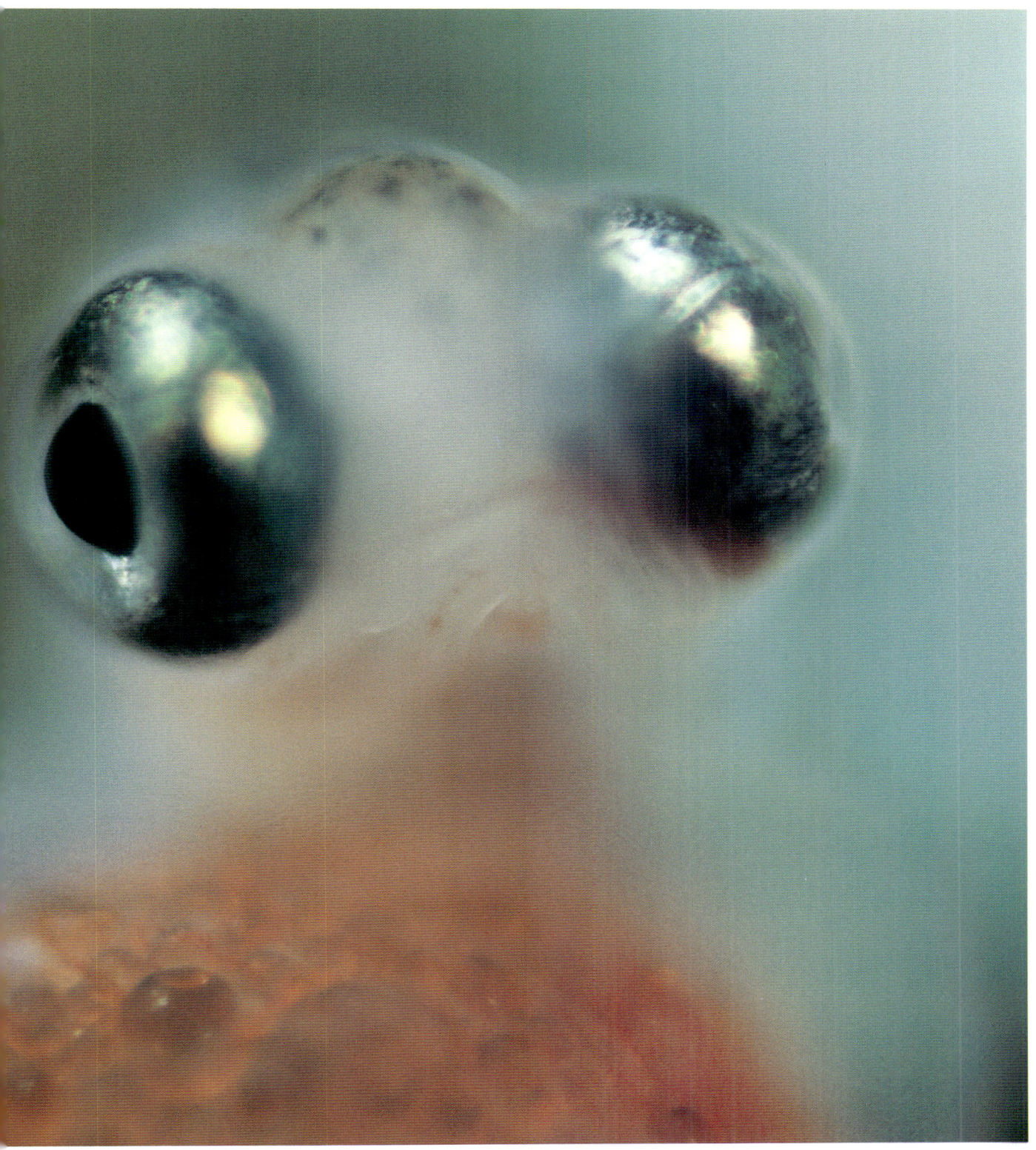

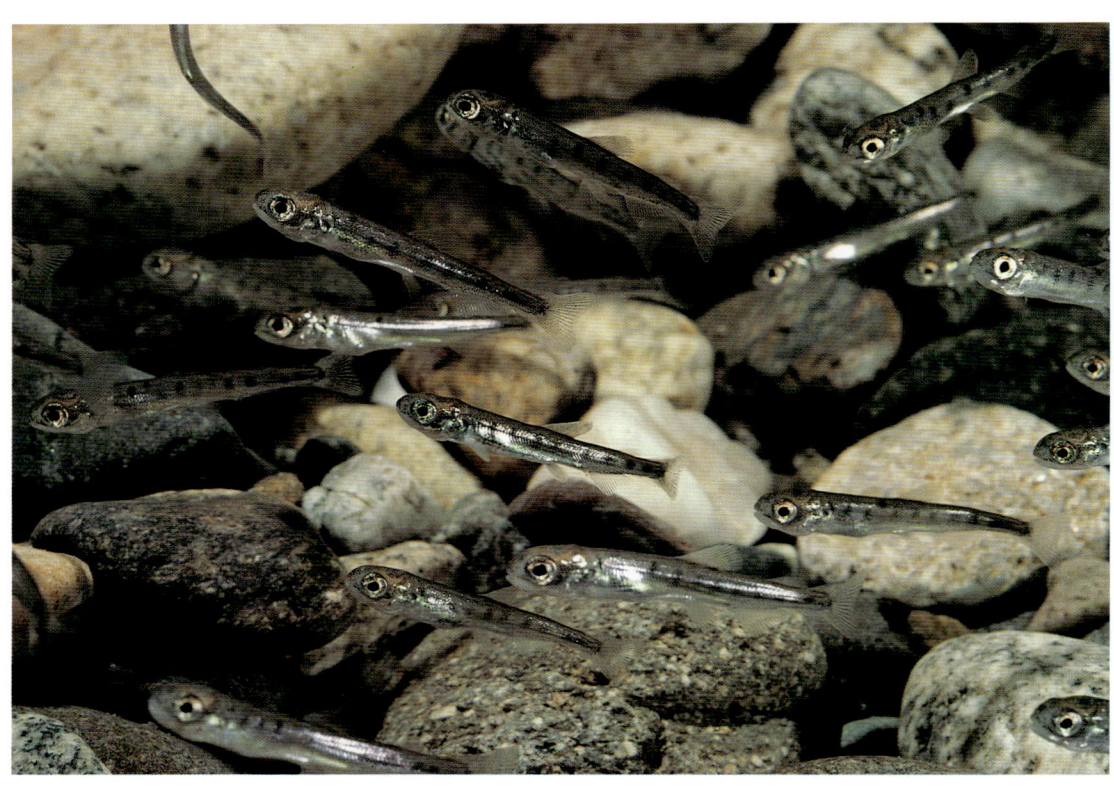

When the yolk sac is gone, the little fish, now called a fry, swims up through the gravel and into the stream to search for food.

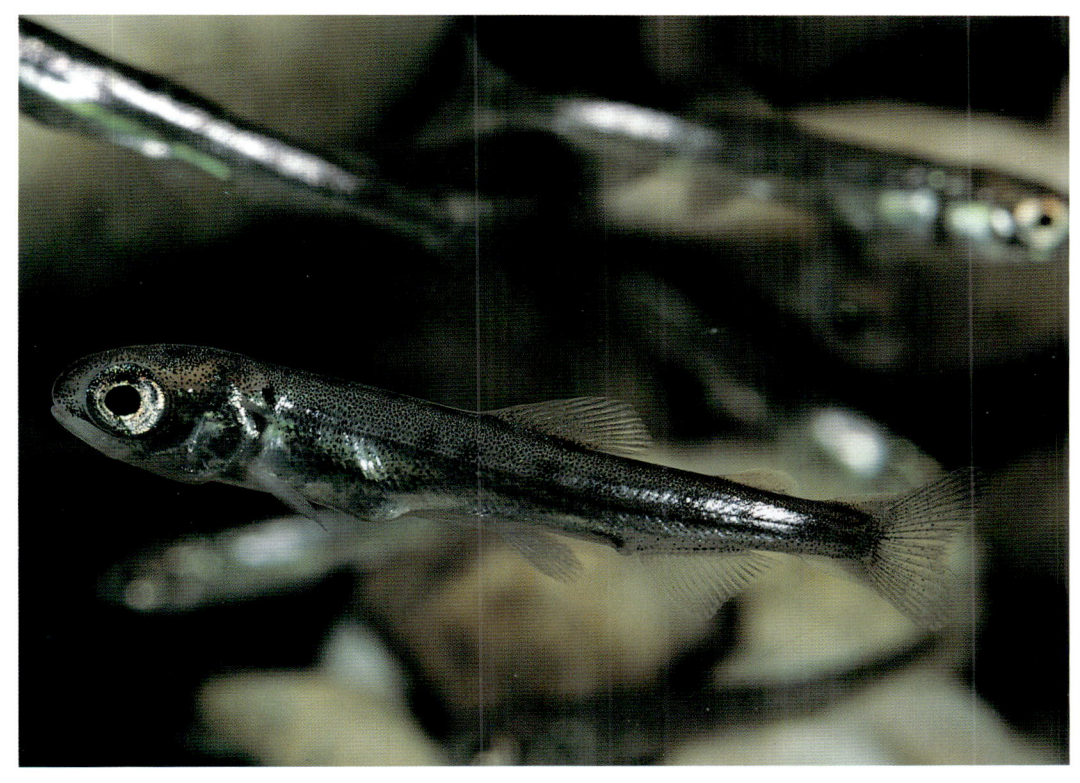

Dark bands or parr marks on the fry's silver sides help camouflage the fragile youngster.

Above: In their first spring, fry move downstream into nursery lakes, where they will feed and grow for a year.

Right: In their second spring, young sockeye begin their downstream migration to the sea under the cover of darkness.

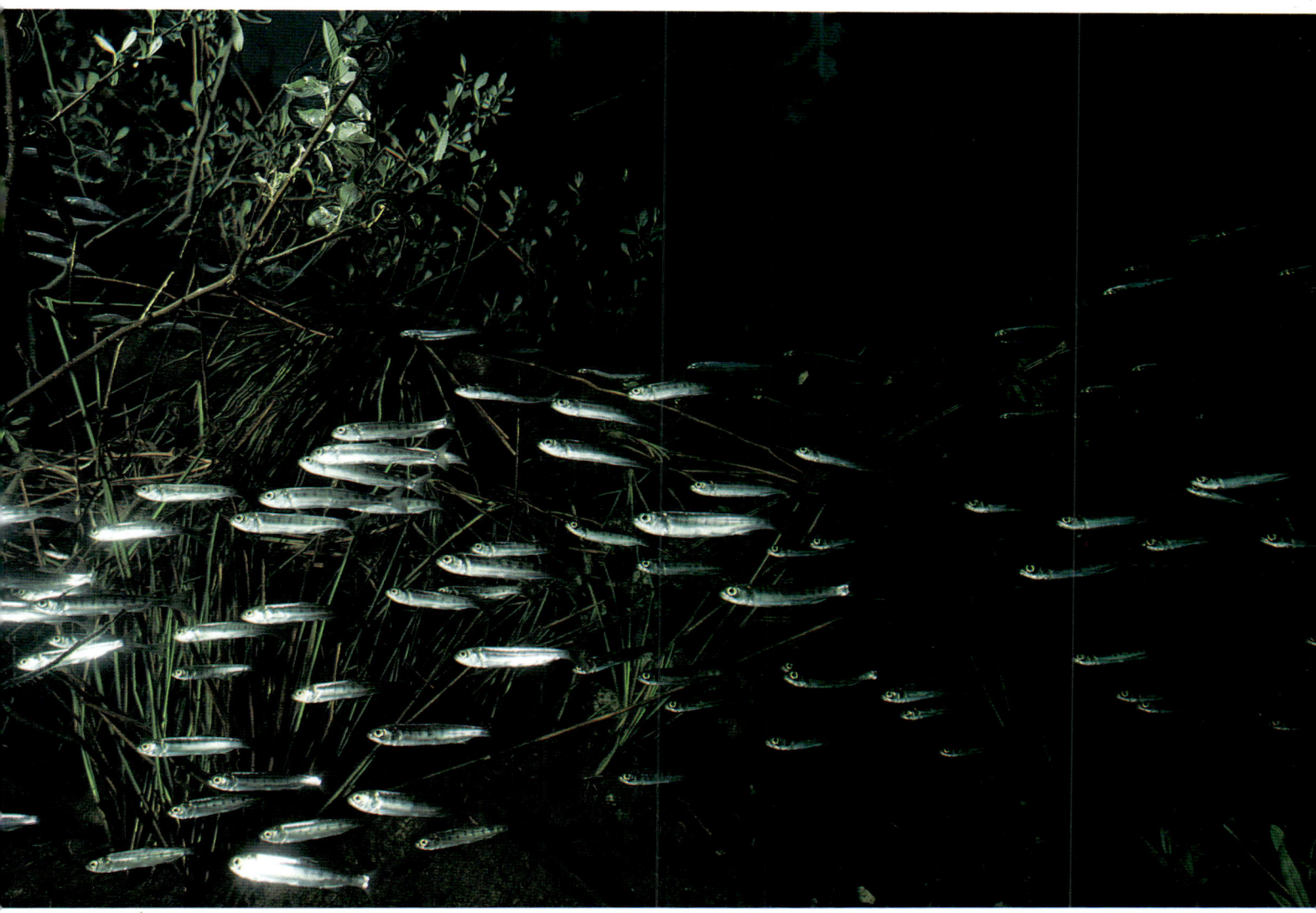

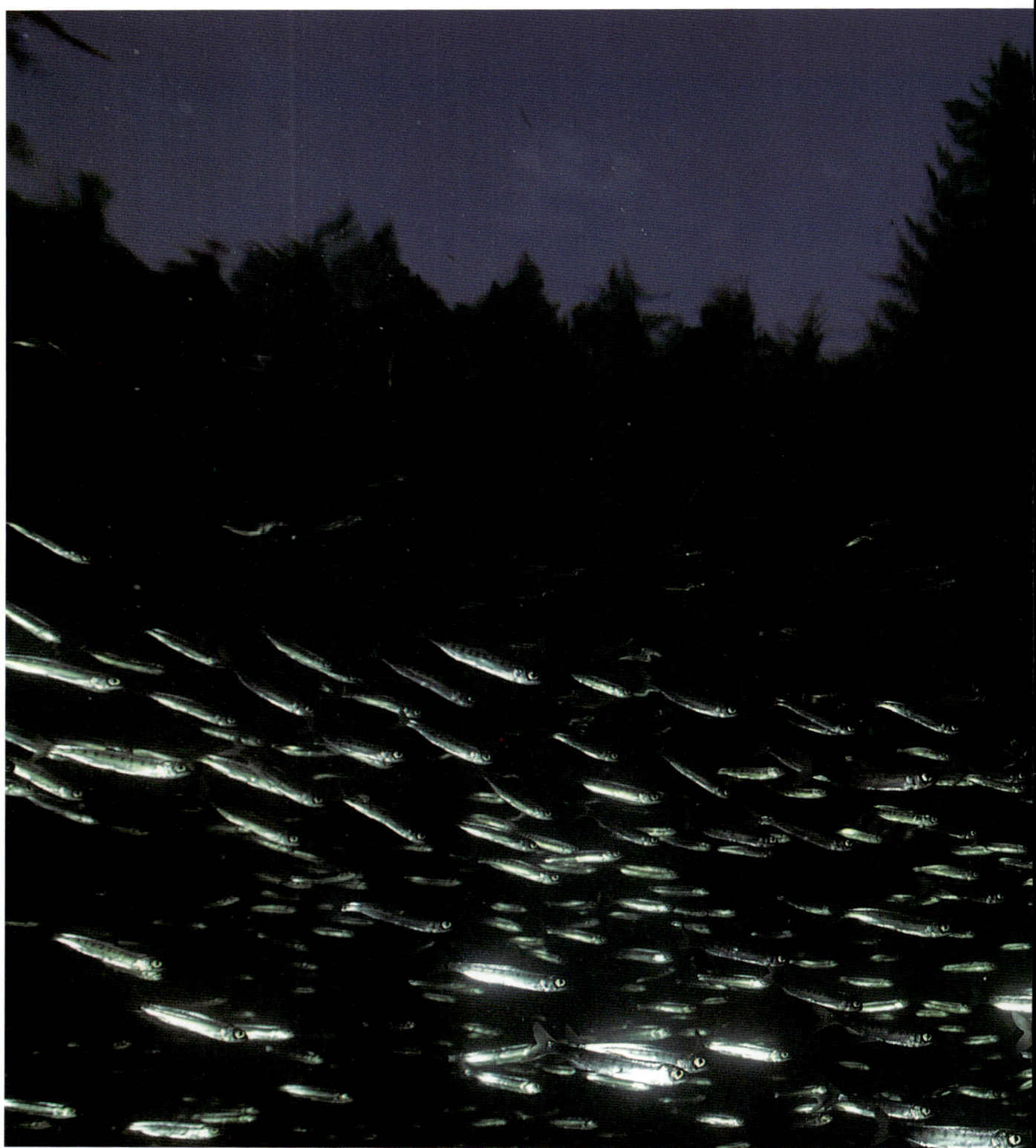

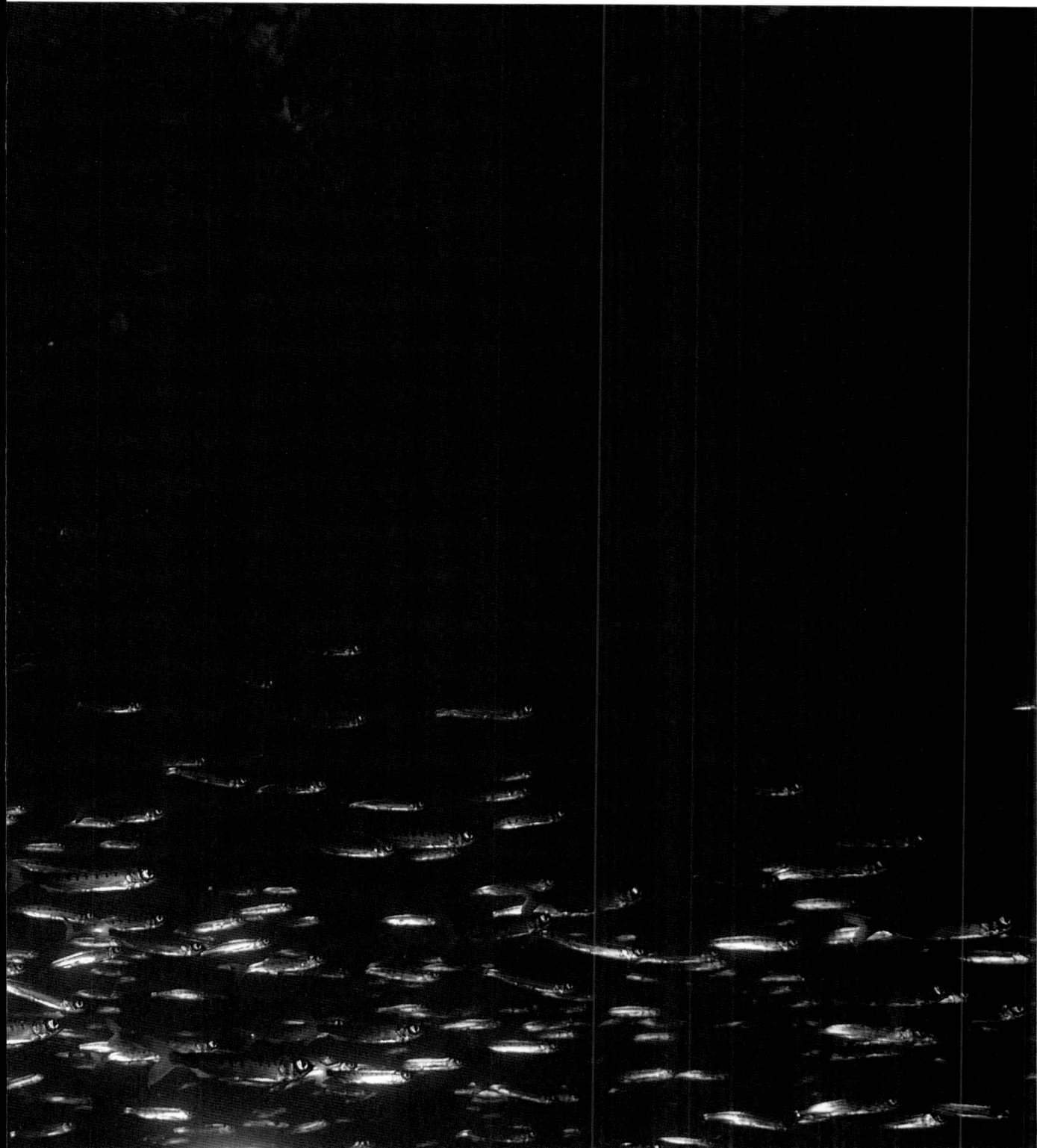

Pages 110–111: Now referred to as smolts, the fish lose their parr marks as they prepare for life at sea.

Right: Young sockeye swim away from river and estuary, heading for the open North Pacific. In their fourth year they will return, repeating the marvellous, mysterious life cycle of the sockeye salmon.

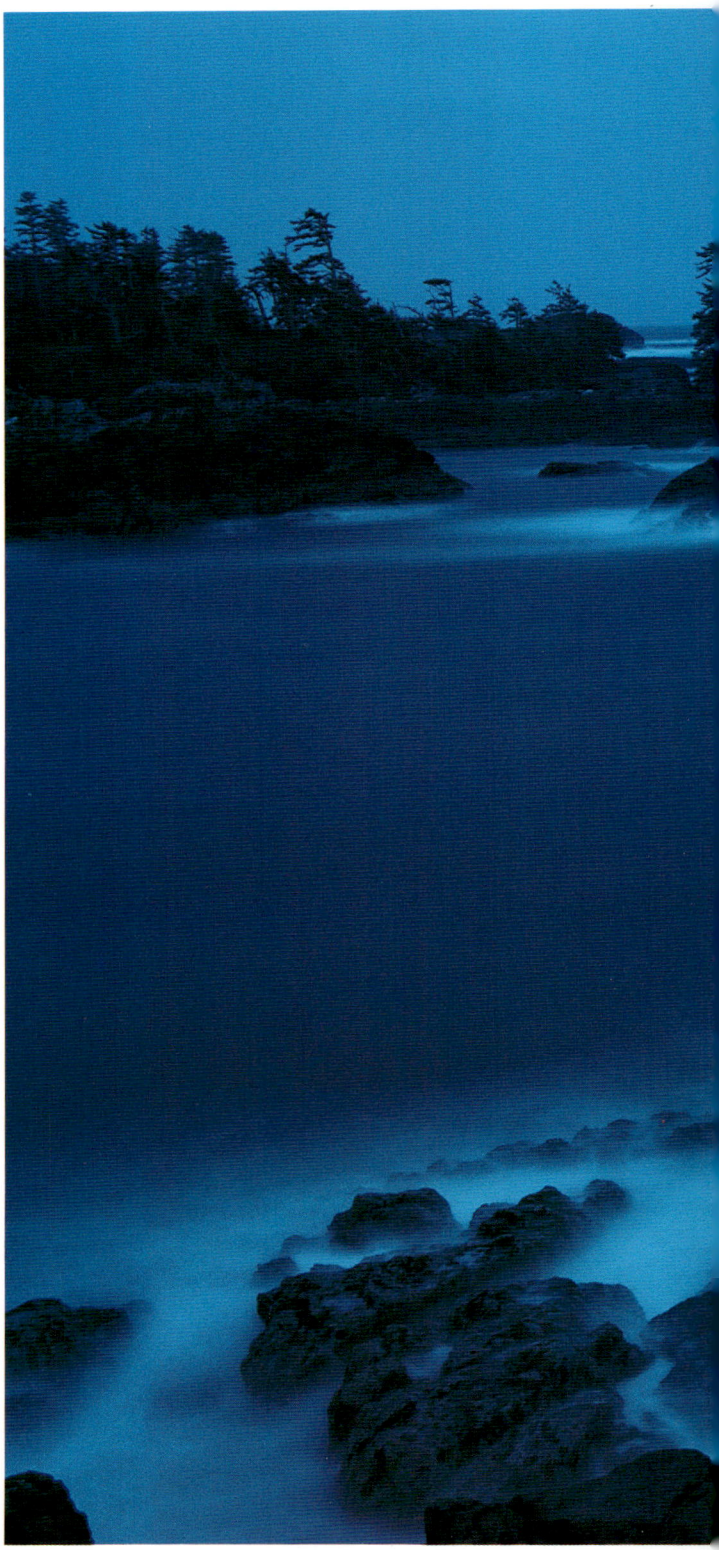

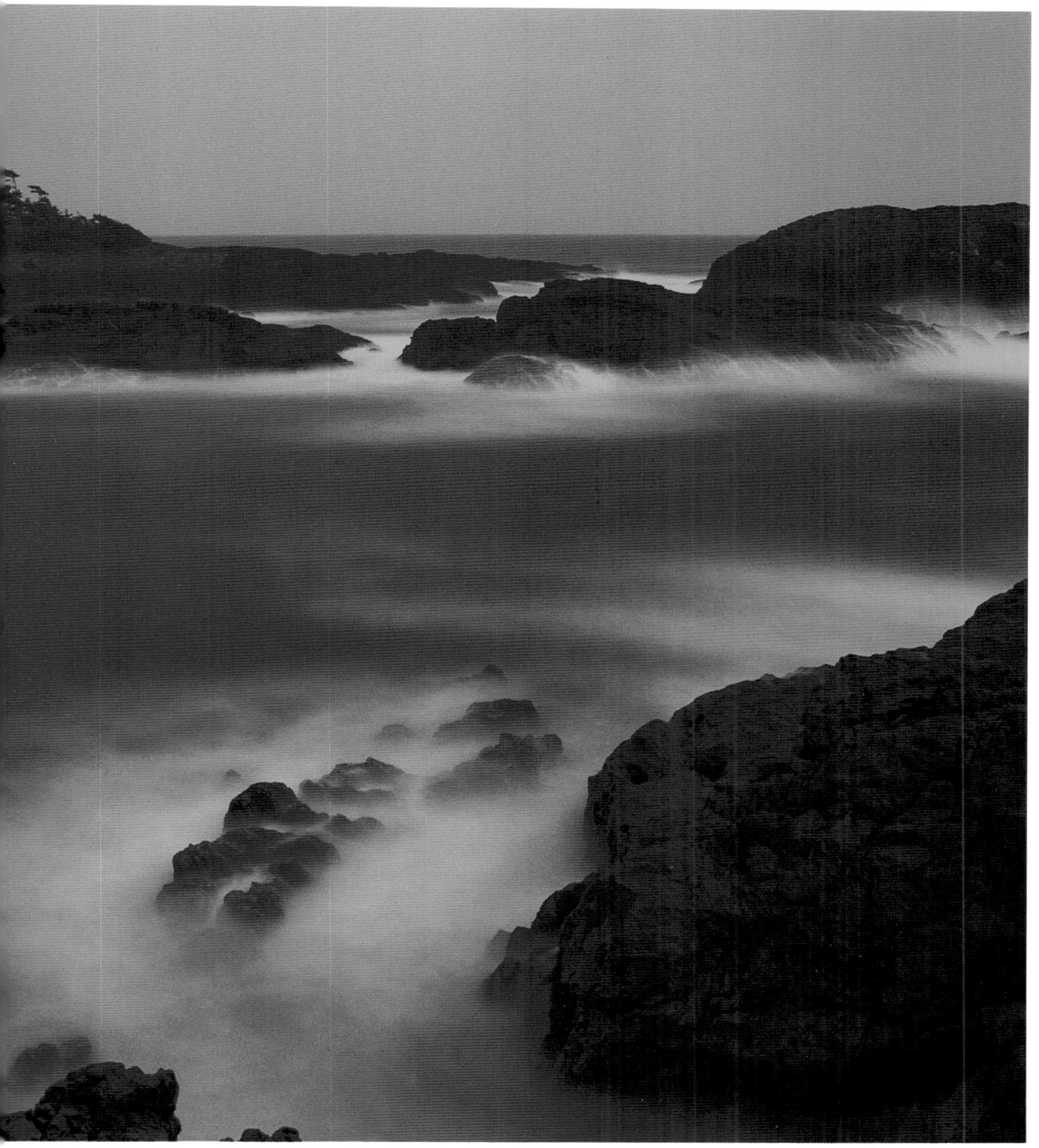

FOR FURTHER READING

Readers who wish to know more about the Pacific salmon may find the following titles of interest.

Childerhose, R. J., and Trim, M. 1979. *Pacific Salmon.* Vancouver: Douglas & McIntyre.

Groot, C., and Margolis, L. 1991. *Pacific Salmon Life Histories.* Vancouver: University of British Columbia Press.

Roos, John F. 1991. *Restoring Fraser River Salmon: A History of the International Pacific Salmon Fisheries Commission, 1937–1985.* Vancouver: Pacific Salmon Commission.

Stacey, D., and Stacey, S. 1994. *Salmonopolis: The Steveston Story.* Madeira Park, BC: Harbour Publishing.